WOMEN MΛKING HISTORY

PROCESSIONS – THE BANNERS

WOMEN

PROCESSIONS

MAKING

THE BANNERS

HISTORY

On Sunday 10 June 2018, tens of thousands of women wearing scarves of green, white and violet took to the streets in Belfast, Cardiff, Edinburgh and London as part of PROCESSIONS, a mass artwork to mark 100 years since the first women were allowed to vote in the UK

Produced by Artichoke based on an idea by Creative Director Darrell Vydelingum, and commissioned by 14–18 NOW, the UK's arts programme for the First World War centenary, PROCESSIONS was a moment for celebration and reflection on what it means to be a woman* today.

In the months leading up to that memorable day, Artichoke invited 100 arts and community organisations across the country to work with women artists of their choice to make banners: original artworks inspired by the banners made by the suffragists and suffragettes who had campaigned for votes for women a century before. A further series of PROCESSIONS banners was commissioned by Artichoke from fourteen artists and designers.

These twenty-first-century banners are powerful statements made in text and textile, referencing the earlier struggles for equality and reflecting the modern-day concerns of women and those identifying as women.

Women Making History: PROCESSIONS: THE BANNERS is the first opportunity to see each of these banners up close in all their glorious detail and to observe a historic moment, when a mass artwork made by women in all their diversity transformed the central streets of our four capital cities.

* Throughout this book, 'women' encompasses those identifying as women or non-binary

Women making history

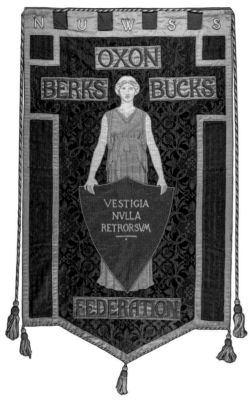

'The voices that had sounded so loudly in that first joyful victory in 1918 rang out again'

→ Helen Marriage MBE

CEO / Artistic Director,
Artichoke

'Let us go then, and make banners ... and let them all be beautiful!' The words of artist and women's suffrage campaigner Mary Lowndes echo across the years since the first campaigning women from Britain and Ireland took to the streets to fight for equality and their right to vote. PROCESSIONS was inspired by the actions of these ancestors – women in long skirts and hats who stare out from the pages of history books, glaring defiantly at their opponents, but also glaring at us, their descendants, daring us to emulate their courage as we struggle for the causes we hold dear today.

Creative Director Darrell Vydelingum suggested the idea of recreating one of the huge processions organised by the early women's movement at the turn of the century, and the work was commissioned by 14–18 NOW, the programme of arts commissions for the First World War centenary. We imagined a single day of mass action across the four political capitals – Belfast, Cardiff, Edinburgh and London. For maximum impact this was to be preceded by months of painstaking work by groups in cities, towns and villages nationwide, coming together to create hand-stitched artworks expressing the hopes, fears, aspirations and arguments of the many diverse communities taking part.

A visit to the Women's Library, currently housed at the London School of Economics, to see the collection of suffragist and suffragette banners from that time, cemented our idea that a nationwide initiative to revive the old

Above
National Union of Women's Suffrage Societies (NUWSS) banner.
Photo courtesy LSE Women's Library

Opposite
A banner from 1908 on a ground of cream and purple cotton sateens, with appliquéd lettering. The reverse reads 'Votes for women', appliquéd in green cotton. Photo courtesy LSE Women's Library

skills of banner-making amongst women and girls would lie at the heart of our project. Text and textiles have often been central to women's protest — a way of saying on the outside what is felt on the inside by those with no real voice in society.

Artichoke invited 100 groups across the country to work with women artists of their choice to make banners expressing their wildest dreams, which would be carried as part of the mass artwork on Sunday 10 June. We also commissioned a special series of PROCESSIONS banners for the day from fourteen artists and designers. We worked with women with experience of stitching and those with none, with women who still didn't have the vote, who had experienced homelessness, who had lived experience of the criminal justice system, who were refugees or of no fixed address. We worked with women of all sexualities, women of all abilities, of all ages, of different cultures and religions, those who identified as women, women who were community heroes — often unsung. We challenged them to reach out to other women in their areas and invite them to take part.

Embroidery has a long history of being a communal activity and of forging bonds and, as each group stitched and sewed, they talked and learned. For many it was the first opportunity to think about their own voice in the political process; for others, it was a chance to learn about the courage of those women who had fought for their right to vote. For most, it was the first time they had signed up to be part of a major contemporary artwork.

There were so many stories. A refugee woman incorporated material from her grandmother's dress into her banner; a farmer in the Western Isles contributed wool from her sheep. Individually and collectively, they created an extraordinary series of banners that led the processions in each city and which are now illustrated in their full glory through the pages of this book.

The ambition of PROCESSIONS was to create a single unifying moment of celebration and commemoration, when communities could take to the streets creating a glorious portrait of women and girls in the twenty-first century. Groups of women took over train carriages, some got ferries, others shared lifts. One group leader drove across the north coast of Scotland, picking up participants for the long journey to Edinburgh, staying overnight in a parish kirk before starting the seven-hour journey back north. So many of one group of young mothers from Hull wanted to join, that a bigger coach had to be booked.

As I walked the last part of the route from Pall Mall to Whitehall on the morning of Sunday 10 June, I noticed that all of the BBC camera operatives were women, something I'd suggested but hadn't dared hope would be possible. And just a few hours later, the ceremonial streets of all four cities were invaded by tens of thousands of women, huge streaming processions wearing scarves of green, white and violet representing the unfurling of the suffragette flag.

The voices that had sounded so loudly in that first joyful victory in 1918 rang out again as the continuing campaign for women's equality resounded through the streets 100 years later.

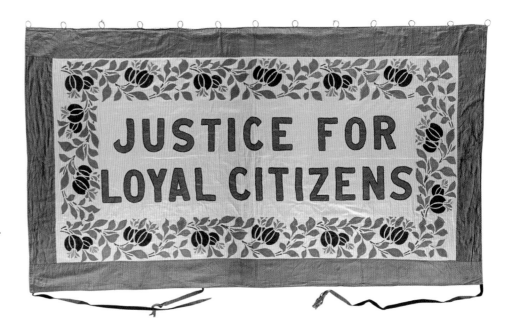

→ Jenny Waldman CBE

Director 14–18 NOW, the UK's
arts programme for the First
World War centenary

Two momentous changes in women's rights took place in 1918, at the end of the First World War. In February 1918 the Representation of the People Act gave 8.5 million women the vote. Later that year women won another victory – the right to stand for election as MPs. The December 1918 general election, held five weeks after the end of the war, saw the first women in Britain voting and the first woman, Constance Markievicz, elected as an MP. Not all women were granted the right to vote in 1918 – only those over the age of thirty and on the property register – but the scale of the change, and the victory for the women's suffrage campaigners, was remarkable.

How unimaginable this must have seemed four years earlier, before the First World War. The campaign for women's suffrage had been building for decades, reaching peak activism in the years before the war. The suffragettes became headline news with letter bombs, cat-and-mouse policing, imprisonment, hunger strikes and force-feeding. And yet just four years later votes for women was so non-contentious that the law was changed without any real opposition. What had changed in those four years?

One major factor was the massive change in women's roles and the perception of women during the 1914 – 18 war. With the men away fighting, women took on new responsibilities and replaced men in factories, on railways and buses, and in other traditionally male roles. In all, around 2 million women took on men's jobs – though at a lower wage. Women became 37 per cent of the workforce. Ironically the war afforded women new opportunities, and attitudes began to change. Women's contribution to the war effort was one of the justifications for the change in opinion on women's right to vote and take a role in public life.

This landmark moment in women's rights was a huge inspiration for artists in the 14–18 NOW programme of arts commissions for the First World War centenary. These commissions were invitations to artists, from the UK and around the world and across all art-forms, to create new artworks for people in every part of the UK. We invited them to create ambitious, large-scale art connecting a new generation to the events of 100 years ago, and that explored the resonance of the First World War in the world today. Over 100 projects saw artists exploring many and varied aspects of the First World War and, over the course of the centenary, some 35 million people in the UK engaged with the 14–18 NOW commissions. The changing role of women during the war was an inspiration

for several projects. Artists looked at the heroism of women at the front, at women's changing roles at home and, of course, at the fight for women's rights and the achievement of the first votes for women in 1918.

From the start, we wanted to reach as wide an audience as possible, with many projects that were free, outdoors, large-scale and invited participation. Artichoke's PROCESSIONS was one of the largest of the 14–18 NOW commissions, and the most celebratory, inviting women and girls in all four nations of the UK to participate in creating an artwork that took place across the UK and was seen around the world. The banners created by women in all parts of the country were carried in the PROCESSIONS in the capital cities of the four nations. The beautiful, creative, witty, thought-provoking banners were both reminders of the suffrage campaigners' banners and expressions of today's ambitions. Artichoke masterminded the PROCESSIONS of thousands of women wearing the colours of the suffragettes and taking over the streets of our capital cities, with the banners held aloft. It made an unforgettable sight. Women came with mothers, daughters, aunts and grannies. Some dressed in full Edwardian suffragette outfits, others brought homemade banners and hats — one woman wore a scale model of the Houses of Parliament on her head. The PROCESSIONS were joyous, uplifting and memorable.

PROCESSIONS captured the zeitgeist. Dreamt up well before #MeToo, it gave women of all ages the opportunity to celebrate women's achievements in the campaign for suffrage that led to those landmark acts of parliament in 1918, and at the same time to reflect on a century of progress in women's rights and to renew our determination to continue the campaign for women's equality 100 years later.

Posse of Protesters,
PROCESSIONS London.
Photo by Sheila Burnett

The struggle for women's suffrage

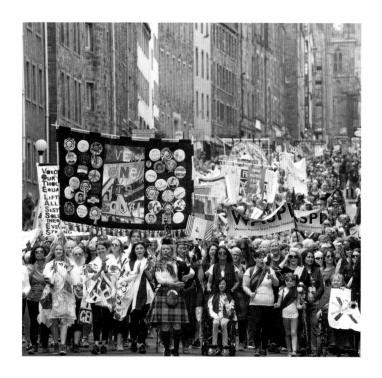

Left
Lord Provost of Edinburgh's official piper, Louise Marshall, piping PROCESSIONS down the Royal Mile, Edinburgh. Photo by Lesley Martin

Right
Flora Drummond and others under arrest, 1914. Photo courtesy LSE Women's Library

* Anna Muggeridge, 'The Missing Two Million', *Revue Française de Civilisation Britannique*, XXIII–1, 2018, www.doi.org/10.4000/rfcb.182

→ Dr Helen Pankhurst CBE

PROCESSIONS Ambassador.
Author of *Deeds Not Words:*
The Story of Women's Rights,
Then and Now
Advisor to CARE International
and founder of March4Women.

If we close our eyes and think of feminist demonstrations we see women together, in sisterhood, determined, unwavering, often angry, often joyful. In the foreground of these demonstrations are the posters and the banners – the visual expressions of a cause; the medium through which messages are relayed. The significance of messaging through posters and banners applies to all demonstration, across time and space.

For feminism, the first wave over a century ago started it all. The action took the form of writing, lobbying, demonstrating on the streets, and direct action demanding women's suffrage. This was the first time that women campaigned in large numbers together as women and on women's issues, with men relegated to support roles rather than as the focus of attention. The demand was around women having a say in society, a right to draft the policies and the laws of the land. It was about the right to vote and to stand in national and local elections.

Beyond the vote, there were many other demands, developed further by subsequent waves of feminism, and which echo through the ages. These included equal pay and property rights, equal access to services, control over fertility, calling out double standards around sexuality and addressing the different structural bases that perpetuate gender-based violence.

In the twenty-first century, there are centenaries around the world of that first wave of feminism. In the UK, 1918 is critical as the date some women gained the parliamentary vote. This meant women over thirty who met a property qualification or were university educated. Approximately 8.4 million women were enfranchised. An estimated 7 million*, had to wait another ten years for equal voting rights. In the USA, in 1920, it was the Nineteenth Amendment of the Constitution that opened the door, stating that 'The right of citizens of the United States to vote shall not be denied or abridged by the United States or by any State on account of sex.' However, the right to vote was barred on other grounds, and it was only following the Voting Rights Act of 1965 that African, Hispanic, Asian and women of Native-American heritage gained that most basic of rights. Centenary celebrations have reminded us of the successes but also of the schisms and the partial nature of the gains.

There has been a myriad of initiatives to honour the past and encourage reflection on how far we still have to go. For example, in Sarah Gavron's 2015 film *Suffragette*, Maud, the main character, is politicised by work-placed sexual abuse. The now global #MeToo campaign has since opened our eyes both to how little has changed and to how powerful women's voices can be.

The voice of individual and collective resistance looms large, and feminist symbols of courage resonate through the ages. In 2018, a statue to my great-grandmother Emmeline Pankhurst, one of the most iconic figures of women's rights globally, was erected in her hometown of Manchester, also the birthplace of the suffragette movement. Emmeline was welcomed home with a march of thousands of people. The words and deeds of many other suffragettes and suffragists were shared with new generations, and hundreds of thousands came out into the streets of Belfast, Cardiff, Edinburgh and London for the centenary PROCESSIONS on 10 June.

The new generations have found that the need for marching has not gone away, and banners and posters expressing demands are still being made. They are as relevant and as powerful a summary of a cause as ever they were. One difference today is that, for the most part, they are produced in a hurry. They are often humorous and poignant but don't always involve the level of 'craftivism' of old.

Which is why this book about the banners designed for the 1918 centenary is so important. It shows banners in all their glory, and includes an understanding of how they were conceptualised and crafted in groups, by hand, in the past tradition of banner-making. People came together to represent their problems and their aspirations, drawing links to the past. The way they collaborated to make the banners, the products themselves and their use on the streets in 2018, are all symbols of sisterhood and solidarity.

As we prepare for further centenaries globally, I hope these banners will inspire and encourage others not just to remember but to keep going – to keep marching, banners held up high.

△ A big idea

→ Darrell Vydelingum

Creative Director, PROCESSIONS

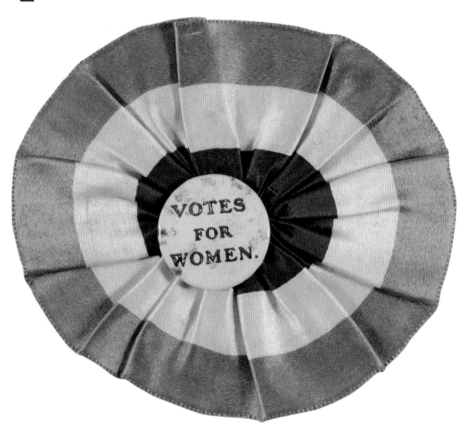

Above
Votes for Women rosette, c. 1913.
Photo courtesy LSE Women's Library

Opposite
Ethel Smyth at a Women's
Social & Political Union (WSPU) meeting, c. 1912.
Photo courtesy LSE Women's Library

Like most movements, campaigns, causes (and art projects), everything starts with a big idea and PROCESSIONS was no different: commemorating the anniversary of the first women gaining the vote. A project full of banners, thousands of women on the streets of the UK's four capital cities, and a human flag in the colours of the suffragette movement.

But where did it all start? Back in 2013 I was invited to develop a fashion project to mark 100 years since the First World War. Incongruous as it sounds, I was soon deeply immersed in fashion, war and women's rights. The war radically changed women's position in society and as a result, their clothes. As men went to war, women stayed home and kept the country running, driving buses and making munitions in factories. It meant tight corsets were replaced by the newly invented bra, and long hemlines and heavy fabrics gave way to trousers. I invited today's leading designers, from Vivienne Westwood to Roksanda, to reimagine the story for today. The result was *Fashion & Freedom*, an exhibition that toured the UK throughout 2016.

Arguably, the First World War fast-tracked women's rights; the proof was in the pudding — women could do the jobs that previously only men had been allowed to do. With the centenary of the first women getting the vote falling in 2018, I wanted this moment to be honoured in a very big way.

The creativity and imagination of the women's movement was unparalleled, virtually inventing the PR stunt. At a time when media was in print form only, their slogan 'Deeds Not Words' lives on loud and proud today. Anecdotally, their colours reinforced the message (Green = Give, White = Women, Violet = Votes) and were used on sashes, badges and, more subversively, on tea sets and even jewellery. They rode around on bicycles with placards publicising events and made banners to promote their cause.

But the energy of the movement was strongest in the mass processions. The power of women marching in unison became synonymous with emancipation, a symbol of the fight and of hope.

On a cold rainy day in February 1907, 3,000 women processed from Hyde Park down to the Strand in London. The largest demonstration for women's suffrage at the time, it became known as the 'Mud March' on account of the bad weather and mud-splashed clothes. It was a turning point, one of the first marches organised by the suffragists, and widely reported in the press.

A year later, 'Women's Sunday' in Hyde Park became the largest women's suffrage rally yet. Over 350,000 people took part, carrying 700 banners. The women's movement had arrived. After decades of activism and campaigning, in 1918 the first women finally won the right to vote. It was this collective power I wanted to reignite, and who better to take this idea forward than the Artichoke team, commissioned by 14–18 NOW. And so PROCESSIONS was born.

100 years on, on 10 June 2018, we honoured those first women in style. It's a day I will never forget — how many people can say they shut down four major cities? I was in London and witnessed women, and those as identifying

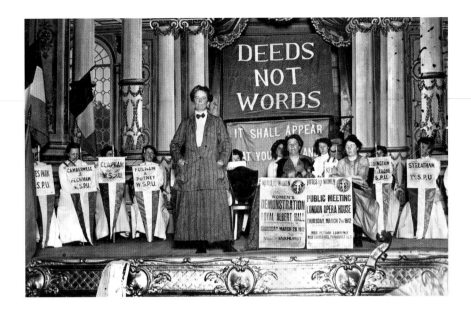

as women and non-binary, of all ages and backgrounds marching, banners in hand — mothers, friends, families, organisations and groups — with a true sense of sisterhood.

Thousands walked the streets of our four capital cities, each wearing one of the suffragette colours. Over 100 women artists had worked with over 100 groups to create beautiful banners that punctuated the route with campaigns and slogans for today.

And unlike that cold muddy day in 1907, the sun shone brightly and music spurred us on as thousands of us walked in the footsteps of our feminist ancestors from Hyde Park to Parliament, imagining them smiling down on us.

This Big Idea came to pass and I'm so proud of what we achieved that day. The beautiful banners, new friendships, and a better understanding of the fight and struggle. The year 2018 seemed to capture the zeitgeist, with feminism once again

a mainstream global movement, this time for the hashtag generation.

Christabel Pankhurst, daughter of Emmeline, once said: 'Remember the dignity of your womanhood. Do not appeal, do not beg, do not grovel. Take courage, join hands, stand beside us, fight with us.' Words that capture the spirit of PROCESSIONS 2018.

PROCESSIONS felt like one of those 'I was there' moments. A portrait of women today — with hopes, aspirations and calls for change. It was also a dedication, to those who started the journey 100 years ago and to those who continue to fight for gender equality today.

An excerpt from a speech given
by Her Honour Judge Wendy Joseph
and Fiona Adler at the launch
of PROCESSIONS in January 2018,
hosted at the Old Bailey in London.

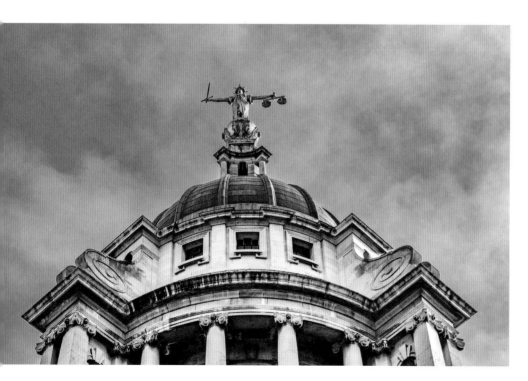

Justice stands over the Old Bailey.
Photo by Joe Dunckley / Alamy

Wendy

Welcome to the Central Criminal Court,
known to many as the Old Bailey.

I am Judge Wendy Joseph and I am
one of the twelve permanent judges here
at the Bailey, of which five are women.

Fiona

And I am Fiona Adler, a past sheriff of
the City of London, and I was just the fifth
woman to be elected in 900 years.

Wendy

We are delighted that the Recorder and sheriffs
have let this building be used for the launch
of PROCESSIONS. It's a fitting place for it to
start. You are sitting in the space, breathing
in the air, where for 700 years Newgate Prison
stood. It's impossible to imagine the degradation
and distress that women, and their children,
their babies, suffered here. It took a woman
to help them – step forward Elizabeth Fry.
Their ghosts and hers would have been proud
when in 1912 and 1913 Emily Davison and
Emmeline Pankhurst, amongst others, stood
in the dock in Court 1 and declared to the
court and to the world what they were doing
and why.

Fiona

From 1905, frustrated at the lack of progress, the suffrage campaign had turned militant. Under the leadership of Emmeline and Christabel Pankhurst, the Women's Social and Political Union staged demonstrations and engaged in acts of vandalism such as breaking windows by throwing stones. There is a report of a speech by Emmeline at the Savoy Theatre on 15 February 1912 in which she said:

'No matter how obscure any woman thought herself she could rise to the level of the highest. The people of China won freedom at the price of blood, but the women of England would win freedom only at the price of a few panes of glass. I have come to the conclusion, that if I had broken a pane of glass with other women when younger than my daughter, women would have had the vote long ago. Since we cannot get our freedom by women's ways, then I am going out to throw my stone with the rest of you.'

Wendy

My journey to the Bailey was a little less traumatic, but other women – some in this room – have made far more spectacular journeys than mine. I went to a girls' grammar school, got a scholarship to a girls' school in California, and then on to a women's college in Cambridge. In fact by the time I came to London to read for the Bar I'd spent most of my life amongst women, and I had not the faintest idea what awaited me. I was the only woman at the chambers for my first pupillage and for the six months the clerk never called me anything but 'Sir'. The male barristers treated me like an amusing toy. It wasn't done out of cruelty. It was done because that was how they thought women were to be treated. My first job was in the chambers of a man called John Roberts. He was the first black criminal QC. He'd gathered a band of waifs and strays – men and women, mostly from ethnic minorities. His basement set wasn't luxurious. We had no loo! Over the years that followed more and more women were making their way to the Bar. By the time I got work in this building, I found the tiny ladies' robing room a busy place, presided over by women who were the role models for people like me. There are now as many women being called to the Bar as men and we should be congratulating ourselves in how far we have come, and urging ourselves – and others – to go further.

I am delighted that PROCESSIONS will be celebrating the achievements of women of the past and present, acknowledging how far we've come, and highlighting the need for further change to achieve equality for women and girls.

Fiona

Just one final thought. Standing above you over there is a magnificent woman – all 22 tonnes of her . . . On top of that dome is Pomeroy's sculpture of Lady Justice clutching the sword of retribution in her right hand, and the scales of justice in the other, but contrary to the well-worn adage she is not blindfolded – this particular woman has witnessed the 100 years since women gained the vote.

15

→ June Sarpong OBE

participated in live BBC
broadcast of PROCESSIONS
on Sunday 10 June

The PROCESSIONS march of 10 June 2018 was a particularly poignant day for me. Being asked to take part in the march and television show to celebrate the centenary of female suffrage, I couldn't help feel the weight of the achievements we were honouring, yet everyone gathered knew there was still so much further to go. I think what really strikes me about the fight for female suffrage is that it was something that affected half the human population and yet, at the time, the suffragettes were seen as a radical minority group of privileged women and did not have universal support, even from women. I contrasted that with the present day, where I was amongst a diverse group of women coming together to celebrate a massive political and cultural shift that enabled women to vote for their elected representatives, just like their fathers, husbands, brothers and sons. I was both proud and elated to have been asked to take part in the two-hour BBC broadcast, and I remember the magical sight of tens of thousands of women invading central London wearing purple, white and green scarves, many carrying beautiful handmade banners. However, PROCESSIONS was not an exclusive London-centric event but rather a nationally inclusive, vibrant gathering that attracted hundreds of thousands of women and male allies all over the country.

As I was celebrating this historic milestone in equality, I couldn't help but consider, in spite of a century passing, the many milestones we have yet to achieve in terms of career opportunities, reproductive choices and safety from exploitation and violence. I have always

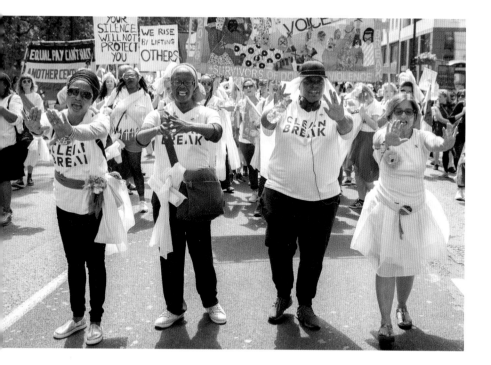

Clockwise from above
Women from Clean Break dance in front of their banner as part of the London PROCESSIONS on 10 June 2018. Photo by Tracey Anderson

Drumming women,
PROCESSIONS 10 June 2018,
London. Photo by Sheila Burnett

Southall Black Sisters,
PROCESSIONS 10 June 2018,
London. Photo by Sheila Burnett

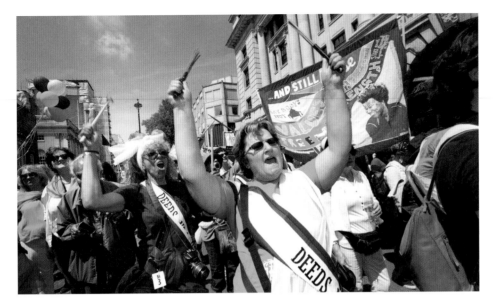

movement is about equality and that should not exclude anyone, regardless of their social background, ethnicity, faith, sexual orientation, gender identity, age or any form of disability that they may have. Equality and fairness have become points on our moral compass guiding us towards the society that we seek to become. Milestones like female suffrage, the abolition of slavery and same-sex marriage have brought us further on our journey and those values of equality and fairness are inseparable from British values. We all acknowledge we have further to go, but PROCESSIONS and the support it received convinced me that the fight for equality is not and should never be a minority movement or fringe concern. With all of us marching together, who knows which milestones will be celebrated in the next 100 years from the stands we are taking today.

had a curiosity about the world around me that has attracted me to embrace travel and reading, and so when I was asked to take part in PROCESSIONS I wanted to understand more about the intersectionality of the struggle for gender equality. The story that I was taught included brave women like Emmeline Pankhurst and Emily Wilding Davison, who took on the political establishment here in the UK. However the majority of history we are taught about this heroic struggle omits the pivotal role played by women of colour in the fight for gender equality, which is not the preserve of any ethnicity, social class or nation.

I think particularly about women like Sojourner Truth in the United States, a former slave and abolitionist who, after surviving the ordeal of being a female enslaved by men who saw her as property, became a force in the movement for equality for all women in the US. I imagine that her lived experience as a woman escaping slavery and then fighting for abolition brought an additional perspective

and understanding of the urgency in addressing gender equality. The role of women in the Indian independence movement who were at the same time fighting for female suffrage and equality is another historic struggle we must not allow to be erased or forgotten. The stories of Ambujammal Desikachari, Purnima Banerjee and Kamaladevi Chattopadhyay have rarely been told, with the focus reserved for men like Mahatma Gandhi, Jawaharlal Nehru and Subhas Chandra Bose. Few people are aware of the fight for gender equality that coincided with the independence movement, and although the latter has been achieved for India, the former continues.

Many of our struggles for equality are more than the one dimensional stories that they are presented as, and so in reflecting on the achievements of the feminist movement it is important to take an intersectional approach. As we bring more women and men under the banner of feminism it is important to remember that ultimately the

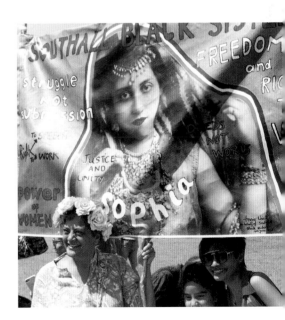

Text and textiles

→ Clare Hunter

PROCESSIONS Banner-making Consultant
Author of *Threads of Life: A history
of the world through the eye of a needle*

By the turn of the nineteenth century, after years of gentle persuasion, of petitioning and lobbying, women's suffrage in Britain remained elusive. The Women's Social and Political Union, formed in 1903, advocated a more intemperate agenda. It incited its members to adopt more violent measures, targeting the bastions of male power. Politicians' homes were bombed, the windows of high-street stores smashed, and suffragettes invaded the very seat of male governance, the House of Commons, unfurling a banner proclaiming their right to vote. Their actions were condemned by politicians and press, who denounced such anarchy as unwomanly and unrepresentative, dismissing it as the crazed antics of middle-class, intellectual harridans. The suffragette movement began to be lampooned. Cartoons appeared sporting its campaigners armed with rolling pins and umbrellas. The suffragettes were portrayed as women who cared nothing for their families or for their appearance: women devoid of feminine sensibilities.

A new tactic was urgently needed if the suffragettes were to safeguard the support they had mustered and court greater public sympathy. What was needed was an undeniable show of women's capacity and resolve — across class, geographies and generations. The idea of mass rallies was born. In a Victorian era characterised by a fascination with spectacle and scale — elaborate theatricals, gaudy fairgrounds, music-hall marvels — the rallies the suffragettes organised were designed to be thrillingly magnificent: thousands of women marching together through city streets accompanied by a swell of mass choirs, the blast of pipe bands, a rainbow drift of processional colour animated by the sway and silken gleam of hundreds and hundreds of beautiful banners held high above the throng.

It was the artist and designer Mary Lowndes who masterminded the banner pageantry. For the National Union of Women's Suffrage Societies rally on 13 June 1908 she distributed a banner-making guide to participants to ensure that what she termed 'women's own adventure' was manifested in glorious visual splendour, insisting that 'a banner is a thing to float in the wind, to flicker in the breeze, to flirt its colours for your pleasure . . . Choose purple and gold for ambitions, red for courage, green for long-cherished hopes.' Women gathered in local halls and their own homes to make banners which proclaimed who they were and where they belonged: the villages, towns and cities they came from; banners that celebrated the women through time who had championed female advancement: Josephine Butler, Jane Austen, Elizabeth Fry, Marie Curie, Mary Wollstonecraft amongst them and, most audaciously of all, Victoria, Queen and Mother.

Participants made their banners in fabrics displaced from the drawing room — silks, velvets, brocades — and purposefully embellished with delicate embroidery to emphasise a woman's presence. This was, Lowndes encouraged, to be 'a declaration', a visible assertion of women's protest, of women sprung from the confines of domesticity to defiantly parade on the streets and claim their rightful place in public life. Over a quarter of a million people came out to watch them pass.

For PROCESSIONS, Artichoke's 2018 event in honour of those marching women, it was my privilege to be commissioned to follow in Mary Lowndes' footsteps and devise a banner-making kit for participants. Thousands of women and girls followed in the footsteps of their grandmothers and great-grandmothers to fashion banners from scraps of fabric and multi-coloured threads as visual expressions of twenty-first-century women. These were banners that had no need to be delicate. They were flamboyant and multi-textural, reflecting the diversity and creativity of their makers. Their slogans told of confidence and energy: 'Our Voice is Powerful and Will Be Heard', 'We Will Have What We Want', 'We Are Here', 'We Know Where We're Going', 'Girls Bite Back'. And, while many referenced the suffragettes' struggle, others emphasised contemporary concerns about pollution, domestic abuse, racial inequality and social exclusion. The hundreds of banners made for PROCESSIONS were heart-warming celebrations of challenges overcome and heartfelt manifestos for those that lay ahead: autographed in an exuberance of multi-layered colour, pattern and texture to materialise collective action. As the thousands of participants conjoined in their violet, white and green scarves and streamed through Britain's city streets, their banners punctuated their flow as spirited exclamations of promise and power.

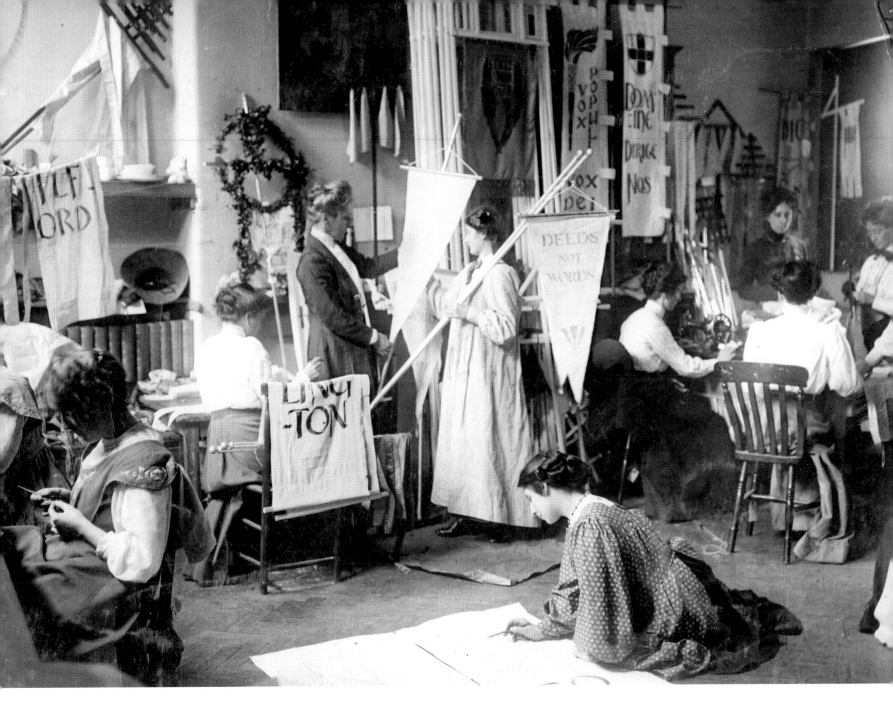

Suffragettes making banners and pennants
for the procession to Hyde Park, 23 July 1910.
Photo courtesy LSE Women's Library

19

Making the scarves

→ Geetanjali Sayal

Project Intern

Geetanjali Sayal came to London from India in 2017 to study and followed this with a work-experience placement at Artichoke. Here is the story of how she came to be involved in the production of the beautiful scarves that were given out to everyone to wear as part of PROCESSIONS, to create the visual effect of a human banner — a tricolour river of green, white and violet through the streets of Belfast, Cardiff, Edinburgh and London.

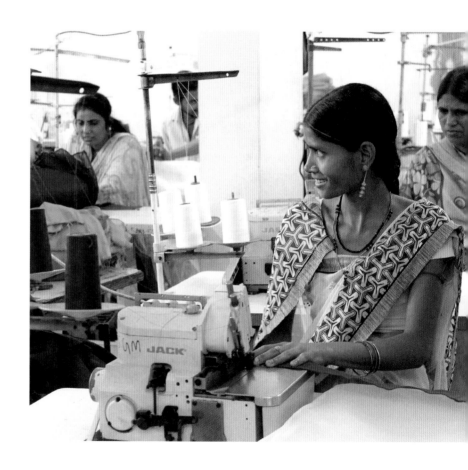

Right
Making the PROCESSIONS scarves in New Delhi.
Photo courtesy Geetanjali Sayal

Opposite
The New Delhi machine room.
Photo courtesy Geetanjali Sayal

How did your family end up managing the production of the PROCESSIONS scarves?

It all started with our team at Artichoke looking at suppliers. The brief was that we needed tens of thousands of scarves in three different colours: purple, white and green. My mother, Sangeeta Sayal, used to run a small boutique in our house in India fifteen years ago, and she still has friends and connections in the industry. We thought it would just be a matter of her placing the order, but we quickly realised that it wasn't as easy as it initially seemed. It was loads of fabric, which had to be sourced from several different locations across India, in Rajasthan and Gujarat.

Tell us more about how the scarves were produced.

The dyeing happened in the villages in Rajasthan and Gujarat. We weren't involved in that side of things. We employed 150 women for the project, working in the factory, sewing, mainly involved in the overlocking process. We also employed about 100 men, who were mainly prominent during the cutting stage and as drivers working to get the material to and from the factories. The thread we used came from the south of India, where it was also dyed. It was then sent over to New Delhi, which is where most of the production was happening. The production was basically split across New Delhi and a place nearby where my family house is.

How did you ensure that the workers were treated ethically?

We created a system where we could actually be physically present in the factories. It was all done through my mother and we were able to make sure that, when the money came in, we distributed it equally, because we were dealing with them directly. Everyone was paid for what they worked. Also, all of the women were at least in their thirties. We knew it was important, as this industry is often associated with exploitation. We also made sure that we employed more people than we needed so that they wouldn't have to work really long hours. And we made sure they got enough breaks during the day and we had people who were sorting food for the workers.

Did the women have a sense of what they were making the scarves for?

The production ran for about two months, and obviously the women didn't know about the project at the beginning because they had never been involved in anything like this before. But while they were working on it they were having conversations with my mother and she explained the magnitude of the project. They knew that the scarves were going to London and that people will be wearing them celebrating democracy and one hundred years of women voting. And afterwards we shared images of how the scarves were used.

→ Saoirse-Monica Jackson

PROCESSIONS Ambassador

'Being a Derry Girl, well it's a f**king state of mind'

Lisa McGee, *Derry Girls*

Taking part in PROCESSIONS in Belfast was an extremely personal and exciting prospect for me, as I am sure it was for every other person who took part or supported in the lead up to 10 June 2018.

As is well documented, we have a strong tradition of parading, protesting and politicising ourselves in the North of Ireland, sadly in a negative light more often than not. I truly feel that that tradition was flipped on its head with the collective imagery of women, girls and those who identify as female coming together from all corners of the North of Ireland in a moment of artistic joy and celebration.

Growing up as a young woman in the North of Ireland there was always such a strong sense of matriarchal leadership and strength within our community. We are known for our 'state of mind': being resilient, tough, welcoming and brave. I lived around such intelligent, hard-working women and it was always these women who kept it all together when things looked hard -– there was always a strength within them.

It seemed so crazy to me, then, when I was old enough to understand that in a society so centred on fighting for rights, justice and equality, women's rights were so often forgotten and pushed to the side.

Even as PROCESSIONS took place, abortion and gay marriage were illegal in the North of Ireland. Our two main political parties were led by women, and still we couldn't seem to accept that the rights of women are paramount to a successful, thriving community.

To me, PROCESSIONS was an artistic declaration of revolution, using happiness, joy, colour and togetherness to celebrate the strong women who come from the North of Ireland. It summarised all the attributes associated with our state of mind and gave us a platform to show the world what a positive, vibrant people we are. Seeing the spectrum of participants who walked and supported us on that day, and the wide range of banners created in such vivid colours, proved to the world what can be achieved when women are leaders in creating an artistic moment that can truly change lives and our societies.

Of course, the procession that day was focused on the celebration of 100 years of women's suffrage, but to me, a joint aim was delivered in the North of Ireland -– in celebrating our shared history rather than using it to divide us and glorify the horrors of the past. It showed how far we have come as a people and, sadly, how far we still have to go.

I believe PROCESSIONS leaves a legacy that will be celebrated throughout the lives of all who experienced it. That day should, and will, live on as an inspiration to the next generation of women, girls and those who identify as female, to use art and celebration as a realistic and respected way to change the world.

PROCESSIONS Ambassador
Saoirse-Monica Jackson marks
100 years of women voting in Belfast.
Photo by Brian Morrison

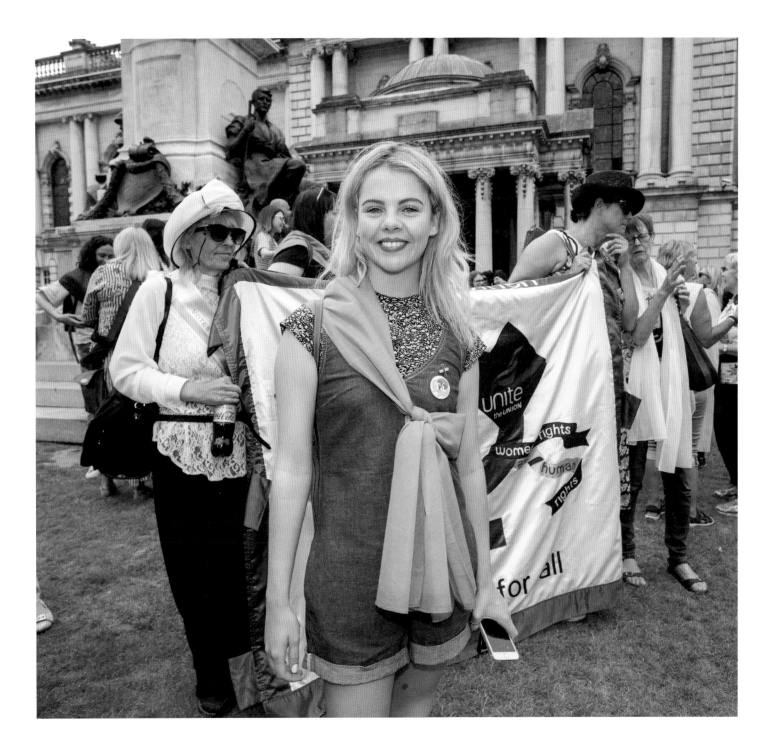

→ Sarah Rolufs /

Volunteer Accessibility Needs

'Then we heard it:
the sound of thousands
of women walking together.
As we saw them coming
round the corner I felt
a chill run down my spine'

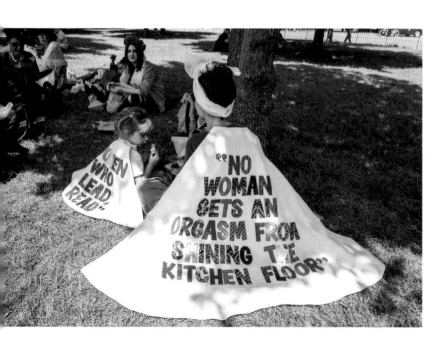

It was a warm London day, the sun peeking out between the occasional cloud. I began my day in the basement of the Hard Rock Café on Piccadilly, where more than 150 volunteers had gathered for their briefing, excited and anxious to be part of something much bigger than themselves. We knew what the procession was supposed to look like. The artist renderings showed three lines of green, white and violet, the colours of the suffragette movement, flowing down Pall Mall, forming a mass human banner. We thought it was possible, or at least we hoped it was possible. It hadn't been done before, not this kind of artwork. Sure, people marched through London all the time. But never had they marched as one, a human flag, a flowing river of colour.

After receiving the briefing, I put on my high-visibility vest and walked the length of the PROCESSIONS route to Trafalgar Square. It was still filled with cars when I arrived, but only a few moments later the streets were empty.

I was to join PROCESSIONS halfway through, as my role for the beginning of the event was to be stationed at Trafalgar Square, where I was to ensure those with limited mobility had a place to sit until the procession reached us. A group of four women, all aged over seventy-five, had brought a picnic lunch complete with sausage rolls and two bottles

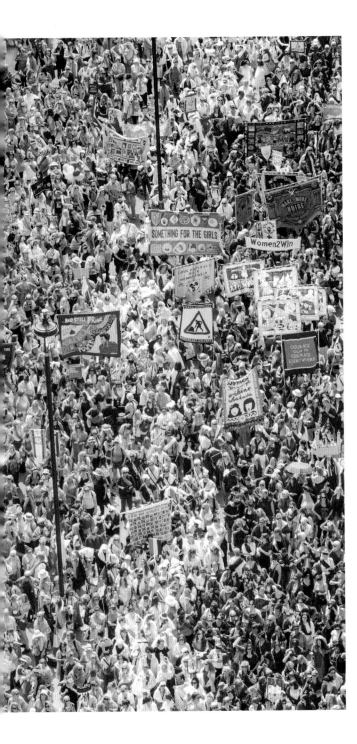

of wine to pre-game the procession. They all wore suffragette pins and badges they'd made themselves and excitedly told me that they had all come together to march in PROCESSIONS. One remarked that she'd been marching for women's rights for over thirty years.

As more women joined us at Trafalgar Square, there was a noticeable increase in excitement and energy. We handed out the green, white and violet scarves: some wore them like sashes, others over their shoulders like a shawl, and others still wore them around their heads or tied into a bow. Women were helping other women put on their scarves, and the joy and pride of wearing them shone in their faces.

I was on the radio with the stage managers and producers and someone said, 'They're coming around the corner from Pall Mall.' That was our cue. I helped line up the women in a block to prepare them to join the procession. Then we heard it: the sound of thousands of women walking together. As we saw them coming round the corner I felt a chill run down my spine. There they were: the lines of colours – green, white, violet. If you've never seen 40,000 women descend upon one city street, it's a difficult phenomenon to describe.

One of the most memorable parts of the experience was the spontaneous singing, chanting and cheering that rose up seemingly from nowhere. Thousands of women were chanting together, phrases like 'Make more noise!' and 'Still we rise!' Everyone around me had a smile on their face, as did I. A truck was stationed at the edge of Trafalgar Square and songs of women's empowerment rang out, including Aretha Franklin's 'Respect' and songs by the Spice Girls and other women artists. What I remember most, however, was the myriad of different women who had come together for this one event. There were older women and young women and children marching together. The demographics crossed lines of race, ability, religion, ethnicity and class. LGBTQ+ identities were represented across the board with groups from all over carrying banners celebrating various sexual identities. Women walked together without visible hierarchies of identities, just a very visual representation of the multiculturalism and multiple identities that make up the very heart of London.

They were there to celebrate 100 years of votes for women, but more than that, they were there to celebrate the strides that women had made in those 100 years, and also how much further women had to go.

Opposite
'No woman gets an orgasm by shining the kitchen floor'. PROCESSIONS 2018, London. Photo by Amelia Allen

Left
Tens of thousands of women gathered in the four UK capitals representing a vast unfurling of the suffragette flag. PROCESSIONS 2018, London. Photo by Amelia Allen

→ Maree Todd MSP

Highlands and Islands Region.
Minister for Children and Young
People in the Scottish Government

I think women having the vote is a precious and hard-won thing and I wanted to celebrate it. During the past century, women like me have gone from complete disenfranchisement to running the country.

It was heartening to be at the PROCESSIONS march with my mum and to reflect on the opportunities that I have had which she did not. It makes me hopeful for my daughters, who were also there. We are making progress – frustratingly slow though it is in some cases. We definitely felt a sense of handing a baton on to the next generation.

There was also a real sense of unity on the day. Women from all political and cultural backgrounds came together to share a sense of achievement, but also to reflect that there is still much work to do.

For those who knew Edinburgh well, it was a powerful and moving thing to process past some of the institutions that have ingrained male domination over centuries.

I loved contributing to making the banner and marching with women from Ullapool. I have known many of them all my life. They are inspiring people, the do-ers of our community.

Artist and storyteller Lizzie McDougall led the banner design at workshops and everyone contributed. Our banner was a work of art. Truly beautiful, with elements of our Highland history and future stitched in – fishing, crofting, music and the distinctive local mountains. A breastfeeding mum was steering the boat – I loved that!

It was a wonderful coincidence that when they were designing the banner, our youngest marcher, Brenna, wanted a girl playing a sport front and centre. And I came along with my rugby shirt from that season.

I play in the parliamentary rugby team, the first woman to do so and still the only female MSP involved. Nelson Mandela started parliamentary rugby, having seen the opportunity to bring very different people together through sport. We play in an international six nations against other parliaments and I am proud to have ensured that women have the opportunity to be involved too.

I am delighted that wee bit of history has been stitched into our banner.

At the time I donated the shirt, I thought we would have new shirts next season. We didn't – and several shirts couldn't be found next year. I had the best excuse for our captain: 'Sir, I'm sorry I don't have my shirt. I cut it up to make a feminist banner!'

As the Irish Captain Senator Neale Richmond said in his speech after hearing the story: 'Countess Markievicz would be proud!'

Clockwise
PROCESSIONS 2018, Edinburgh.
Photo by Lisa Ferguson

PROCESSIONS 2018, Edinburgh.
Photo by Lisa Ferguson

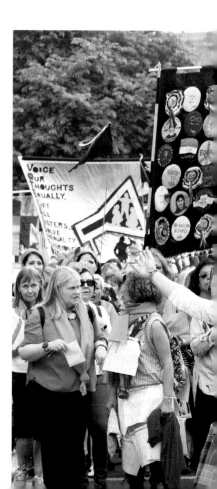

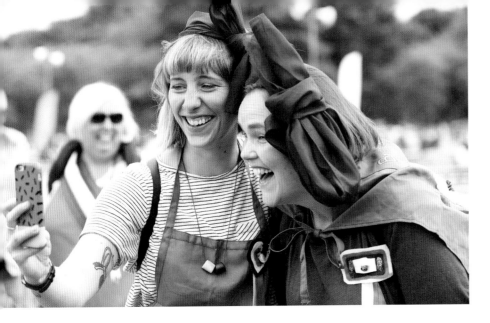

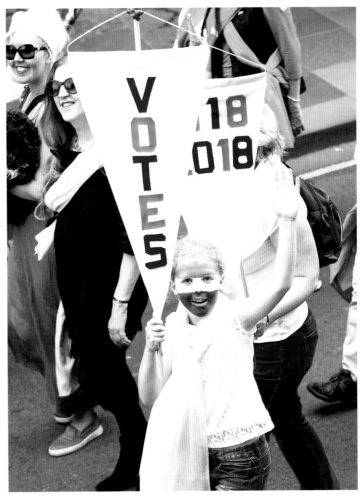

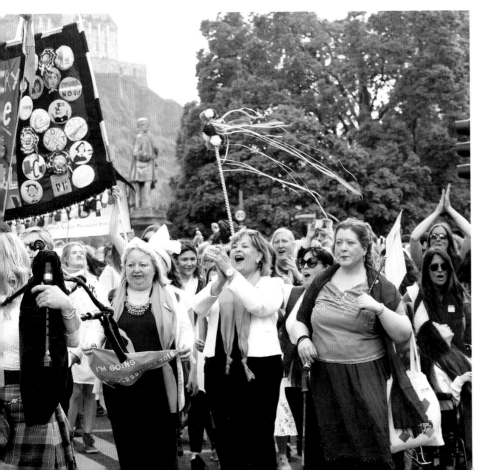

Lord Provost of Edinburgh's official piper Louise
Marshall, paying homage to lone female piper
Bessie Watson who led a procession along Princes
Street in 1909. Photo by Lesley Martin

→ Charlotte Lewis

Banner-maker
Workshop Coordinator,
Cardiff

'Too often feminism, politics and history can feel like it belongs to so few…that day I was reminded that art belongs to everyone'

I received a phone call one afternoon about a project to celebrate and commemorate the suffrage movement, and whether I would like to be involved. I was working for an amazing organisation at the time whose mission was to educate and empower young women and I couldn't think of a more inspiring spectacle to demonstrate the beauty and power that comes when women join together.

I felt nothing but positivity on the day. Cardiff came alive with a celebratory buzz and all women, no matter their background, took ownership of that energy.

The most memorable moment for me was walking home that evening. I stopped to speak to a woman who was homeless and making friendship bracelets. She asked with excitement if I would like a bracelet with purple, white and green like the scarves she saw walking past her that day. Too often feminism, politics and history can feel like it belongs to so few … that day I was reminded that art belongs to everyone.

After working as the Welsh coordinator on PROCESSIONS I co-curated the first Women of the World festival in Cardiff with a friend. So many of the women I'd met on my journey were a part of this later project, not simply as collaborators, speakers and audience but as friends. Being a part of an artistic moment like PROCESSIONS meant we had already shared and bonded through strong emotions linked to what it is to be a woman today. We were reminded of the importance of uplifting and supporting one another by those women walking 100 years before us.

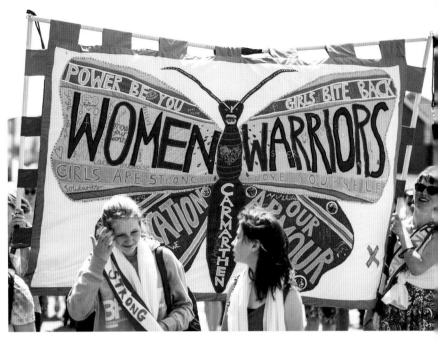

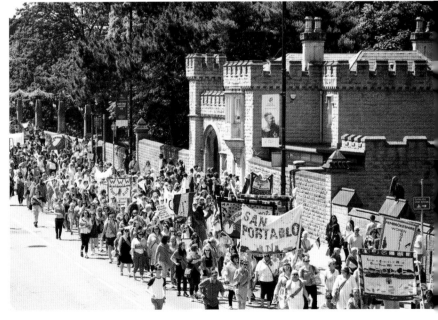

Clockwise
Making more noise in front of
the Thursday Women banner.
PROCESSIONS 2018, Cardiff.
Photo by Polly Thomas

Women warriors are strong.
PROCESSIONS 2018, Cardiff.
Photo by Mary Wycherly

Women passing Cardiff Castle.
PROCESSIONS 2018, Cardiff.
Photo by Sian Owen

BANN

ERS

BANNER DIRECTORY

→ Omeima Mudawi-Rowlings

Artist

See the 'Bridging Voices'
banner on page 166

I was honoured to be commissioned as one
of the female artists for PROCESSIONS.
I was determined from the start that I wanted
to do something that integrated deaf and
hearing women. As a deaf British Sign Language
user, a large part of my philosophy is about
sharing opportunities to communicate across
boundaries and to increase awareness of
the barriers of communication and thought in
creative activities.

With the support of the network at Fabrica
Art Gallery in Brighton, I was able to bring
together ten hearing and ten deaf women and
was delighted with the numbers. We worked
as a group from the start and a large part of the
success of this group, apart from the positive
attitudes that all the participants brought with
them, was the opportunity to provide deaf
awareness training at the very beginning:
to alleviate fears around working with sign
language users and to develop a shared
understanding of how best to communicate
with their deaf collaborators.

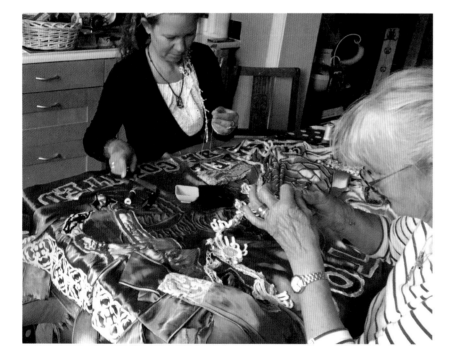

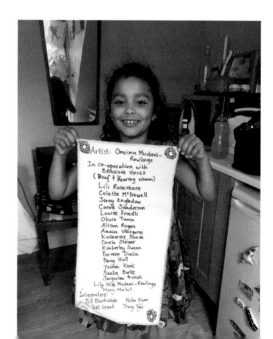

Above
Stitching the banner.
Photo courtesy
Omeima Mudawi-Rowlings

Right
Omeima's daughter, Lily Nile,
joined the march. Photo courtesy
Omeima Mudawi-Rowlings

36

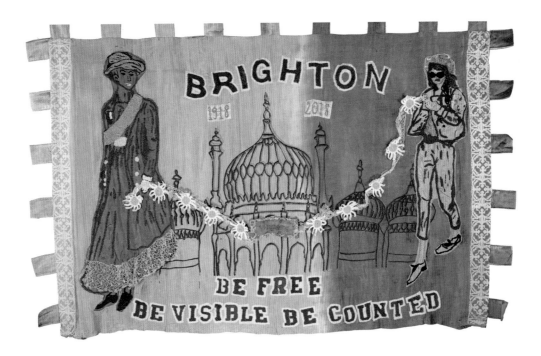

We spent many happy hours together, sharing ideas, skills, knowledge and experience to come up with and make our banner. It was amazing to see how close the two groups of women became and we named our collective 'Bridging Voices'. I think this title encapsulated the spirit of both my own intentions as well as that of PROCESSIONS. I have to say that my favourite addition to our banner was the embroidered quote that we used: 'Be Free Be Visible Be Counted'.

We worked so hard to get it all done in time. What we had designed was quite ambitious and every sewing session was action-packed. The atmosphere was one of excitement and motivatation to get it done creatively. I was so pleased we managed to incorporate so many different techniques – dyeing, embroidery, crochet work, screen-printing and devoré. What was fabulous was how everyone pitched in to teach the others the skill that they had. Everyone worked so well together and learned from each other. It didn't matter what level of skill each brought to the group – some were very inexperienced and some were experts, but those with the knowledge shared it and everyone developed. Throughout this, deaf and hearing women worked together using a mixture of gesture, spoken word and sign language. As the banner took shape, it was amazing to see our design develop and come to life and I'm very proud of the outcome. I think our banner looks unique.

On the day, I was filled with pride and we all marched up to Brighton station together to begin the journey to London. Caroline Lucas, our very own Green MP, had come to the station to send us off! What an unexpected surprise that was, and a highlight of the day for me.

The other main highlight was that my daughter, Lily Nile, joined the march and I felt quite uplifted that she was able to join the procession as part of 'Bridging Voices'. For her to see so many banners, such a mix of ages, a mass of multicultural women, was so important for her to have a first-hand experience of – for her to feel proud and to take that feeling forward as part of a new generation made the whole day for me! It was an amazing day to be a part of, celebrating achievements and, in particular, the equality represented in the beautiful 'Bridging Voices' banner!

Above
The banner made by the Bridging Voices group of deaf and hearing women. Photo courtesy Omeima Mudawi-Rowlings

37

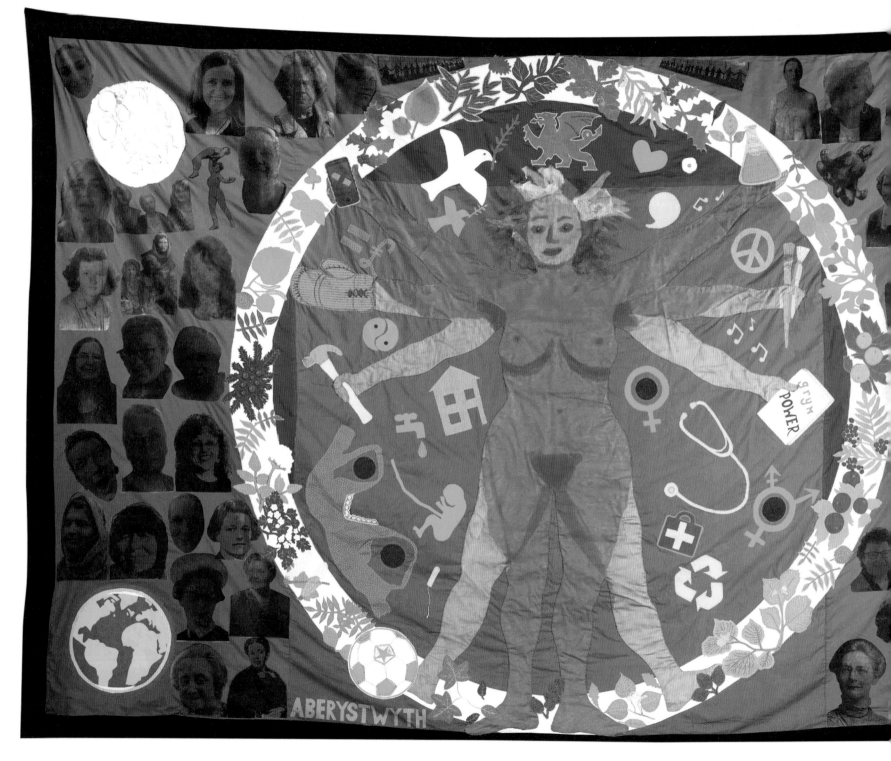

ABERYSTWYTH

ABERYSTWYTH ARTS CENTRE

Artist
Becky Knight

Contributors
The Thursday Women

Aberystwyth,
Wales

Mixed textiles,
print

2340 × 3570 mm
2.89 kg

Beginning with the idea of 'Vitruvian Woman' – proportion and perfection – the group decided to make the woman on their banner life-sized. She is Everywoman, practical, scientific and thoughtful, surrounded by and aware of nature and the passing of time.

The symbols within the circle represent the things she cares about, issues that are and will be vital in the lives of humans. Peace, water, shelter, health, fertility, language, the gender pay gap, period poverty and much else were discussed during the construction and sewing. Around her, supporting, are pictures of mothers, sisters, friends, and many inspirational women.

'She is Everywoman, practical, scientific and thoughtful, surrounded by and aware of nature and the passing of time'

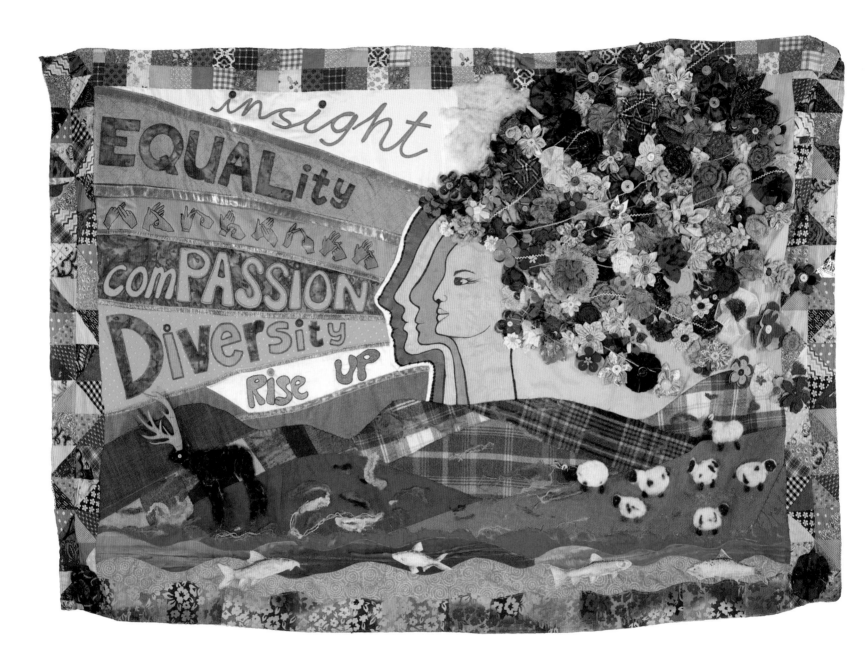

ARTS IN MERKINCH

Artist
Heidi Soos

Contributors
Members of Blazing
Needles and all of
Highland Multicultural
Friends Sewing Group

Inverness,
Scotland

Mixed textiles

1360 × 1890 mm
1.7 kg

The group found this to be
a wonderfully collaborative project,
both in the design and the making.
The members felt that it was important
to ensure that their geographical
location, as well as their diversity
of race, ability and experience, were
clear within the banner. The use of
a variety of sewing, knitting, crocheting
and crafting mediums ensured
that every member of the team could
contribute their own special skills,
while also learning each other's
practice. Some elements (such as
the flowers) could be worked on
by individuals at home when they felt
able. Accessibility of participation
was the most important part of the
process for the group.

A PATIENCEART PROJECT

Artist
Alexandria Patience

Contributors
North Coast Women

Portskerra,
Scotland

Mixed textiles, fabric paint,
diamante, copper wire,
shells, glass beads, PVA glue

1250 × 1410 mm
1.22 kg

Artist Alexandria Patience structured
this banner to represent the most
northerly area of mainland Scotland,
Caithness and Sutherland. She
reached out to rural and remote
locations spanning the north coast
to ensure as many women as
possible would feel a part of this
celebration of women's suffrage
by sharing in the making of a single
banner. Each of the fifteen letters
in 'North Coast Women' was made
by an individual, family or group
to represent themselves and their
communities. See the map on
the banner to locate the makers'
locations, and the group's home.

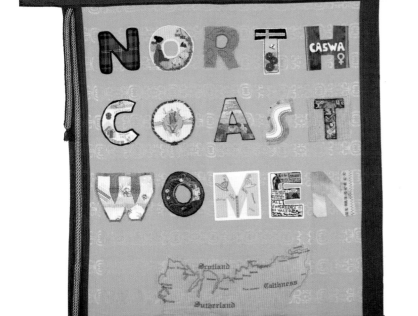

I embarked on this adventure imagining that it would be relatively easy to create an illustration celebrating women getting the vote. The Ullapool gallery An Talla Solais wanted me to make something similar to my Highland Story Quilts, so I had process and materials sorted! The gallery invited women to bring friends and children to a brainstorming first session. A lot came, and by the end my brain felt quite stormed! Fortunately, before the workshop I had had an idea of the banner being a boat that could sail as we carried it in the procession, otherwise I may well have sunk! There was such an incredible outpouring of energy and ideas. I heard things that shocked, saddened, delighted and inspired. People wanted our banner to express experiences of Highland women both now and through the ages, overcoming challenges plus continuing to work towards equality for all women everywhere.

My challenge was to create an image to reflect this and involve all participants in making it.

Altogether about thirty women took part; some knew each other, most didn't and some have still not met. There were six sessions on the west coast and countless in my east coast studio. I did a lot of the pondering and visualising during the sixty-minute drive between the two. So many stories, even some disagreements. I listened, searching for ways to visually pay tribute to all these strong women, centuries of strong women; hopes, dreams and challenges faced, issues overcome – chauvinism, alcoholism, discrimination, convention, tradition – and eventually I joked, 'So basically everything including the kitchen sink.' 'Yes!' was the answer. 'But with the dishes unwashed as we don't have time to do them!' The ice was broken; with all our different experiences and viewpoints we are in the same boat, wanting to play a full role in the world but often also holding the baby and the home together.

Inspiration began on my drive through the beautiful lochs and mountains that surround us like our culture and heritage. Aha! These can be part of the hull of our boat, heading toward equality. Then I imagined the boat was steered by a woman feeding her baby, both modern mum and our Pictish ancestral heroine, as in those times inheritance was through the female line. Then filling the boat with women who have defied convention and overcome obstacles to become scientists, musicians, farmers, rugby players, engineers, producers, politicians, entrepreneurs, artists and storytellers, who encourage others and help children fulfil their dreams. A girl with bagpipes, fairy wings and welly boots, having broken the mould of male military piper, fills our sails with joy and energy.

Everyone enthusiastically cut and stitched the fabric. We needed a slogan, and chose 'Boats for Women', as boats are symbolic of opportunity and connection but are still a very male domain. Choosing the name of the boat was a challenge and I am delighted that in the end we became *The Sistership*.

Lizzie McDougall,
Artist, Inverness

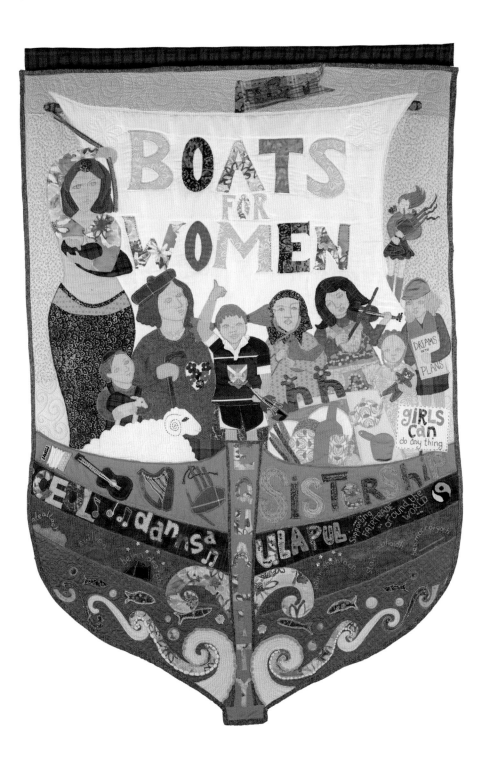

AN TALLA SOLAIS

Artist
Lizzie McDougall

Contributors
Am Bhata The Sistership

Ullapool,
Scotland

Mixed textiles

2030 × 1350 mm
1 kg

Am Bhata The Sistership set out to illustrate aspects of living in the Scottish Highlands for women. Inspired, nurtured and challenged by their environment (both natural and social), the group feel themselves to be on a journey that will not be over until all women have equality. This journey is driven by a will to make a better world for all children, everywhere.

The participants contributed their ideas, time, energy, materials, stories, empathy, multi-tasking skills and sistership. They also contribute massively to the life of the Highlands and beyond, and artist Lizzie McDougall felt very grateful and honoured to have worked with them.

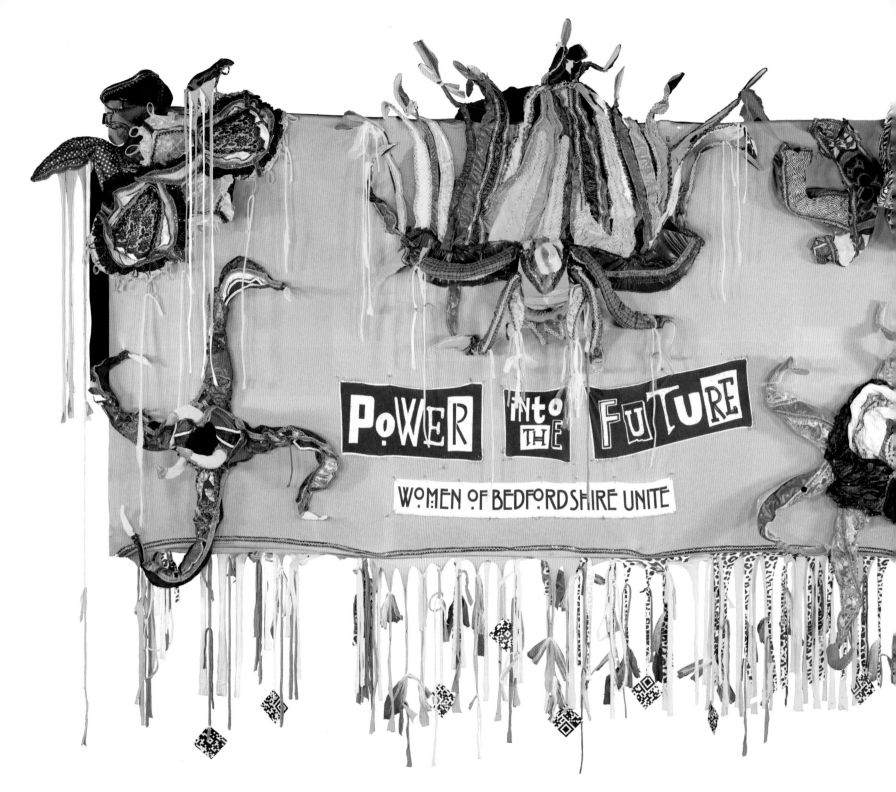

POWER into THE FUTURE

WOMEN OF BEDFORDSHIRE UNITE

BEDFORD CREATIVE ARTS

Artist
Quilla Constance
(aka Jennifer Allen);
typography by Katie Allen

Contributors
Ailene Gray, Alice Burden,
Ana Ortega, Anita Dutt,
Christine Stone, Deirdre
Porter-Hanson, Elizabeth
Howard, Gemma Martin,
Gerry Ewens, Itxaso Leonard,
Jamna Owen, Jane Burden,
June Pedzeni, Kemi Onabule,
Lydia Saul, Michelle Chalkley,
Mique Moriuchi, Natacha
Kobaili, Scarlett Chalkley,
Talia Giles, Tineke Venne,
Wendy Watmough,
Zarina Jamaludin

Bedford,
England

Mixed textiles,
Indonesian and sub-Sahara
African batik, Chinese silk,
sequins, wire, beads,
safety pins, screen-print,
laminated paper

2550 × 3100 mm
7 kg

Paying homage to the bold designs of the suffragettes, Bedfordshire's fluorescent, sequin-emblazoned, sci-fi-punk-carnival creation is a banner for the twenty-first century.

Playfully reflecting twenty-first-century popular culture and the many cultures of the Bedfordshire community – with defunct QR codes, B-movie influenced typography and triffid-inspired creatures – the banner also celebrates the diverse fabrics of the world.

It was designed and made collaboratively through a series of workshops led by artist Quilla Constance and produced by Bedford Creative Arts. It was created to acknowledge the spirit of the early fight for the right to vote and as a reminder of the strength of women today, powering towards a better future for the women of tomorrow.

'Paying homage to
the bold designs of
the suffragettes…
a banner for the
twenty-first century'

MID WALES ARTS

Artist
Loraine Morley

Contributors
Mid Wales Arts, with significant
contributions by Sasha Kagan,
Joy Hamer, Carla Owen, Cathy
Knapp, Celf Able artists, and
ladies from Llys Glanyrafon

Newtown,
Wales

Mixed textiles

1335 × 1885 mm

2 kg

The group considered the role of
women 100 years ago and how it
has changed. They were interested
in the idea that there were very few
women artists 100 years ago.

The group's common threads are
that they all enjoy making art, they live
in Mid Wales and are members of Mid
Wales Arts. The group members recognise
and appreciate the comparative freedom
they have to live creative lives. Mid Wales
is full of natural beauty and inspiration,
with wide open skies full of a variety
of birds, including the red kite. As these
birds soar above, they convey freedom
and community. The hills and river
represent time and continuity.

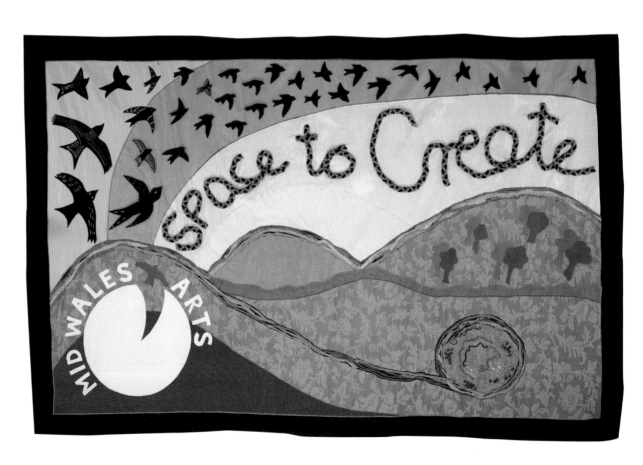

SPAN ARTS

Artist
Nia Lewis

Contributors
Women Survivors
Support Project

Narberth,
Wales

Cotton, calico,
mixed textiles

1370 × 2100 mm
1.58 kg

This banner was inspired by the format and powerful graphic style of the original suffragette banners.

Listening to a reading of Emmeline Pankhurst's 1913 'Freedom or Death' speech resonated deeply with the women and, as the artist Nia Lewis said, 'The atmosphere in the room changed.' Consequently, those words became central to the workshop conversation and the final design. The group connects the suffragette fight for the vote with their ongoing struggles to assert their own freedom and seek justice.

For this group of survivors of domestic abuse, the motif of hands represents the future and moving on. One participant described this as 'the support we give each other, reaching out in friendship'.

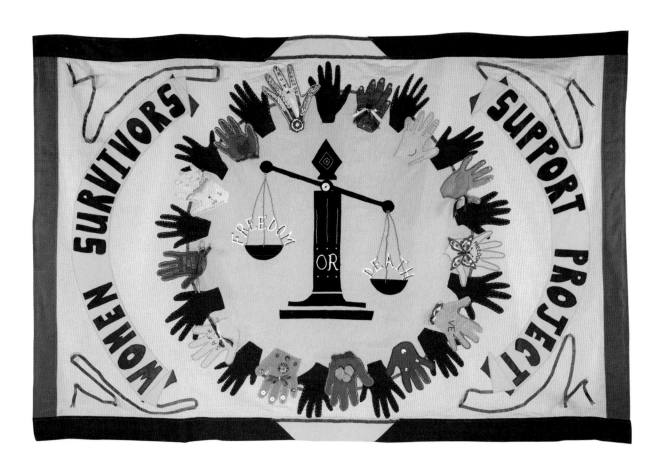

Building on 2017's Silk River legacy, which connected communities along the lower Thames Estuary, Kinetika, led by lead artist Ali Pretty, continued to work with Silk River artists from five communities — Barking & Dagenham, Dartford, Purfleet, Gravesham and Southend — to create five silk batik banners, one for each community. The artists drew up a longlist of inspirational local women, past, present and future, either working in their communities or in the public eye across a range of professions. The public were invited to vote on social media to select the women who would be represented on the final banners.

The inspirational women who appear on the five banners encompass a huge range of experiences, occupations, backgrounds and talents, ranging from a nineteenth-century champion of physical education for women to a sixteen-year-old youth mayor.

Kinetika is a women-led company specialising in high-quality community projects. Through a variety of workshops and programmes Kinetika aims to nurture new artistic talent and engage communities, raising aspirations and building a sense of place.

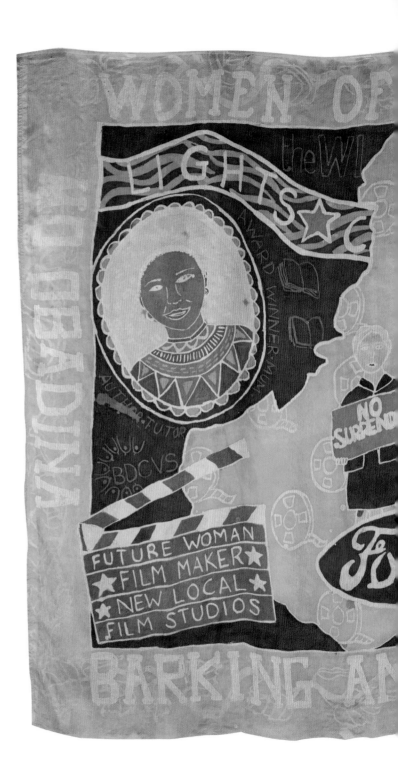

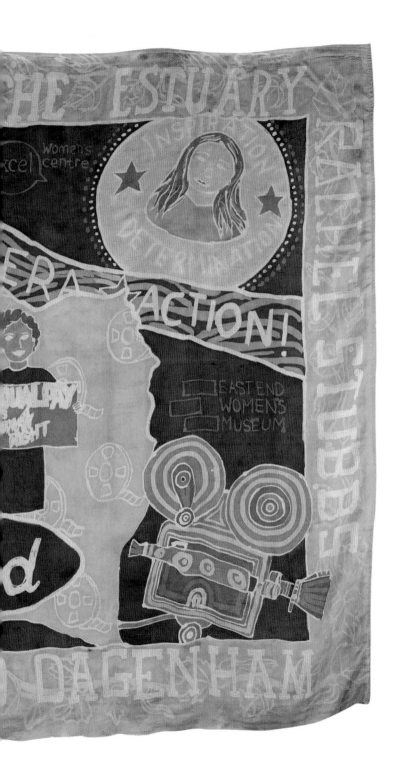

KINETIKA (BARKING AND DAGENHAM)

Artist
Ali Pretty

Banner Artists
Susanna Wallis
and Kushnood Ahmed

Purfleet,
England

Hand woven, undyed
Murshidabad silk

1180 × 1470 mm
0.16 kg

The artists worked with residents to select the inspirational women for this banner.

The Dagenham Ford Strikers were local women who made history in 1968 by changing the way women were paid. They encouraged the government to establish the Equal Pay Act, paving the way for others to do the same, and championed the emerging Women's Movement during the late sixties and seventies.

Mo Obadina was born in Nigeria, lives in Barking and Dagenham, and has studied to PhD level while working and raising a family as a single mother. She has written a book to encourage others, is a positive role model, gives talks, and works to unite communities and engage people in cultural activities. Mo now lectures at the South Bank University.

Rachel Stubbs is eighteen and has just completed her first year at UCA studying Film Production. She started there a year earlier than her peers after achieving high grades in her BTEC despite having dyslexia and dyspraxia. Rachel is a proactive member of her community and has taken part at various local events and community projects. She would like to follow her degree with a career in film, possibly at the new studios opening in Dagenham.

KINETIKA
(DARTFORD)

Artist
Ali Pretty

Banner Artists
Ruth Howard
and Tanya Outen

Purfleet,
England

Hand woven, undyed
Murshidabad silk

1180 × 1470 mm
0.16 kg

This banner features Mme Osterberg, the pioneering founder of women's physical education at Dartford College who introduced netball to the UK. Images of the game were used alongside her portrait to represent her spirit and her revolutionary approach to the establishment.

Cllr Patsy Thurlow holds the arts portfolio for Dartford Cabinet and some of her personal achievements over the last twenty years include her work with young people. This banner includes a portrait of her and a marquee to illustrate the annual Dartford Festival, and the Skate Park, with skate-boarders.

The What if...? Gallery in Dartford highlighted the work of Anne Graves and Ruth Howard, who volunteered for thirteen years to present community art workshops.

KINETIKA
(SOUTHEND-ON-SEA)

Artist
Ali Pretty

Banner Artists
Sally Chinea, Hazel Huber,
Lisa Meehan, Jacci Todd

Purfleet,
England

Hand woven, undyed
Murshidabad silk

1180 × 1470 mm
0.16 kg

Rosina Sky (1858–1928) was a single mother of three and an active suffragette who led the charge for votes for women in Southend. Running her own tobacconist shop, a woman in a man's world, Rosina had all the responsibilities with none of the rights accorded to men in the same position. In 1911, she defied authority by refusing to adhere to the census, writing across the form 'No votes for women. No information from women'.

Lucy Hodges is an international sailing champion. She has won a number of gold medals in international sailing competitions and has proved nothing is impossible, as she is registered blind. She has been an inspirational sporting figure for many years, winning the Rochford District Sports Personality of the Year in 2010. Lucy won two silver and two bronze medals, and went on to achieve her dream of a gold medal. In 2013 she was awarded an MBE in recognition of her achievements both on and off the water.

Maise Riley is a sixteen-year-old student at Chase High Academy, where she has been a prefect and head girl, and sat on the student council for many years. She also organises and runs many fundraising events in sports, arts, debating and drama. Maise is an active member of the youth council and is currently Youth Mayor for Southend and the LGBT Chair for Southend.

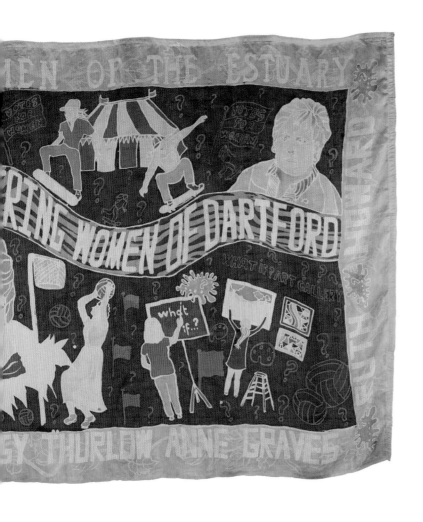

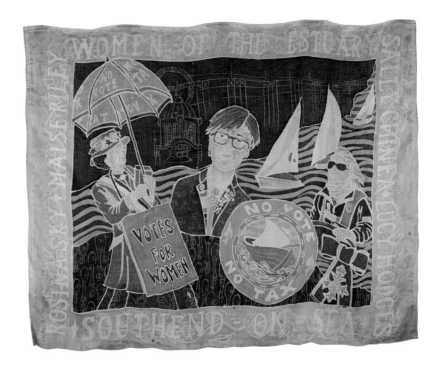

'A woman in a man's world, Rosina had all the responsibilities with none of the rights accorded to men in the same position'

KINETIKA
(GRAVESEND)

Artist
Ali Pretty

Banner Artists
Kirsty Gaunt, Sonnia Montes,
Cathy Mayers, Elizabeth
Staupmanis, Mneesha Bungar

Purfleet,
England

Hand woven, undyed
Murshidabad silk

1180 × 1470 mm
0.16 kg

The inspirational women featured on the banner were selected from a public call for nominations.

Georgia-Mae Fenton is seventeen years old and won a gold medal at the 2018 Commonwealth Games. She features in the centre of the banner.

Parm Gill has developed and coached the successful girls team at the Gravesend Guru Nanak Football Club.

Enid Marx was an English painter and designer who taught at Gravesend School of Art. She was the first woman to be designated as Royal Designer for Industry, and was well known for her textile designs for the London Transport Board. Her work has inspired the background patterns and swans.

KINETIKA
(THURROCK)

Artist
Ali Pretty

Banner Artists
Lesley Robinson, Margaret Hall,
Christine Rowles, Emily Moon

Purfleet,
England

Hand woven, undyed
Murshidabad silk

1180 × 1470 mm
0.16 kg

Kate Luard was born in Aveley in 1872. She trained as a nurse and served in South Africa during the Boer War, and in the First World War. She was awarded a Royal Red Cross and bar for exceptional service in military nursing.

Fatima Whitbread overcame the difficulties of a turbulent childhood to become a renowned javelin thrower. She was named BBC Sports Personality of the Year in 1987.

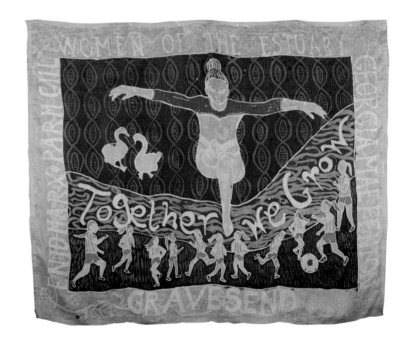

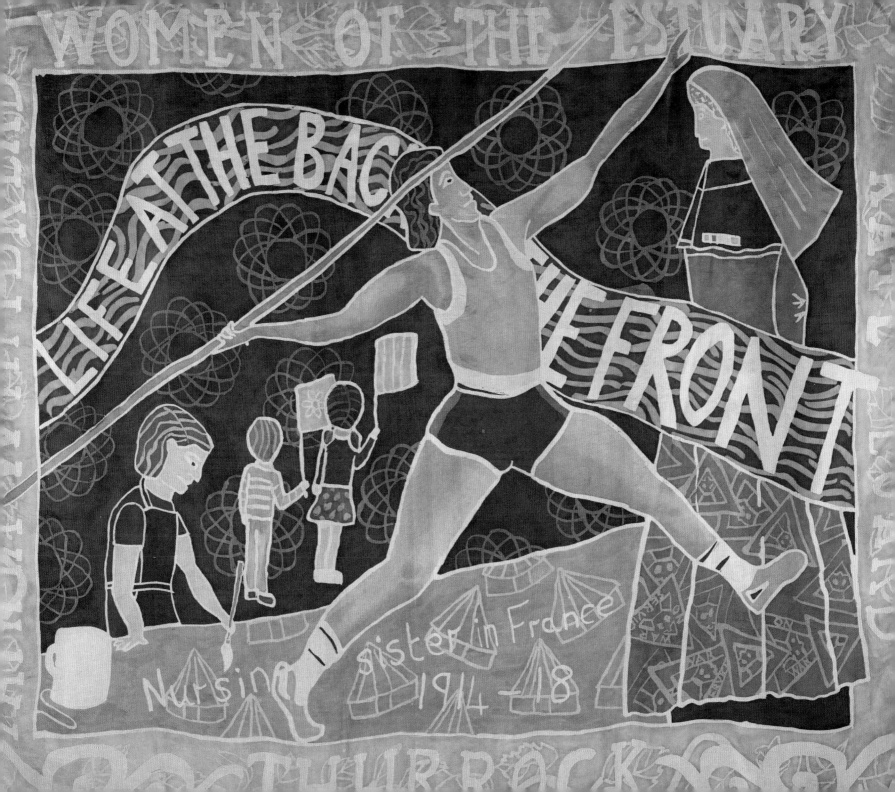

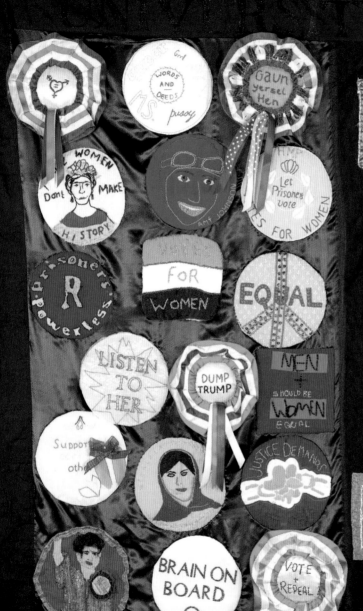

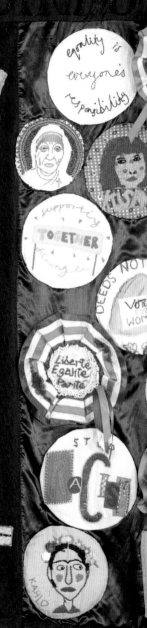

EVERY ONE IS EQUAL

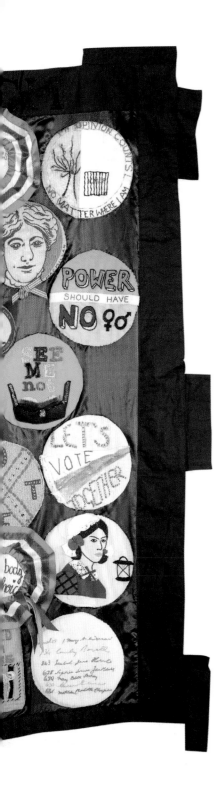

EDINBURGH COLLEGE OF ART (EDINBURGH UNIVERSITY)

Artist
Lindy Richardson

Contributors
University of Edinburgh
students, staff and women
of HMP Cornton Vale

Edinburgh,
Scotland

Mixed textiles, net, beads

1550 × 2320 mm

2.5 kg

The banner brings together a series of badges as responsive slogans from the group's discussions around suffrage and the disenfranchised. Each of the badges was made individually by group members, some at university, some at home and some in cells in Cornton Vale Prison. Each participant has a badge of equal size and space on the banner, every voice and statement being equal in this united artwork. The banner celebrates influential women past, present and future, who have inspired and continue to inspire women seeking equality and change.

At PROCESSIONS on 10 June, the group also carried pennants emblazoned with the names of 'The Edinburgh Seven', the UK's first female university students matriculated at Edinburgh University and admitted from 1869. They had a very difficult experience negotiating their way into education and endured terrible prejudice. They were pelted with eggs and flour when entering the examination hall, and there was even a sheep let loose in the exams to disrupt proceedings. The Seven took their case to the House of Lords, asking that they be allowed to vote as university graduates. Their case was thrown out.

'Each of the badges was made individually by group members, some at university, some at home and some in cells in Cornton Vale Prison'

55

HOLLY FULTON

Artist
Holly Fulton

London,
England

Cotton panama, satin

1480 x 2150 mm

1.5 kg

✎ COMMISSION

As a female creative, lucky enough to be running and managing my own business and generating work that is my passion, it was an honour to be involved with PROCESSIONS and to recognise the legacy that was set in motion 100 years ago, acting as the catalyst for the freedom we enjoy today. The idea of uniting women the length and breadth of the UK is incredible; in the current climate, a celebration of who we are and the diversity that exists amongst us felt perfectly timed. A true celebration of womanhood in all its forms, to toast how far we have come and also still to go.

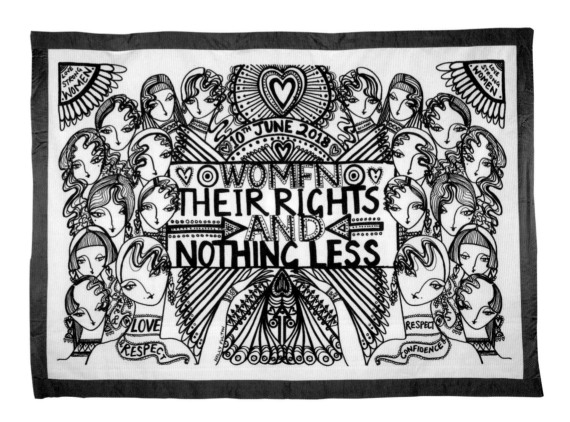

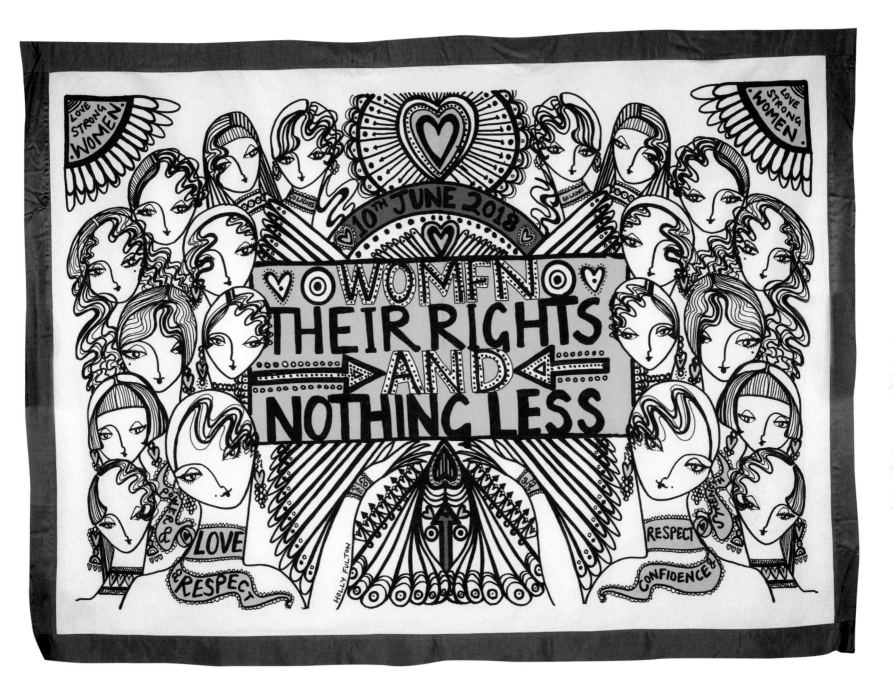

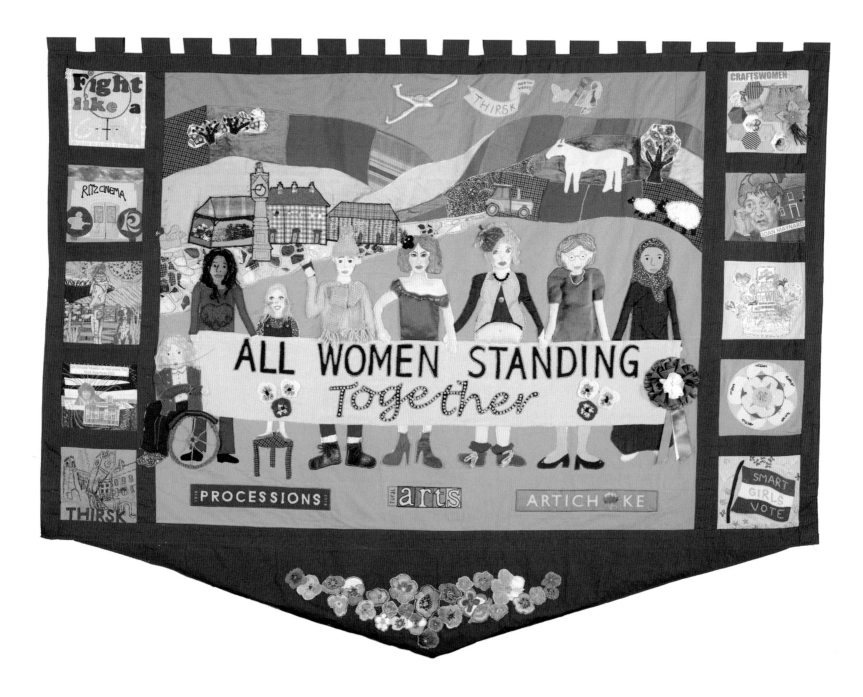

RURAL ARTS

Artist
Angela Hall

Contributors
Rural Arts North Yorkshire

Thirsk,
England

Mixed textiles

1750 × 2070 mm
2.86 kg

This banner is a celebration of women and girls from rural North Yorkshire, set against a backdrop of the agricultural market town of Thirsk and the rural landscape of the North Yorkshire Moors. The group decided to make a statement piece that would stand out in a crowd. 'All Women Standing Together' reflects the diversity of the community and the contribution that women make to the local economy. This is highlighted in the side panels, which capture MP Joan Maynard, who championed agricultural workers' rights; the first champion female butcher; women working in agriculture; and women's organisations, including the Women's Institute (WI).

THE BRICK BOX

Artist
Jean McEwan

Contributors
Kirrah Shah, May McQuade,
Lou Sumray, Sharena
Lee Satti, Penny Green,
Sonia Sandhu, Niamh Bryson,
Julie Longden, Kitty Pearson,
Katie Mahon, Molly Rumford,
Rosie Freeman, Eleanor Barrett

Bradford,
England

Mixed textiles

1285 × 2005 mm
1.37 kg

The group wanted to express that theirs is a city that nurtures strong women who connect with each other to take action and make change together. The group is proud of the great spirit of co-operation and solidarity in Bradford, which brings women together from all backgrounds. They wanted to celebrate and shout about this.

The green backing colour refers to Bradford Women for Peace, a local campaigning group that gave out lime-green ribbons in response to the English Defence League (EDL) coming to the city in recent years. This sent a message of harmony, peace and unity, and has become a powerful symbol in Bradford.

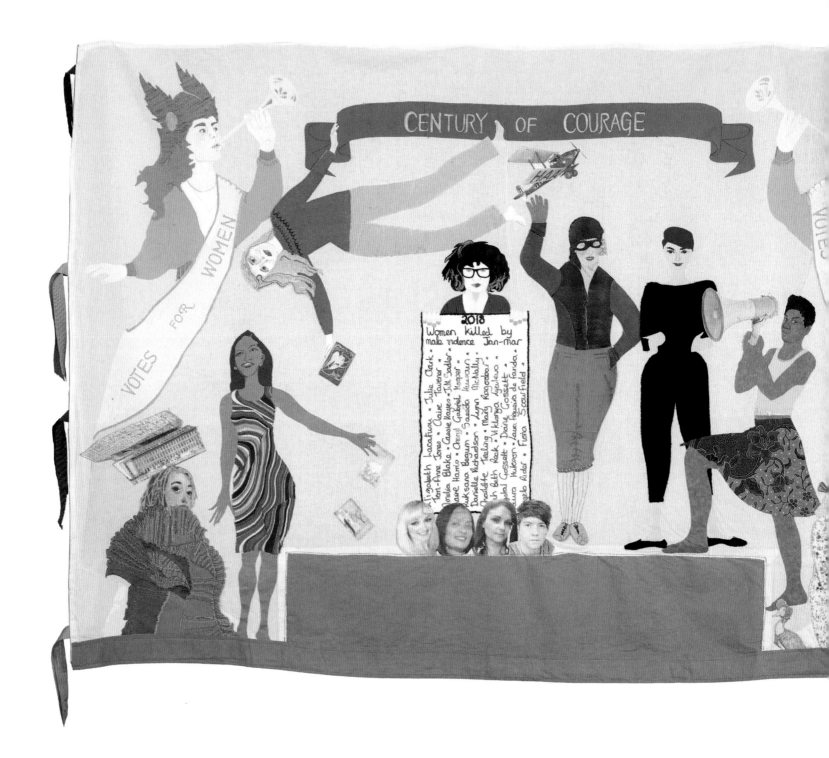

NEWLYN ART GALLERY & THE EXCHANGE

Artist
Elizabeth Loveday

Contributors
Cathie Ashley, Faye Dobinson, Rae Dougan, Tracy Flett, Cat Gibbard, Jen Gourley, Sheelagh O'Donnell, Tamsin Young

Newlyn,
England

Fabric, embroidery silks and photographic transfers

1540 × 2340 mm
1.36 kg

Through an open call, a group of eight women came together with textile artist and illustrator Elizabeth Loveday to create this banner. Each participant chose an iconic British female figure they wanted to represent, their choices reflecting the diverse ages and interests of the group. The women featured include: Gina Miller, Audrey Hepburn, Zaha Hadid, Amy Johnson, Olive Morris, Karen Ingala Smith, Beatrix Potter, Angela Carter and Emily Hobhouse. The goddess Hera, protector of women, is portrayed on either side of the figures.

'Each participant chose an iconic British female figure they wanted to represent'

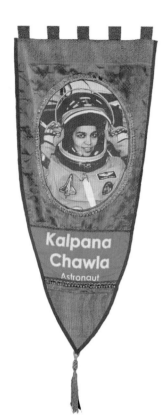

Kalpana Chawla
Astronaut

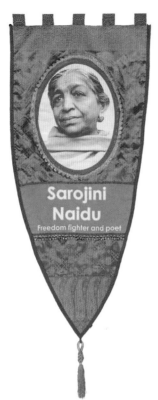

Sarojini Naidu
Freedom fighter and poet

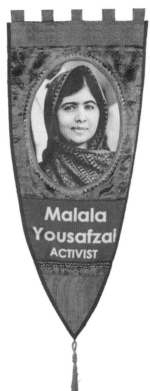

Malala Yousafzai
ACTIVIST

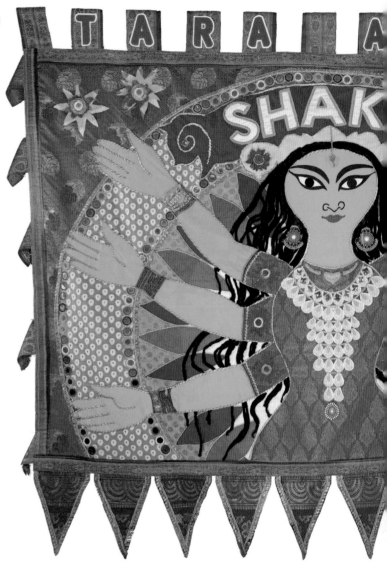

TARA A

SHAK

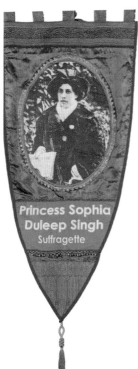

Princess Sophia Duleep Singh
Suffragette

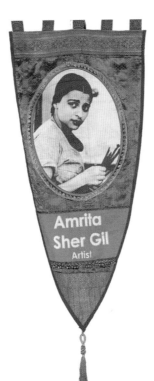

Amrita Sher Gil
Artist

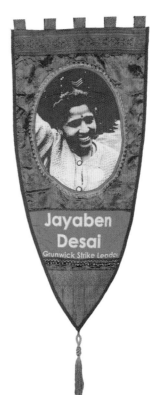

Jayaben Desai
Grunwick Strike Leader

TARA ARTS

Artist
Madeline Herbert

Contributors
Tara Arts

London,
England

Sari silk, felt, muslin,
wool, cotton, beads

1760 × 2250 mm
2.35 kg
pennants:
1100 × 480 mm (6 ×)

This banner celebrates Shakti, the goddess of power, and illustrates the dynamic creative forces empowering her daughters. Drawing on the rich textile heritage and embroidery techniques of South Asia, the group have used recycled saris and fabrics kindly donated by women local to Tara Arts, in southwest London.

This banner commemorates trailblazers such as suffragette Sophia Duleep Singh, activist Malala Yousafzai, freedom-fighter Sarojini Naidu, trade unionist Jayaben Desai, astronaut Kalpana Chawla, and artist Amrita Sher-Gil. These are just some of the Asian women who, through their actions over the 100 years, provide inspiration today.

PLYMOUTH COLLEGE OF ART

Artist
Elizabeth Masterton

Contributors
Caroline Wilkins and Emily Kemp (assistant artists), staff, students and affiliates from Plymouth College of Art and Plymouth School of Creative Arts (PSCA), Ali Goodworth (lead at the PSCA), and Jedna Hall (tattoo artist)

Plymouth,
England

Mixed textiles

1640 × 2280 mm
2.45 kg

The collective design of this banner emerged from a series of group discussions and creative workshops, which shared personal histories and political opinions. The mottos 'The women before us' and 'The women to come' were inspired by a painting by Sonia Boyce that depicts a woman supporting the next generation on her shoulders. The two interlocked arms with tattoos represent indelibility and commitment. Ivy is a Victorian symbol of friendship and longevity. The slogan 'Hold Fast', a traditional sailor's tattoo, completes the design, suggesting fidelity, tenacity and strength against all odds, while obliquely referencing Plymouth's masculine seafaring heritage from a twenty-first-century female stance.

'The slogan «Hold Fast», a traditional sailor's tattoo, completes the design, suggesting fidelity, tenacity and strength against all odds'

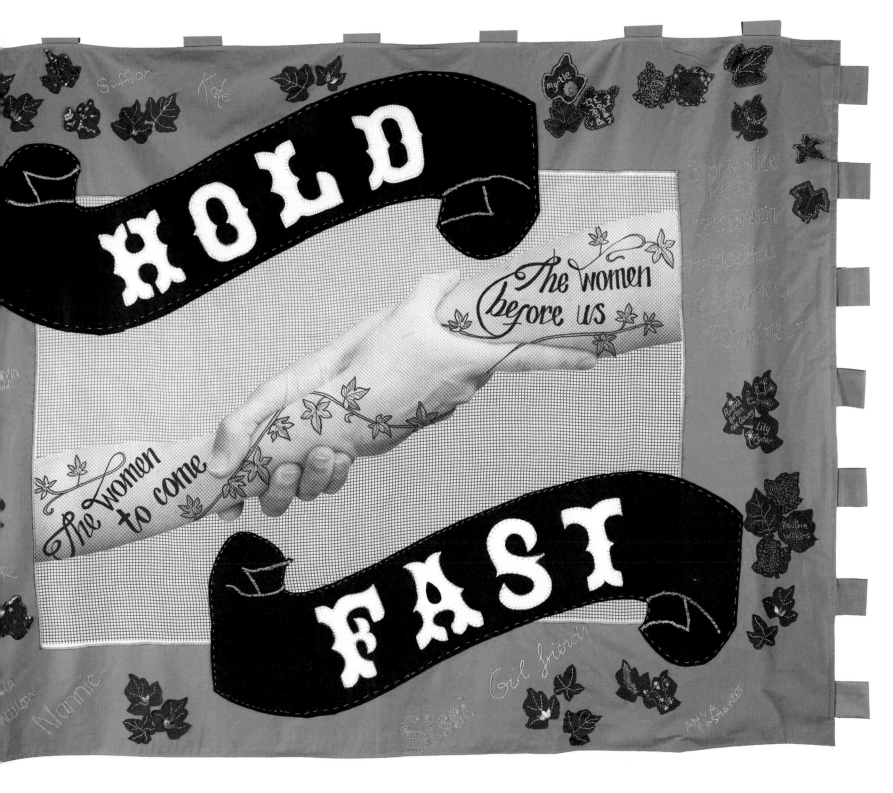

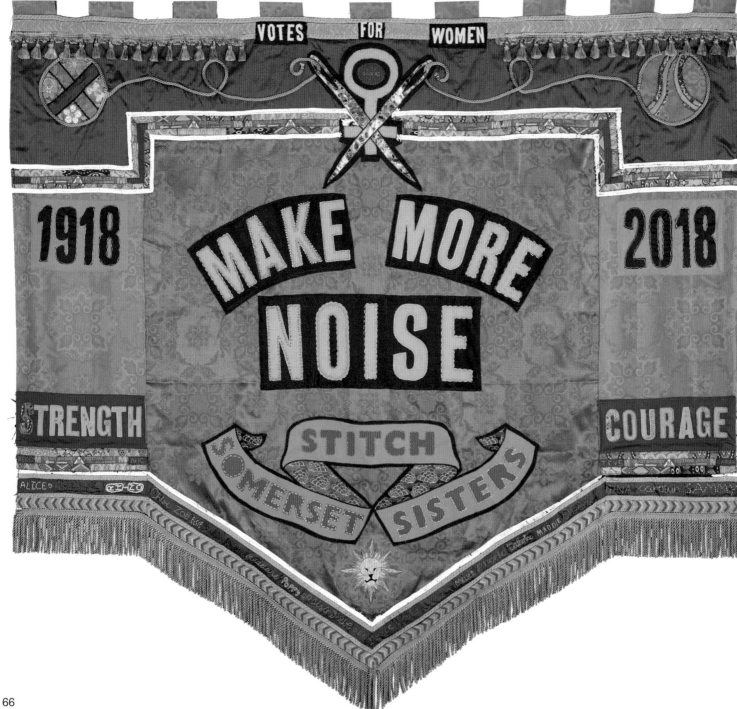

SOMERSET ART WORKS

Artist
Dorcas Casey

Contributors
Students from
Strode College

Langport,
England

Mixed textiles

1860 × 1945 mm
2.87 kg

This banner was influenced by original suffrage banners, Thalia Campbell's 1980s Greenham Common Women's Peace Camp banners, and Somerset's culture and identity. Elements from an original Weston-Super-Mare suffragist's banner were used as a starting point for the composition.

The slogan 'Make More Noise' forms the centre point of the banner. It comes from a speech by Emmeline Pankhurst and sums up the sentiment of the suffrage processions – a call to women to be more visible, to make a spectacle, to make their voices heard. Glastonbury Festival wristbands have also been incorporated into the design. The festival is intertwined with local identity, protest and alternative ways of living.

MIDDLESBROUGH INSTITUTE OF MODERN ART

Artist
Jane Cuthbert
and Kate Pounder

Contributors
Members of
the PROCESSIONS
Middlesbrough Group

Middlesbrough,
England

Netting, mixed textiles

1800 × 1100 mm (3 ×)
1.59 kg

The banner brought together women from across MIMA's programmes. This included members of Creative Age, a group living with dementia and their care-givers and family, Cultural Conversations, which uses the MIMA collection to make new friends and practise speaking and listening skills to learn English, and Mini MIMA, a group for early years with their adults. Collectively, the group represents women of all ages, faiths and colours. The group shared stories of women in members' own worlds and celebrated these amazing conversations using craft, gentle activism and the handmade.

For the group, the project is about hope, the future and moving forward. It's a call to action.

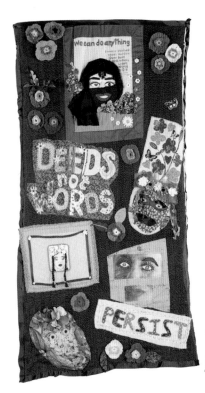
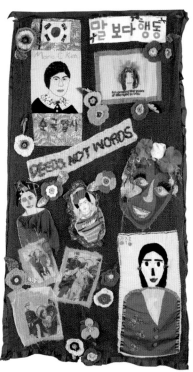
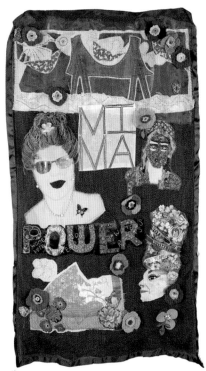

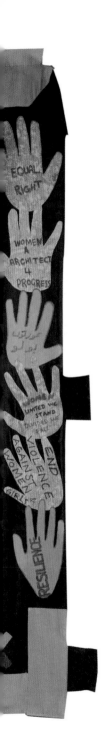

SCOTTISH REFUGEE COUNCIL

Artists
Paria M. Goodarzi
and Helen de Main

Contributors
Women from the refugee
community in Glasgow

Glasgow,
Scotland

Mixed textiles

1360 × 2110 mm
1.06 kg

This banner was designed and embroidered by women from the refugee community in Glasgow, along with artists Paria Goodarzi and Helen de Main. It features fabric from the women's home countries, including Zambia, Zimbabwe, Kurdistan, Pakistan and Iran. Most women with refugee status in the UK are still excluded from voting in Westminster elections.

'Most women with refugee status in the UK are still excluded from voting in Westminster elections'

I worked with a group of women over a series of workshops to research, design and produce a banner for the Scottish Refugee Council. The banner was made by cutting and sewing together fabrics that participants donated which were precious to them and represented their stories, cultures and hometowns. The texts around the edge came from a variety of different women's voices, drawn from conversations that we had within the workshops around what one's message is as a refugee woman, as well as from research in the library's archive, notably the banner and badge collection. A larger central section has figures of women from different ethnic backgrounds.

The banner represents the experience and movement that started 100 years ago and is not over yet. It represents a group of women who moved from their homeland with the hope of achieving basic human rights and freedom, but then needed to stay strong and fight for their rights in the country that 100 years ago women were fighting for.

As a result of working on this project, all these narratives made me think of the history of human beings, how capitalism and post-colonialism take hold of people and separate them from their nature and their culture, how each of us is related to this world, how we experience the world, and how those experiences make us feel.

Paria M. Goodarzi,
Artist, Glasgow

RUDY LOEWE

Artist
Rudy Loewe

Contributors
Womankind Worldwide

London,
England

Cotton, satin, jersey,
acrylic paint, beading

1820 × 1450 mm
1.5 kg

 COMMISSION

Womankind Worldwide were keen that the banner reflected the kinds of women that they work with. These are women doing feminist organising and forming women's movements in Africa and Asia.

Rudy Loewe is a visual artist working with comics, illustrations and printmaking. Rudy currently collaborates as part of Collective Creativity, a group of artists focused on creating dialogue around queer artists of colour and black arts history. In 2016 Rudy founded the Brown Island collective in order to form a space for people of colour at Konstfack, Sweden's university of arts, crafts and design.

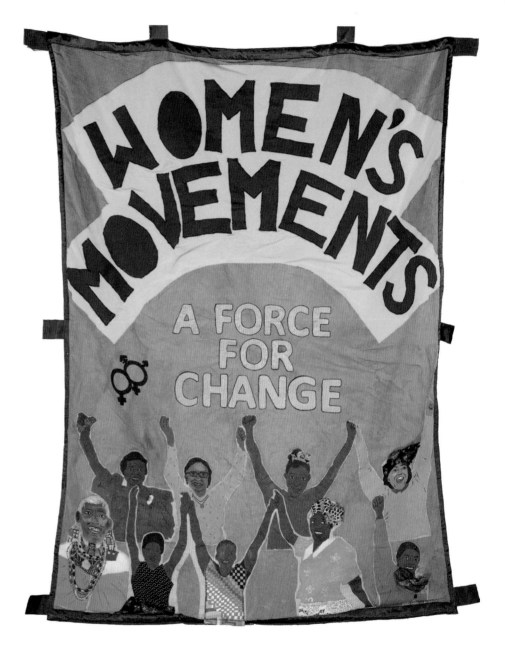

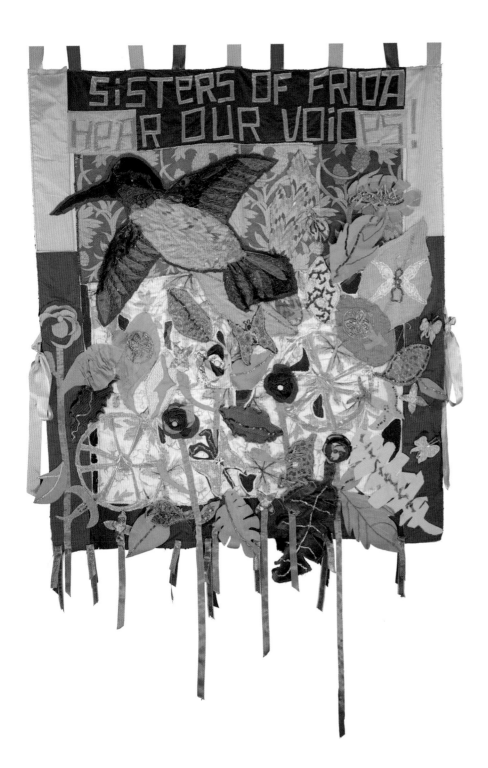

DELAINE LE BAS

Artist
Delaine le Bas

Contributors
Sisters of Frida

London,
England

Cotton, gauze, sequins, felt

2445 × 1560 mm
2.08 kg

✖ COMMISSION

In collaboration with artist Delaine le Bas, the group decided that their banner would focus on Frida Kahlo. The figure of the hummingbird is the group's logo and symbolises freedom and life, and the wheel represents the wheel of fortune, or change.

Foliage, flowers and butterflies are often shown in Frida's paintings. These elements make the banner visually interesting and ensured that the whole group could contribute. The group chose to make the banner patchwork for the same reason, and so that they could work in the colours of the suffragettes.

BREWERY ARTS CENTRE

Textile Artist
Kate Reid

Spoken-word Artist
Ann Grant

Contributors
Kristienne Brandreth, Sylvia Taylor, Lyndsay Slater, Sarah Vowles, Isabella Reid, Kathleen Shaw, Caroline Stow, Rebecca Last, Sara Last, Valerie Butcher, Karen Tredwell, Tricia Gordon

Kendal,
England

Mixed textiles

1320 × 1960 mm
2.04 kg

The message on this banner is 'Woman Up and Roar'. Around the edges are the words 'You stand on Helvellyn and scream for your soul / It echoes right back and stays there'.

The group wanted to depict a Cumbrian woman, who they agreed can be hard-working, proud and 'say it how it is'. Some group members often say 'woman up' instead of 'man up'.

The words around the edges of the banner are from a poem by Ann Grant about belonging to Cumbria and being working class. It was read out during the group's discussions and the group then agreed that it summed up what they wanted to say.

'The words around the edges of the banner are from a poem by Ann Grant about belonging to Cumbria and being working class'

You stand on Helvellyn and scream for your soul

Woman UP and Roar

KENDAL WOMEN

It echoes right back

THE WHITWORTH

Artist
Jackie Haynes

Contributors
Alison Hagger, Ann Knowles,
Aysha Yilmaz, Brenda Hickey,
Gwynneth McManus,
Jackie Pertoldi, Janet Holmes,
Janice Bonner, Julie Nagy,
Kath Walls, Maureen Stirpe,
Nuala Wilson, Philippa Usher,
Sandi Gregson, Sheraine Easy,
Claire Cowell

Manchester,
England

Cotton

1450 × 2320 mm
3.5 kg

The banner aims to communicate both individual and collective voices. The group began by looking at selected works from the Whitworth Collection. They referred to, amongst others, a list of artists whose work was attacked by the suffragettes, drawn up by the Emily Davison Lodge group.

The group collectively chose Walter Crane's *The Workers' Maypole* to base their design on. They made streamers with individual messages and motifs to be held aloft alongside the main banner. The front of the banner articulates the main collective message, referring also to Manchester – the home of the Pankhursts – along with the 'Worker Bee' symbol.

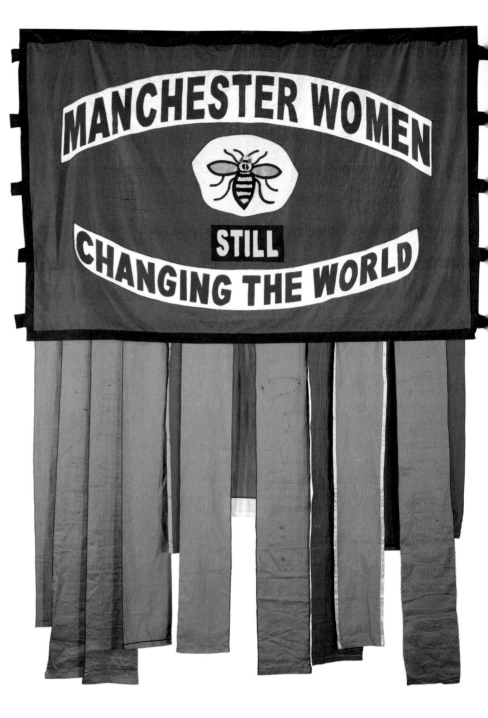

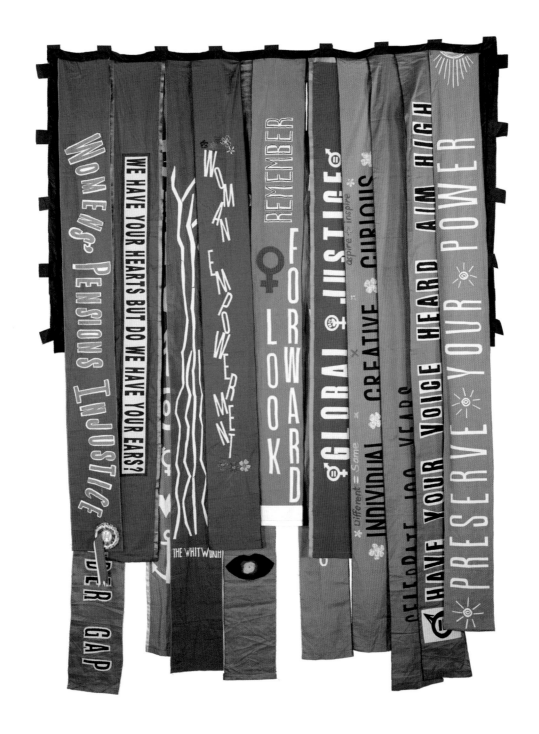

SOMETHING FOR THE G

SADIE WILLIAMS

Artist
Sadie Williams

Contributors
Youth advocates,
Girlguiding UK

London,
England

Bonded metallic lamé, print

1520 × 2410 mm
0.7 kg

✎ COMMISSION

Playing on the history of Girlguiding badges, the inspirational youth advocates identified the issues they felt were most important to communicate. Each badge represents one of these issues, such as 'Positive Body Image', 'LGBT Pride' and 'Period Poverty'.

Artist Sadie Williams worked her love of modernity and craft into the piece by creating hand-collaged print designs with the youth advocates. The collages were heat-pressed onto metallic fabric and then cut, bonded and appliquéd onto shimmering fabrics in the classic suffragette colours. The bold and youthful banner proudly sports the slogan once used by the fearless Girlguiding originators at a Boy Scouts convention in 1909, who demanded that there should also be a space for young women to bond, adventure and grow strong together.

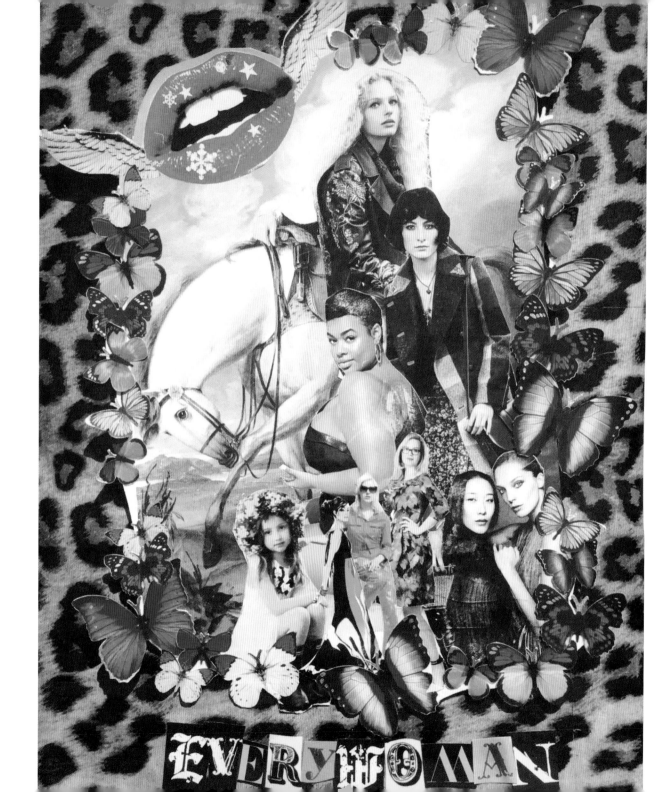

GOLDEN THREAD GALLERY: 'EVERYWOMAN'

Artist
Lesley Cherry

Contributors
Kilcooley Women's Group,
County Down

Bangor and Belfast,
Northern Ireland

Printed vinyl

2100 × 1300 mm
1 kg

This banner, entitled 'Everywoman', was inspired by traditional banners, mainly from the Hibernian and Orange Order traditions in the North of Ireland. These are very patriarchal organisations, and the participants wanted to reclaim this style of banner for themselves. Orange Order banners traditionally depict William of Orange on a white horse. The group wanted to completely rethink this image, using collage and images of as many different types of women as they could.

Using old prints and contemporary magazines, the women created an image of the white horse, head bowed, with women cascading down around its side. Symbolic butterflies in the suffragette colour purple frame the image, and the glamorous leopard backdrop symbolises a fighting cat spirit.

GOLDEN THREAD GALLERY: 'CHOICE'

Artist
Lesley Cherry

Contributors
Kilcooley Women's
Group, County Down
and Hazel Cherry

Bangor and Belfast,
Northern Ireland

Mixed textiles

1940 × 1000 mm
1 kg

'Choice' is soberer in tone than 'Everywoman'. Hand-knitted words highlight the choices or lack of choices for women, even today, 100 years after getting the partial vote. This is significant in Northern Ireland, where until as recently as October 2019 it was illegal to have an abortion, with women having to travel to the UK to seek advice and treatment. The banner also highlights the equality of choice women have, from equal marriage to job recognition, pay scales and opportunity.

LIGHTHOUSE

Artist
Denise Poote

Contributors
Carol, Manda, Laura, Liz, Jackie, Jane, Juliet, Michele, Dot, Wendy, Val, Linda, Susan, Rosemarie, Denise, Perdie

Poole,
England

Mixed textiles

1625 × 1950 mm (1 ×),
1625 × 1100 mm (2 ×)
1.45 kg (1 ×),
0.9 kg (2 ×)

The group decided to make a triptych banner, which would explore the three messages that they felt were most important to communicate. The pieces focus on commemorating the centenary, highlighting the group's locality and expressing the need for equality.

'A triptych banner, commemorating the centenary, highlighting the group's locality and expressing the need for equality'

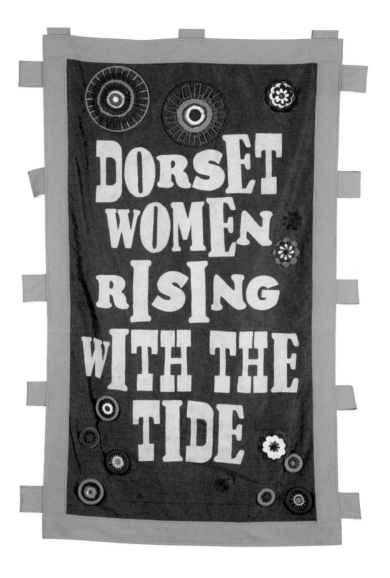

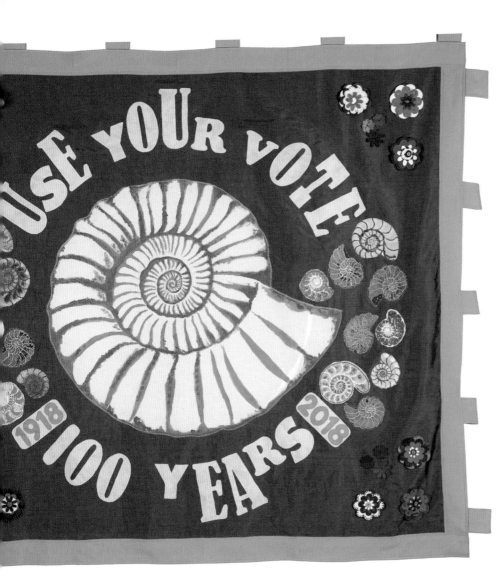

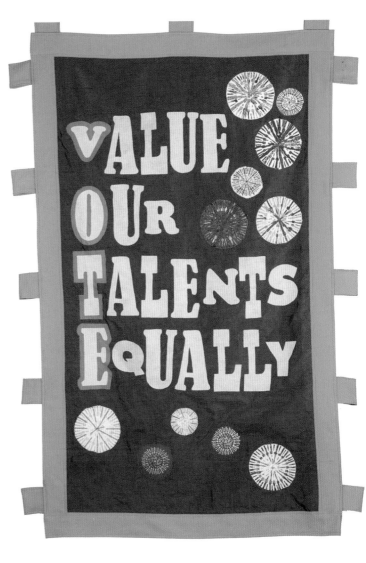

81

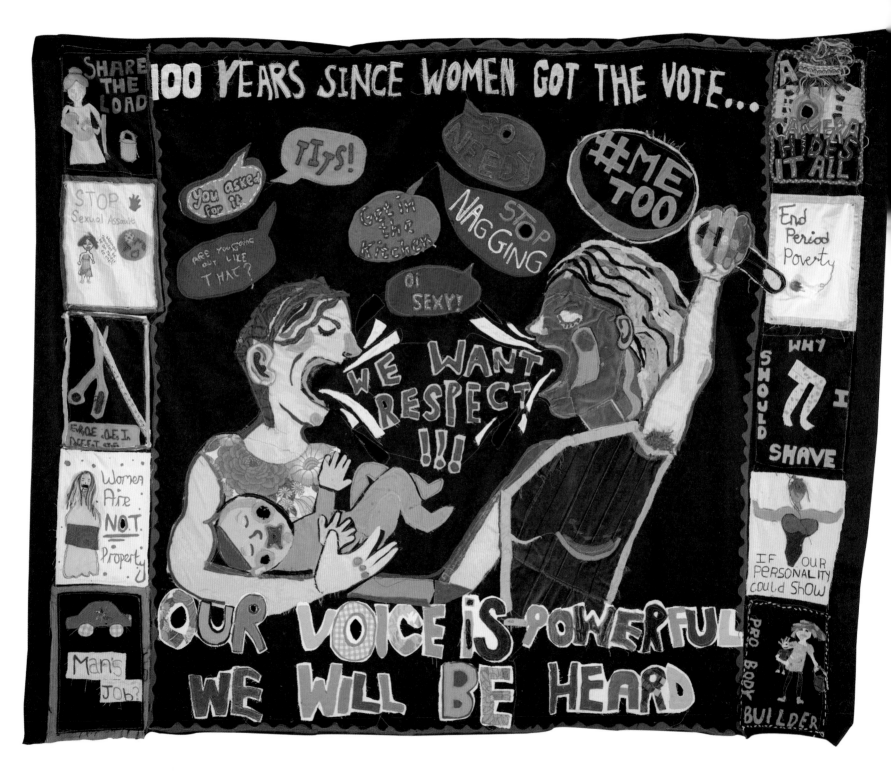

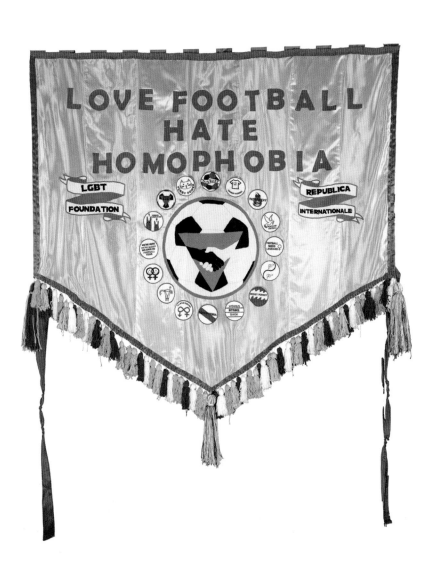

ARTLINK HULL

Artist
Ella Dorton

Contributors
The Boulevard Centre

Hull,
England

Mixed textiles

1500 × 1820 mm
1.66 kg

The participants are attendees at two centres of alternative provision for pupils who are unable to access mainstream education. Although the girls are too young to vote, the group felt that it was important that a youth voice was represented in the project.

The girls who made the banner have a lot of responsibility in their lives at a young age. The artist facilitated an exploration of the real-life struggles and issues that affect them, 100 years on from women gaining the partial right to vote. The group is now very much aware that their voices matter and that they should use their voices to shape their future.

SARAH-JOY FORD

Artist
Sarah-Joy Ford

Contributors
Republica Internationale
Women's Football Team,
and the LGBT Foundation

Manchester,
England

Mixed textiles

1450 × 1630 mm
1.38 kg

✖ COMMISSION

This banner celebrates women's football and the radical possibilities for social change that it can bring. It raises the issues of ongoing sexism and homophobia faced by women in sport. Much anti-homophobia campaigning in sports has focused on men's experiences, whereas this collaboration focuses on the unique challenges of being female and gay. The banner champions grassroots football, in particular explicitly anti-fascist teams like Republica Internationale, as spaces for celebrating LGBT people, and challenging ongoing discrimination.

Women's rights belong to all women and the group's message is that therefore we must have inclusion, representation and solidarity for all women before we have true equality.

83

MADEINROATH

Artist
Jessica Akerman

Contributors
Ellie Ware, Helen McCormack,
Rosie Edwards, Hillary Roberts,
Lucie Alexander, Alice Smith,
Megan Winstone, James
Cocks, Eva Elliott, Amanda
Harrington-Kiff, Pip Tudor,
Shân Taylor

Cardiff,
Wales

Mixed textiles

3480 × 4330 mm
4.85 kg

The banner was inspired by the dazzle ships of the First World War. Their geometric patterns confused and disrupted the enemy's ability to fire on target. This banner is the antithesis of camouflage: hi-vis cloth combines with leatherette (sham leather), a material celebration of the suffragettes' adoption of the sneering moniker first used by the *Daily Mail* to imply the activists were 'sham Suffragists'.

Structured sculpturally to reflect the prow of a ship, the banner is accessorised with homemade cardboard armour as a nod to that worn by suffragettes under their dresses. The partially camouflaged slogan responds to Wales' feminist heritage. Gently subverting the national anthem of Wales, 'Hen Wlad Fy Nhadau' (Old Land of My Fathers), this text reads 'Hen Wlad Fy Mamau' (Old Land of My Mothers).

'Inspired by the dazzle
ships of the First World
War this banner is the
antithesis of camouflage'

HEXXX

Artists
Jessye Curtis, Phoebe Davies
and Sarah Smith

Contributors
Participants from Welsh
Women's Aid: Chloe, Lynne,
Cathy, Melanie, Gauri, Tina,
Helen, Charlotte

London,
England

Screenprint on fabric

1320 × 2300 mm
2.1 kg

✎ COMMISSION

At the core of the banner is the manifesto collectively written by a group of women from South Wales who have encountered gender-based violence. This manifesto calls for the demands and needs of the group; from the personal to the political, local to national, sitting room to courtroom.

WE SEE YOUR GENTLE THREATS

CALLING ALL UK MEMBERS OF PARLIAMENT, WELSH ASSEMBLY MEMBERS AND LOCAL COUNCIL LEADERS. WE DEMAND YOU ALL ACKNOWLEDGE THE EXISTENCE OF ABUSE: IN PUBLIC SPACES, WORKPLACES, SCHOOLS, DETENTION CENTRES, WITHIN FAMILIES, BEHIND CLOSED DOORS AND ON THE STREETS.

WE DEMAND A COMMITMENT TO THE DECONSTRUCTION, DE-BUNKING AND UN-LEARNING OF SCRIPTS AND POWERS PASSED DOWN FROM THE SEXIST, HOMOPHOBIC, RACIST, PATRIARCHAL STRUCTURES WE LIVE UNDER.

WE DEMAND TRANSPARENCY IN YOUR POLICIES AND RECOGNITION OF A NEED FOR SYSTEMIC CHANGE IN OUR EDUCATION SYSTEMS, CRIMINAL JUSTICE SYSTEMS AND CORPORATIONS.

WE DEMAND SPECIALIST SERVICES THAT ARE ACCESSIBLE. THESE SERVICES MUST BE DESIGNED GROUND-UP, CENTRING ON ALL SURVIVORS' VOICES. WE MUST BREAK DOWN THE BARRIERS THAT TRAP US IN ABUSE.

DO NOT MAKE ASSUMPTIONS. VIOLENCE AND TRAUMA AFFECTS DIFFERENT PEOPLE IN DIFFERENT WAYS, ACROSS CLASS, RACE, RELIGION, ABILITY, ECONOMICS, AGE, SEX AND GENDER.

OUR SAFETY SHOULD NOT BE DEPENDENT ON OUR ECONOMIC POSITION, LOCATION OR MIGRATION STATUS. WE DEMAND THAT REFUGEE AND MIGRANT WOMEN, AND WOMEN IN DETENTION CENTRES SHOULD BE GIVEN THE SAME HUMAN RIGHTS AS WOMEN ACROSS THE UK.

WE DEMAND LAWS THAT SUPPORT ALL WOMEN'S SAFETY, WHETHER YOU ARE A CHOIR LEADER, POLICE OFFICER, PARENT, MP, REFUGEE, CARER, ADMINISTRATOR, DOCTOR OR RUGBY PLAYER.

WE DEMAND SEX AND RELATIONSHIP EDUCATION, EQUALITY AND RACIAL JUSTICE TRAINING, AND SEXUAL VIOLENCE AND DOMESTIC ABUSE AWARENESS TO BE TAUGHT THROUGHOUT ALL SCHOOLS, WORKPLACES AND COURT ROOMS.

EXPLICITLY WE DEMAND EDUCATION THAT IS GENDER INCLUSIVE AND INCLUDES THE BROAD SPECTRUM OF ABUSE FROM FINANCIAL, EMOTIONAL, PHYSICAL, PSYCHOLOGICAL AND SEXUAL CONTROL.

LANGUAGE IS IMPERATIVE. WE DEMAND THAT ALL GOVERNMENTAL, LOCAL AUTHORITIES AND CIVIC ORGANISATIONS LEAD BY EXAMPLE AND USE GENDER AND LGBTQI+ INCLUSIVE LANGUAGE ACROSS ALL INTERNAL, PUBLIC AND ADMINISTRATIVE COMMUNICATIONS.

NO MORE VICTIM BLAMING. WE DEMAND SURVIVOR-CENTRED LAWS. HOLD PERPETRATORS TO ACCOUNT AND CHALLENGE THEIR BEHAVIOUR.

WE DEMAND MEN TAKE ACTION. WE CALL ON MEN TO BE AMBASSADORS FOR INTERSECTIONAL FEMINISM: MARCH, PROTEST, EDUCATE, AMPLIFY AND SMASH THE PATRIARCHY. IT OPPRESSES YOU TOO.

CALLING ALL THOSE IN POSITIONS OF POWER. YOUR SUPPORT AND ADVOCACY IS IMPERATIVE. SPEAK UP. YOU CAN BE THE SOLUTION. END VIOLENCE AGAINST WOMEN AND GIRLS.

PRIME CUT
PRODUCTIONS

Artist
Bobbi Rai Purdy

Contributors
Falls Women's Centre,
Shankill Women's Centre,
Greenway Women's Centre,
Windsor Women's Centre
and Atlas Women's Centre

Belfast,
Northern Ireland

Linen, mixed textiles

2250 × 2700 mm
3.17 kg

The banner is made from loose-weave, unbleached Belfast linen, reflecting the rich and vivid heritage of textiles in the city, once known as 'Linenopolis'. Belfast's linen industry was world famous, and was founded on the backbreaking work of the city's women, known as 'the Millies'. Created over a four-month period by this cross-community group, the banner uses the colours of the suffragettes and resonant motifs like the pansy and shamrock to reflect the history and character of Belfast, and the participants' aspirations for the future.

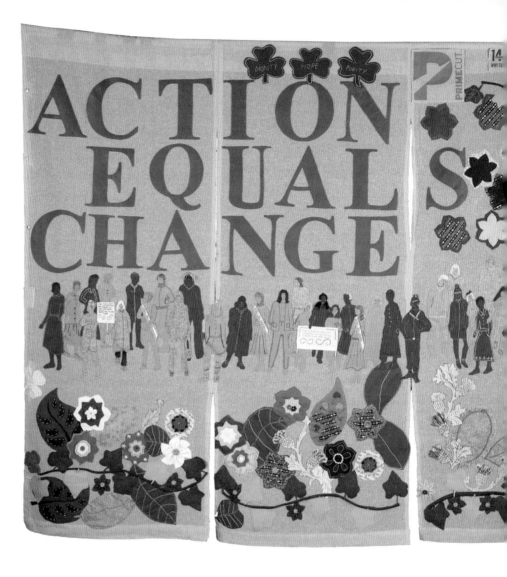

When I was invited by Prime Cut Productions to be part of PROCESSIONS, I was delighted. Working as a visual artist in Belfast for the last twenty-five years, I have seen the pain, scars, conflict and the very slow healing of these fractured communities. PROCESSIONS enabled a group of women from both communities in Northern Ireland to come together in a safe environment and work on this emotive and passionate project.

Where to begin? Una Nic Eoin, Executive Producer for Prime Cut, just said the magic words 'Irish Linen'. That was my starting point. The Irish linen used already meant a lot to all these women and because of this commonality, the stories came rolling in!

We looked at how to say in a visual way how we all felt: how our own executive at Stormont lay dormant and what having the vote meant to us here today. The images became personal, and silhouettes of the women's bodies made in purple felt were incorporated. The women felt that they had left their mark!

The colours used and their meanings were different to what they were used to. Being Catholic or Protestant and being surrounded by their own colours of flags in a society with which they identified became unimportant. As a visual artist I was welcomed in both communities and over the years saw parts of Belfast each side would never get a chance to experience or feel welcome in.

I have worked in many mediums, and working on a textile piece was a joy because, coming from an Indian background, fabrics and patterns were all around me growing up and the care that my mother and aunties would take to make their own clothes depended on the prints that were available to them. The workshops were informal and fun and the banner grew and grew! At one point during the project, the ladies realised that they knew of people, stories and places they all had connections to at different times in their lives and this was great. They even sang during the making and laughed out loud. This made me so happy. We were all delighted and proud of the result.

Their words, 'Action Equals Change', are true, and united them and me. All the appliqué flowers and vines were sewn on individually, as were the letters and silhouettes. At the march in Belfast, members of the group carried the banner in the forefront proudly.

For me it was a wonderful moment to see this group of proud, independent women, whose paths would never ordinarily cross, become friends and share their stories and listen to others.

I am so proud to have had this opportunity to celebrate such a necessary and momentous time in our lives here in Belfast. Women here have a lot to say and being given a platform was amazing and they used it powerfully.

Bobbi Rai Purdy,
Artist, Belfast

WORCESTER ARTS WORKSHOP

Artists
Molly Rozier, Sarah Cotterill,
Libbertine Vale,
Heidi Murphy

Contributors
Worcester Women's Equality
Party, WooFems, and
Worcester Arts Workshop
students and volunteers

Worcester,
England

Mixed textiles

1070 × 2360 mm
1.1 kg

Exploring the herstory of the women's suffrage movement, the vote and participants' identities as women, the group decided on the themes of inclusivity, strength and support for this banner. These ideas were translated into the 'Woman Tree and Sisterhood', each leaf holding images of women that inspire the group: their daughters, mothers and each other.

The group were particularly taken with the concept of the 'hidden' things that aren't necessarily noticeable to everyone, but understood by those who made it, inspired by the secret messages stitched by the suffragettes into their work. It also represents the 'hidden' women that worked in Worcester's glove and porcelain factories many years ago. The names and initials of the group's participants are graffitied into the trunk and branches of the tree. If you look closely, you might find some discarded gloves, a tea cup and faces that you might recognise.

'The group were inspired by the secret messages stitched by the suffragettes into their work'

91

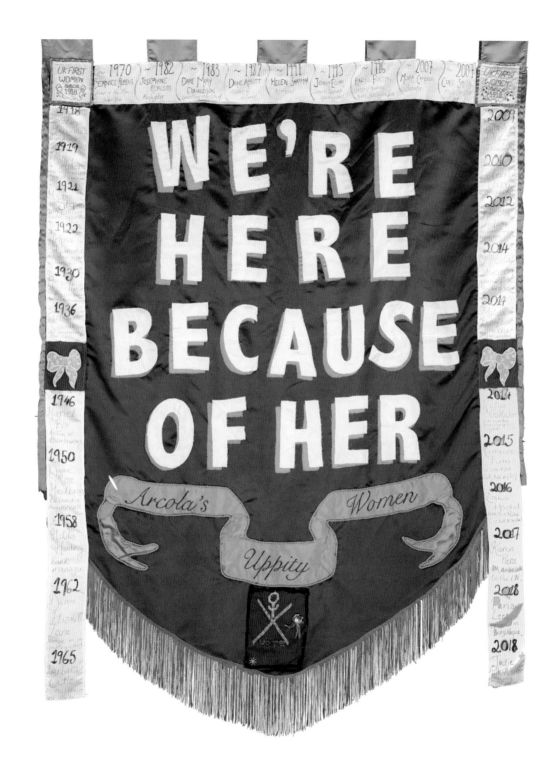

I must admit I was quite nervous to run a workshop for such an important commemoration, and one that means so much to me. Not only had I not made an artwork with a large group before, we were also essentially a large group of strangers. For such an important occasion the pressure was on!

When I met with the group we were all pretty nervous. As the conversation flowed we came to the topic of 'female firsts'. One of the participants was one of the first women to work for the London Fire Brigade. It was fascinating hearing about her experience. I think sometimes we take that for granted. There is always a first woman, or a first few women who buck the trend and create the space for future women to walk in their shoes. We decided to commemorate this by making our banner about 'First Women'. We created a banner with central text reading 'I'm Here Because of Her'. Then around the edges we created a timeline of female firsts in the last 100 years. It was very telling how recent many of the firsts were.

The day itself was absolutely glorious. So many incredible women in one place, with so much creativity and joy. It felt like a massive achievement for all of us. I'm extremely proud to have been a part of it. My research into the suffragette banners, and having the opportunity to see them in person, hugely influenced my next body of work. I went on to create a new painting, inspired by the style of the suffragette banners. This piece is now in the Birmingham Museum permanent collection. PROCESSIONS was extremely important to me, not only because it was an incredible experience, but because it enriched my artistic practice.

Sarah Maple,
Artist, London

SARAH MAPLE

Artist
Sarah Maple

Contributors
Arcola Women's Theatre;
Daisy Montgomery, Najma
Maple, Natalie Audley,
Andrea Francis, Kheira Bey,
Buddleia Maslen

London,
England

Mixed textiles

1760 × 1290 mm
0.5 kg

COMMISSION

The group wanted to recognise women who have paved the way in their fields for future generations since 1918.

Sarah Maple is an award-winning visual artist known for her bold, brave, mischievous and occasionally controversial artworks. They challenge notions of identity, religion and the status quo. Much of Maple's inspiration originates from being brought up as a Muslim, with parents of mixed religious and cultural backgrounds.

Sarah says: 'It is so important to recognise what women went through to achieve the vote. It reminds us that although so much has changed, there is still so much that needs to be done. It feels like we are in the middle of a really important change right now for women and equality in general, and PROCESSIONS is a perfect example of this. I feel so honoured to have been asked to be part of this moment in history!'

AN LANNTAIR

Artist
Chris Hammacott

Contributors
Members of the Western Isles Women's Group: Barbara Ziehm, Alaina Schmisseur, Angela Price, Alison Fox, Caroline Brick, Hazel Mansfield, Anne Edwards, Mary Ann Russell, Betty Matheson, Angela Styles, Marie Macaskill, Gill Thompson, Murial Ann Macleod, Susanne Erbida, Christine Phillips, Catherine Macarthur, Kate Mawby, Elizabeth Whyte, April Whyte

Stornoway, Scotland

Mixed textiles, Harris tweed

1280 × 2285 mm
3.53 kg

This banner represents the diverse range of women who came together to create it. On a backdrop of Harris tweed, each participant created squares representing women who have inspired them. In the centre of the banner is depicted the goddess Brid, from whom the Hebrides take their name. She represents the strong women who live and work there. Over the blocks climb small women figures, helping one another upwards and using the work of inspirational women to help them onwards. The text, 'No Woman is an Island', is written in English and the group's native Gaelic.

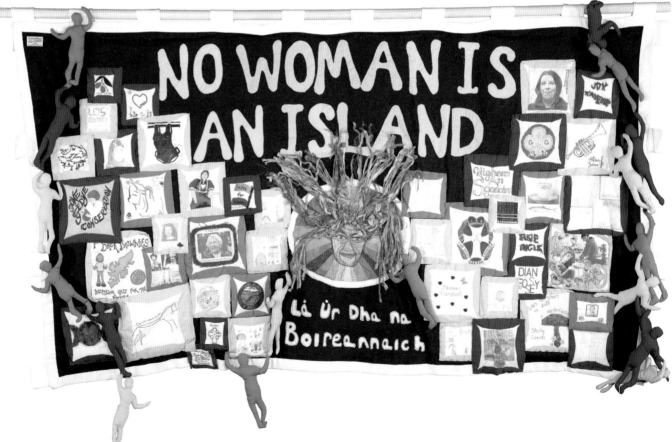

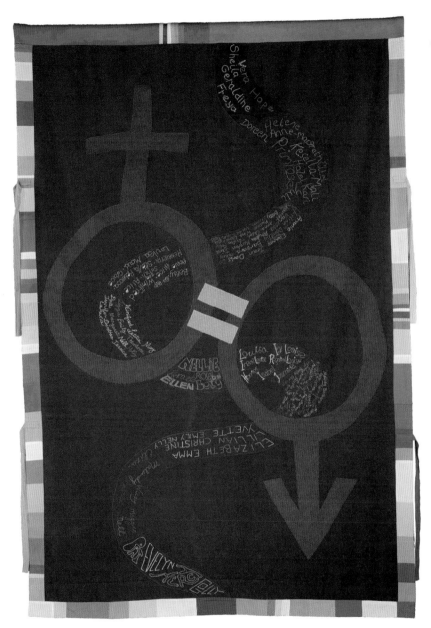

DEVON GUILD OF CRAFTSMEN

Artist
Veronica Gould and
Andrea Foxwell

Contributors
Named on the back of the
banner: Veronica Gould,
Andrea Foxwell, Melinda
Schwakhofer, Janette Staton,
Jan Underwood, Yvette Richer,
Clare Coutts, Yuli Somme,
Irene Course, Phil de Burlet
and Carole Newton. Other
members of the group: Jenny
Hutchinson, Hilary Mathieu,
Carey Scot, Fern Leigh Albert,
Lucy Patrick

Newton Abbot,
England

Cotton, embroidery silk

2000 × 1350 mm
1.8 kg

The banner has a navy-blue
background with large scarlet symbols
for male and female, joined by an =
sign. The suffragette colours form
a narrow border around the banner.
The original poles were made from
hazel, grown in a nearby woodland.
Flowing through the banner is a river
of names: of the grandmothers,
mothers, daughters and other women
who have significance for the group
members, a matriarchal line from
those who had no vote down to their
daughters. The banner has the simple
graphic message: equality. Nothing
more, nothing less.

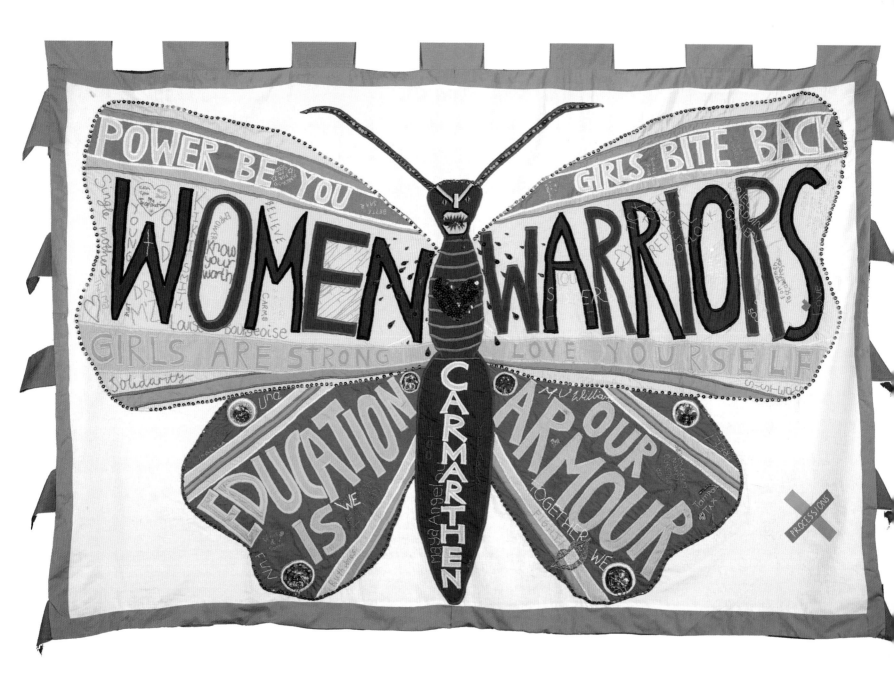

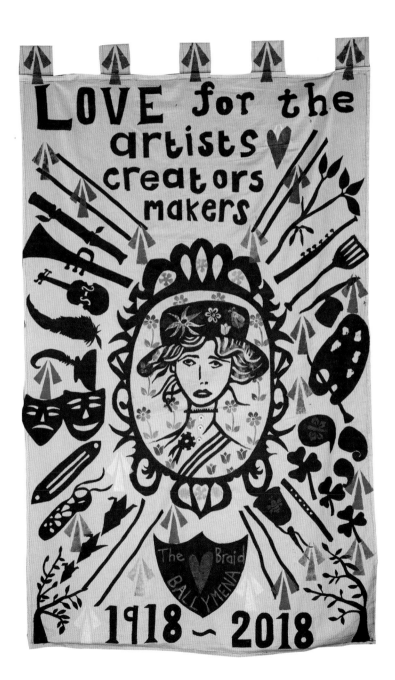

ORIEL MYRDDIN GALLERY

Artist
Rhiannon Williams

Contributors
Oriel Myrddin Gallery
with Dr M'z
(Carmarthen Youth Club)

Carmarthen,
Wales

Cotton, sequins, beads

1510 × 2340 mm
1.68 kg

This warrior-butterfly banner was made by intergenerational volunteers and members of Carmarthen's youth club, Dr M'z. It is adorned with words, phrases and images generated by the group and is decorated with handstitched names and symbols important and meaningful to each individual.

'It demands that the feminine can be strong. It is a symbol of change; in the procession it looked like a huge butterfly flying through the sky with a message in its wings.' – Rhiannon Williams, artist.

'Projects like this are invaluable – bringing people together to express unity and friendship.' – Louise Bird, participant.

THE BRAID ARTS CENTRE

Artist
Rosalind Lowry

Contributors
Mid and East Antrim Inter Ethnic Forum and individual makers in the borough

Ballymena,
Northern Ireland

Mixed textiles

2260 × 1360 mm
1.02 kg

This banner is based on old sepia photographs of suffragettes. It honours the artists, the creators and the makers – whether a policymaker or a homemaker. The group have included a range of symbols, such as the Holloway Broad Arrow prison clothing symbol, and flowers with various meanings, such as tulips for love. A range of symbols represent various art forms, from music, to dance, to weave and crafts. There are also symbols to represent the various cultures of the women who helped sew the banner. A limited palette is used, which represents the colour palette of 1918. The banner is entirely hand-stitched, with hand stencils cut and stencilled over the cloth.

ANYA HINDMARCH

Artist
Anya Hindmarch,
inspired by the work
of Margaret Calvert

London,
England

Cotton, leather

1410 x 1200 mm
1.31 kg

 COMMISSION

A subversion of the 'Men at Work' road sign, this 'Women at Work' banner was a homage to the work of Margaret Calvert OBE, the pioneering typographer and graphic designer who designed many of the road signs used throughout the United Kingdom. Anya Hindmarch was inspired by Calvert's work for her Diversion collection and it has remained a constant source of inspiration.

'Δ subversion of the
« Men at Work »
road sign, this banner
was a homage to the
pioneering typographer
and graphic designer
Margaret Calvert'

LUMINATE

Artist
Fiona Hermse

Contributors
Dunbar Dementia Carers
Support Group: Lorna,
Dorothy, Ricky, Ray, Carol,
Anou, Izzy, Alison, Iris,
Anne P., Anne S., Louise,
Nora, Beth, Rita

Edinburgh,
Scotland

Cotton, digitally printed
satin, dyes, silk paints,
fishing net, lace

1360 × 1935 mm
1.71 kg

The banner focuses on the fishwives and herring girls, an important aspect of Dunbar's heritage. These incredibly hard-working women led extraordinary lives, many of them very emancipated for their time. In 1913, a group of Newhaven fishwives travelled 400 miles to join a deputation of working women led by suffragette Flora Drummond at the House of Commons. The banner incorporates the first part of a quote by Frances Wright, nineteenth-century Scottish abolitionist and feminist: 'Equality is the soul of liberty; there is, in fact, no liberty without it.' The banner was created using spray dye, silk painting, monoprinting, embroidery and pompom techniques.

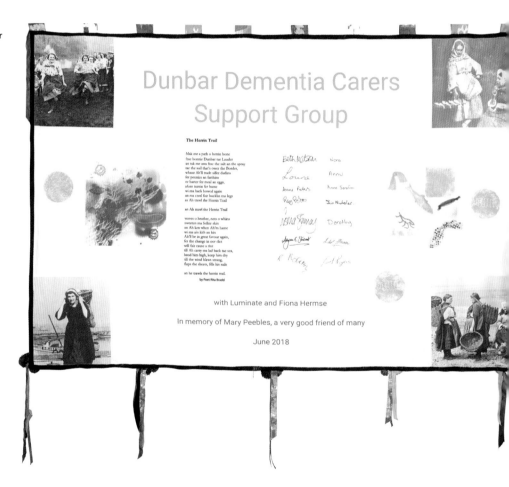

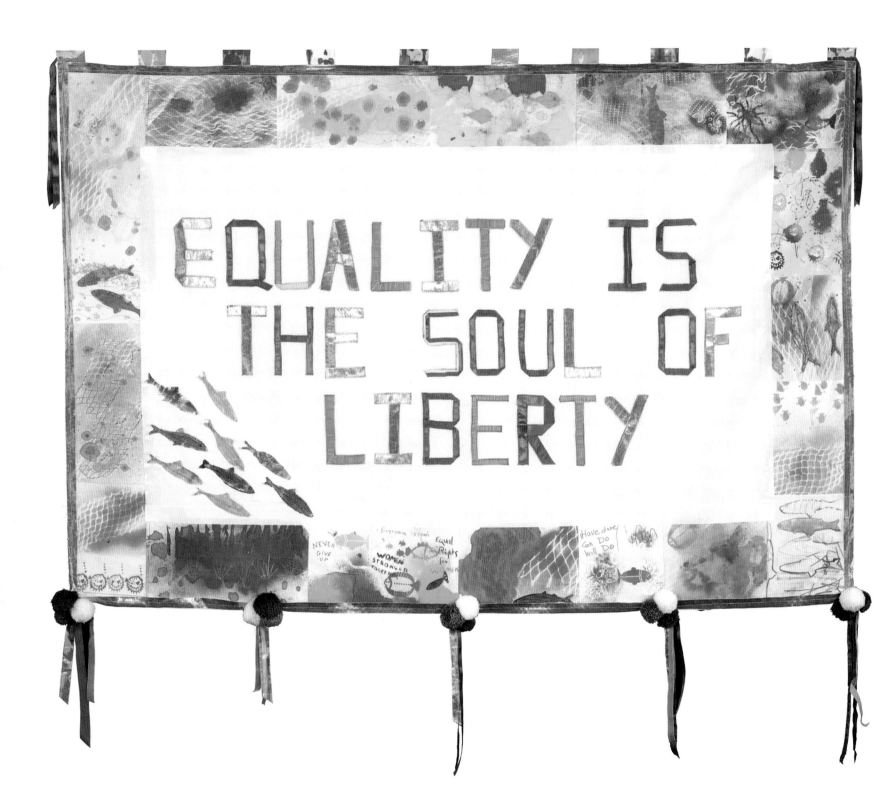

NUNEATON MUSEUM & ART GALLERY

Artist
Tracey Watson

Contributors
Nuneaton Museum
& Art Gallery Group

Nuneaton,
West Midlands

Mixed textiles

1350 × 930 mm
1.79 kg

The group identified with the character of Emily Wilding Davison, a member of the Women's Social and Political Union (WSPU) and a militant fighter for her cause. Although much of her life has been interpreted through the manner of her death, the group felt that she contributed so much more for her cause, including going on hunger strike seven times and hiding herself within the Palace of Westminster. The butterflies on the banner were each created by individuals from the group, symbols of endurance, change, hope and life.

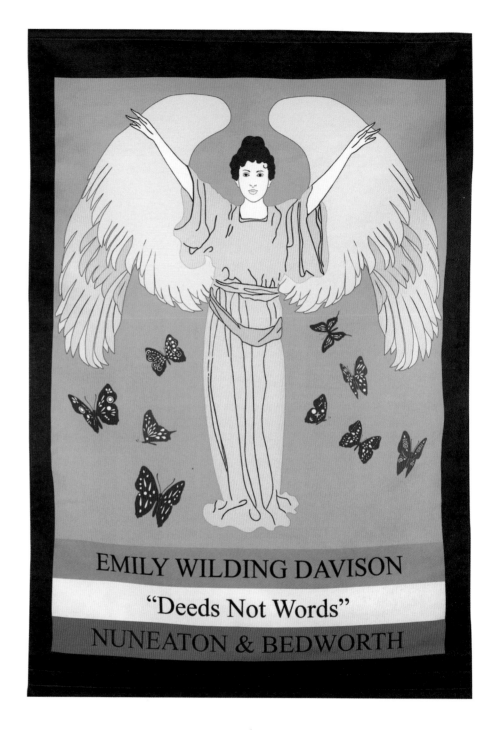

'Women in prison are still unable to vote and encounter many barriers to having their voices heard'

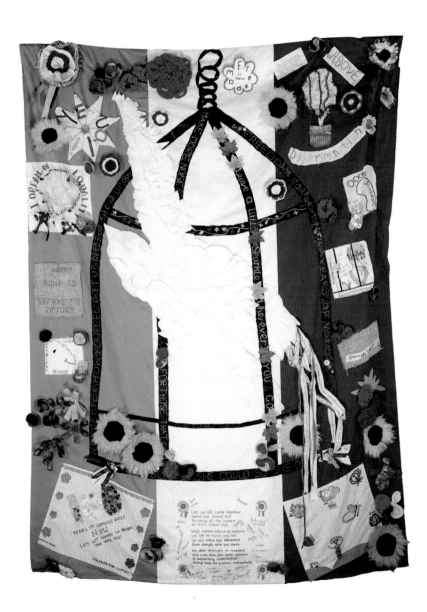

WOMEN IN PRISON

Artist
Lucy Tammam

Contributors
Women in HMP Foston Hall, the Beth Centre in London, and Anawim Women's Centre in Birmingham

London,
England

Mixed textiles, beads

2035 × 1500 mm
2.25 kg

This banner is called 'Freedom', and was created by the national charity Women in Prison, working with women who are affected by the criminal justice system. Workshops were held in the women's prison HMP Foston Hall, and two women's centres, Anawim Women's Centre in Birmingham and the Beth Centre in London. The group were inspired by the branding and motifs used by the suffragettes and created symbols and imagery to represent the fights and struggles of women today who are affected by the criminal justice system. The project was particularly poignant for this group as women in prison are still unable to vote and continue to encounter many barriers to having their voices heard.

THE PLAYHOUSE

Artist
Helen Quigley

Contributors
Kate Guelke, Caoimhe McNulty, Anne Marie McKee, Pauline Ross, Abby Oliveira, Ann Gillespie, Elaine Friel, Alice McCartney, Anne Crilly, Arlene Wege, Eimer Willis, Pat Byrne, Codie Morrison, Maeve Gallagher, Philippa Robinson, Carol Hutahaean, Tina McLaughlin, Christina McLaughlin, Kay Carlin, Rhonda Styles, Audrey Gillespie

Derry,
Northern Ireland

Mixed textiles,
photo transfer paper

1620 × 2450 mm
2 kg

The group worked with three generations of women – grandmothers, mothers and young people – drawing from the skills of Derry's now redundant shirt-making past (Derry was once the largest producer of shirts in the world). The group worked with poet Abbi Olivera to conceive a slogan. 'Ulster Says No' was a huge brand for Unionism in Northern Ireland, and this was transformed into 'Ulster Says Now' (for human rights). The 'w' of 'Now' was fashioned into two breasts. Finally, Dr Anne Crilly talked to the group about women's rights and the suffragette movement in Ireland.

ARTSEKTA

Artist
Emma Whitehead from
Top Floor Art Studio

Contributors
Art Route Collective

Belfast,
Northern Ireland

Mixed textiles, buttons

1220 × 1400 mm
1.09 kg

Art Route Collective, developed by ArtsEkta, works with refugees and asylum-seekers in Northern Ireland with the aim of improving emotional health and social wellbeing. They work in partnership with agencies such as Home Plus NI, Ark Housing, Extern, DePaul and Council for the Homeless NI. Supported by the Public Health Agency, the group meet weekly to engage in arts-led programmes designed to help them feel valued and respected, participate in community life, build self-confidence, develop knowledge and skills to build their lives in Northern Ireland, and be part of social networks and relationships.

For PROCESSIONS, the groups came together to interpret what home means to them, and their journey to Northern Ireland, as well as expressing their own cultural identity through the visual art work.

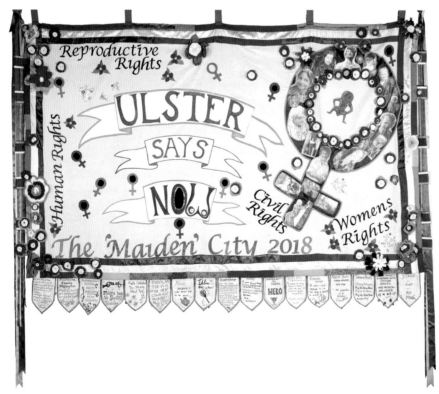

FREEDOM!
WOMEN'S
RIGHTS

artsekta

JUNCTION ARTS

Artist
Karina Thompson

Contributors
Junction Arts, with
women and girls from
across Bolsover

Chesterfield,
England

Digitally printed cotton,
beads, lace, mixed textiles

1840 × 1520 mm
2.5 kg

This banner features the smiles of 100 women chosen because of their significance to the group. They range from international household names to 'ordinary' local women: fictional and real; historical and contemporary; mothers, sisters and daughters; writers, actresses and comedians; scientists, astronauts and adventurers; politicians, campaigners and activists; sportswomen, designers and artists.

The group worked collaboratively in collecting the 'smiles' and in the creation of the lettering. The group were asked to think carefully about who should be on the banner and to have fun creating it. Through the banner, the group want to celebrate the lives of these women, while also giving advice to their contemporaries.

'The smiles of
100 women range
from international
household names
to «ordinary»
local women'

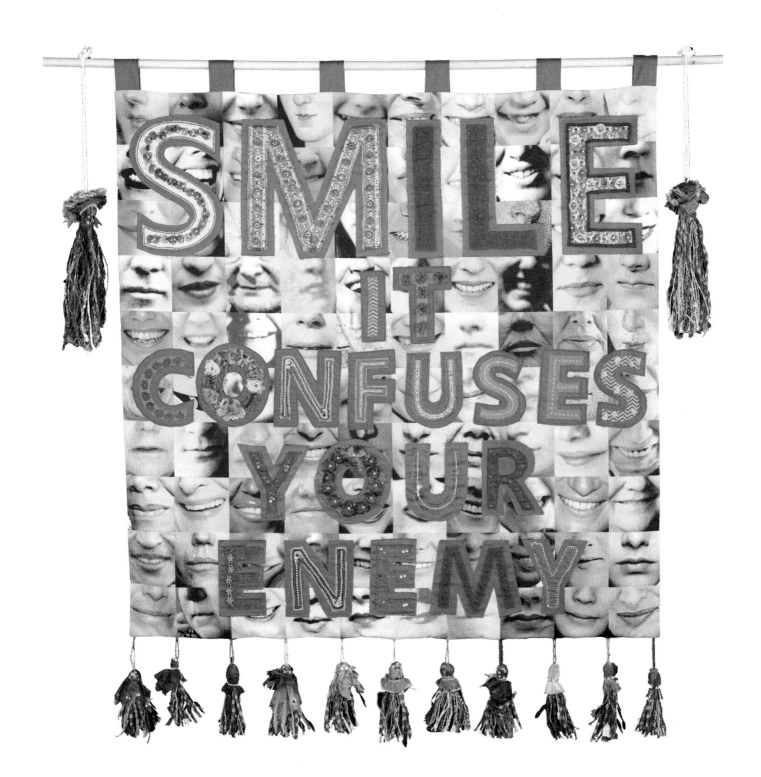

DOWN ARTS CENTRE

Artist
Patricia Dickson

Contributors
Windmill Sewing Group,
Saintfield

Downpatrick,
Northern Ireland

Mixed textiles

1350 × 1030 mm
1.15 kg

Colourful, chain-shaped appliqué links the dates 1918 at the top and 2018 at the bottom of the banner. This chain motif is at times broken, representing the progress that has taken place during this time. The banner powerfully depicts progression towards women's freedom to choose. The felt flowers contain the names of each group member, as well as a special person who inspired them, representing the importance of not forgetting the lives and contributions of earlier generations of women.

ARTS FOR ALL

Artist
Carolyn MacDougall

Contributors
Nikki Turner, M. Jamison, Alison McAuley, Joanne Brown, Arlette Bataille, Tineke Kroes, Lorraine Whiteside, Orlagh McGeown, Betty Cavanagh, Gerardine Young, Patricia Cummings, Jill McDermott, Cony Ortiz

Belfast,
Northern Ireland

Mixed textiles, buttons

1260 × 1900 mm
1.18 kg

The group aimed to make their banner as inclusive as possible. On an Irish linen background, a border of hands holding voting ballots decorates the banner. These were created using embroidery, appliqué, printing and painting. Participants based their design on their own hands. Some are based on historical research undertaken in the initial stages of the project, while others have a personal attribute to them. One participant included a copy of a letter written from her great aunt to her mother on the day she was born. Others based their design on their culture, or on the idea of equality and what their vote means to them.

'One participant included a copy of a letter written from her great aunt to her mother on the day she was born'

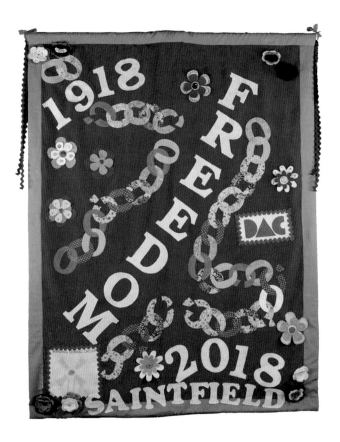

108

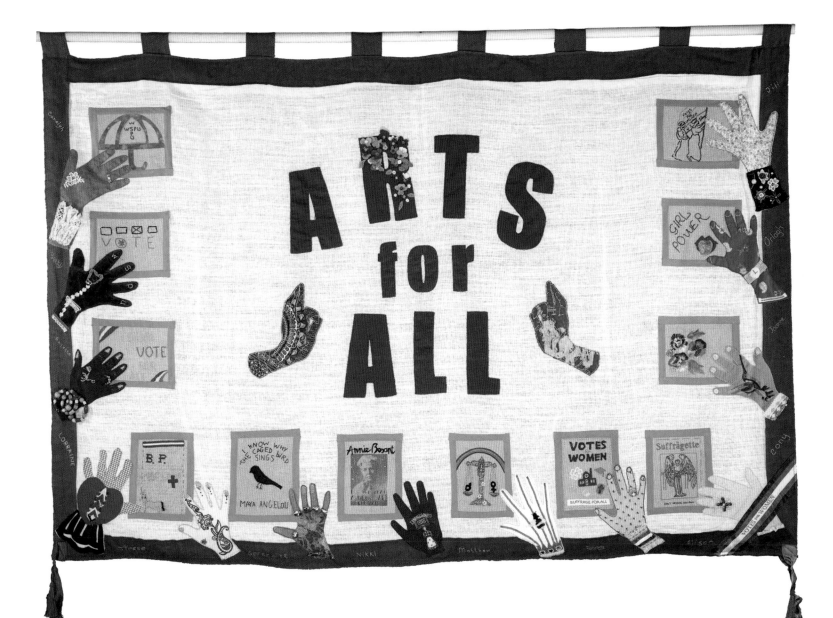

SOUTH HILL PARK ARTS CENTRE

Artists
Amarjeet K. Nandhra
and Dawn Thorne

Contributors
Fiona Hardman, Clare Auburn,
Cary-Ann D'Arcy, Caroline
McMahon, Kaye Periam,
Pat Fuller, Mavis Roles,
Jo Hetherington, Sam Jones,
Val Strudwick, Ann Welsh,
Fran Cooke, Kirsty Howell,
Amanda Annetts,
Diana Higgins, Kim Prior,
Chris Dobson, Angela Scott,
Janet Manning

Bracknell,
England

Mixed textiles

860 × 2450 mm
1.12 kg

This banner marks the centenary of voting rights for some women, signifying the beginning of an important journey. The group wished to celebrate how far women have come, while also marking 2018 as a time for reflection on how much still needs to be achieved. The group wishes for the demand, 'Hear Our Voice', to be upheld as a right for us all, not just for the privileged. The banner's message is that diverse voices of women and girls from all sections of the community, those marginalised and ignored, must also be heard, and that together we stand stronger.

INSTITUTE FOR CONFLICT RESEARCH

Artist
Rita Duffy

Contributors
Institute for
Conflict Research

Belfast,
Northern Ireland

Mixed textiles, beads

2025 × 2020 mm
2.33 kg

Artist Rita Duffy, RUA, and photographer Mariusz Smiejek collaborated with the Belfast-based Institute for Conflict Research to work with thirty women from the Ards Peninsula in Northern Ireland. The resulting 'Re-birth of Venus' includes symbols and components of the women's responses to economic independence, employment, domesticity, sexual reproduction, and pollution in the maritime and rural environment. In so doing, it plays with and disrupts a male gaze and interpretation of femininity, womanhood, beauty and age. It is dedicated to our late Venus, Laureen McGill, whose distinctive eyepatch hid the cancer from which she died shortly after leading out Northern Ireland's PROCESSIONS in her wheelchair (though fully clothed on that occasion).

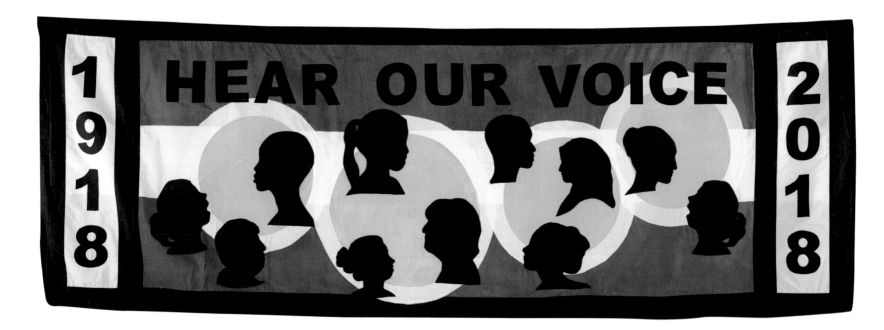

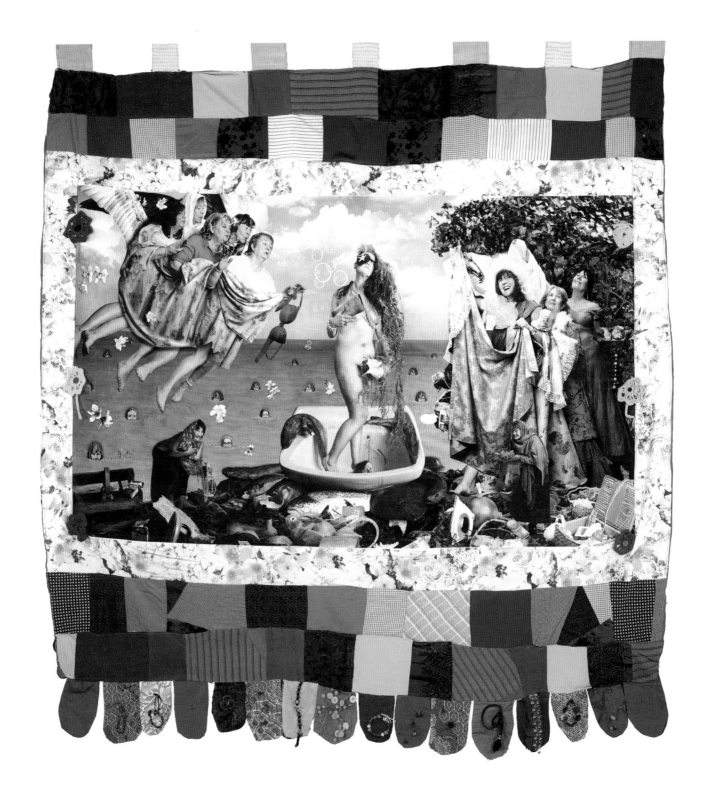

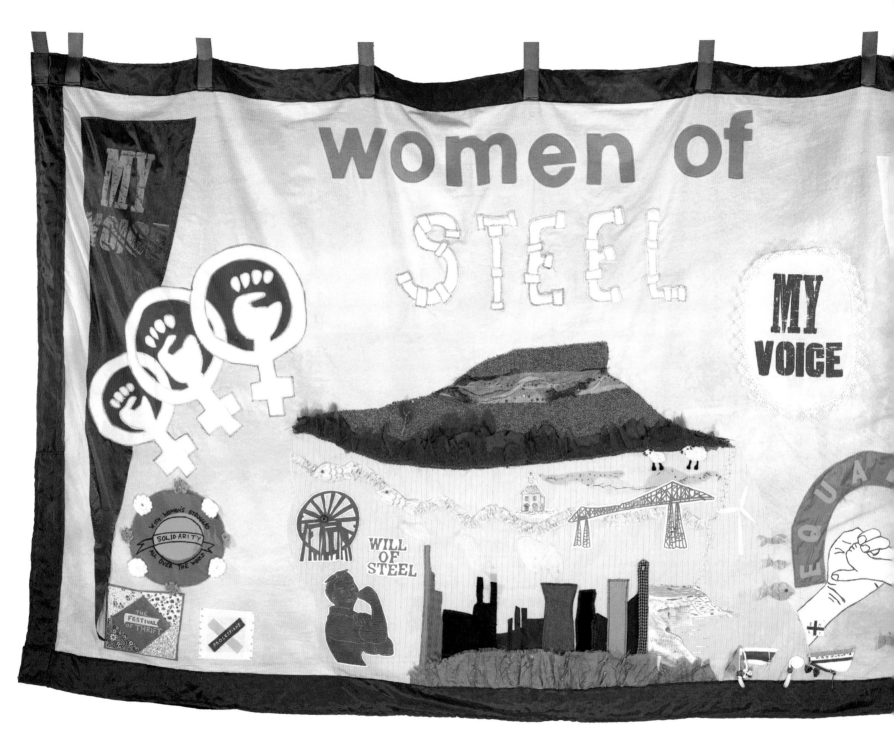

Artists
Pauline Taylor and
Theresa Easton

Contributors
Thorntree Roses,
Middlesbrough; Tees Valley
Arts; Navigator North and
Kirkleatham Museum, Redcar;
Kendra Rolfe, Christine
Lisheung Ying, Pat Sergeant,
Miki Rogers, Pat Laver,
Rebecca Parker, Michelle
McIntyre, Marie Karater,
Victoria Hadfield, Pam Best,
Janet Ford, Karin Slade, Liz
Read, Helen Lorimer, Liz Vine,
Denise, Anne, Elenor Pickett,
Christine Pickett,
Jane Tambling, Susan
Lombardi, Rose Lombardi

Whitley Bay,
England

Screen printed silk, wool,
chiffon, cotton, Harris tweed,
polyester

1320 × 2300 mm
1.7 kg

This banner was commissioned
by Festival of Thrift and jointly
designed and made by women
of the Tees Valley. 'Women of Steel'
refers to the production of steel
at Redcar with iron ore from the
Cleveland Hills, but it is also about
the strength of the women who
have lived in this coastal region for
many years, supporting industry,
farming, fishing and the Royal National
Lifeboat Institution (RNLI). This
project made the group look at what
women went through 100 years
ago to gain the vote, and has made
the members want to do more to
ensure that women continue to gain
equality in the future.

'The banner is about the strength of the women in this coastal region who support industry, farming, fishing and the Royal National Lifeboat Institution'

CENTRE FOR CONTEMPORARY ART

Artist
Aoibheann Greenan

Contributors
Members of
the Rainbow Project

Derry,
Northern Ireland

Mixed textiles,
laminated card

1150 × 1550 mm (4 ×)
4 kg

This banner was created with participants from the Derry branch of the Rainbow Project, an organisation that promotes the health and wellbeing of lesbian, gay, bisexual and/or transgender people and their families in Northern Ireland. The four-faced banner was designed and produced by the artist and participants using collage and cut-up techniques. Each of the four faces relates to the various experiences and struggles of lesbian, gay, bisexual and transgender people, and can be seen as a celebration of queer experience in Northern Ireland.

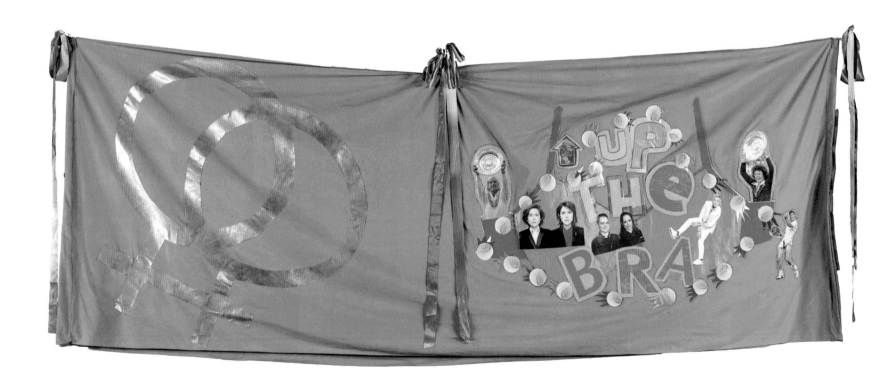

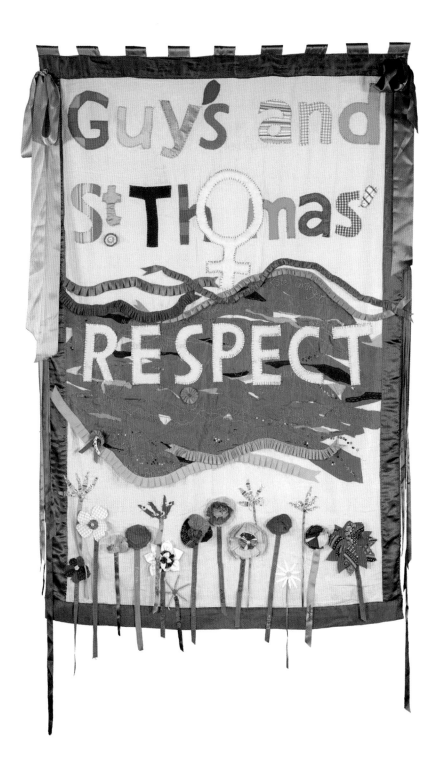

CRAFTS COUNCIL

Artist
Angela Maddock

Contributors
Staff from Guy's and
St Thomas' Hospital,
including Melissa Cardenas,
Claire Dossi, Onyinye Nwulu,
Barbara Fuller,
Angela Aboagye,
Heather Wood and
Hendrika Santer Bream

London,
England

Mixed textiles, West African
wax print cotton

1970 × 1300 mm
2.09 kg

Created by women working at Guy's and St Thomas' NHS Foundation Trust with the support of the Crafts Council, this banner celebrates women in healthcare. Stitched into the River Thames are the names of well-known women, including Mary Seacole, Florence Nightingale and Edith Cavell, and more contemporary women such as Dr Kate Granger, MBE, whose #hellomynameis campaign has improved communication between staff and patients across the NHS. The group also acknowledges the Windrush nurses and midwives and women directly involved in Guy's and St Thomas', like the Chief Nurse, Dame Eileen Sills.

While they worked, the group shared stories of their work, lives and individual women who inspired them; their names are stitched on the flowers at the bottom of the banner. The word 'Respect' is included to represent the group's demand that women in healthcare be recognised and respected.

'The banner features words by poet and civil rights activist Maya Angelou…and a portrait of the black British activist Olive Morris'

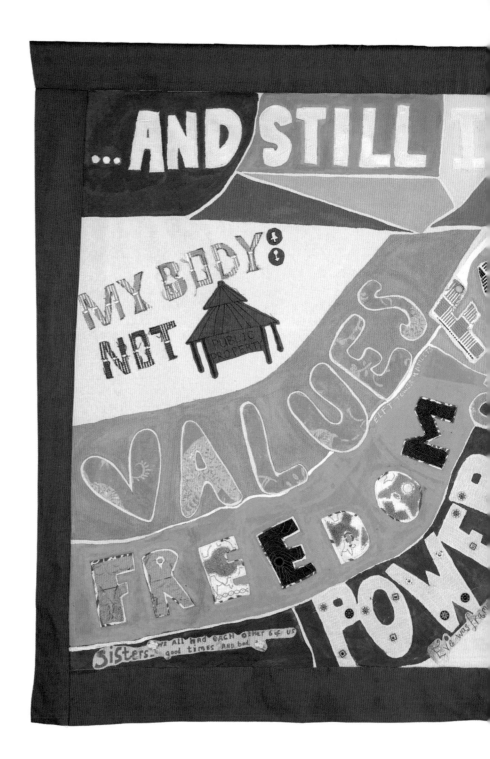

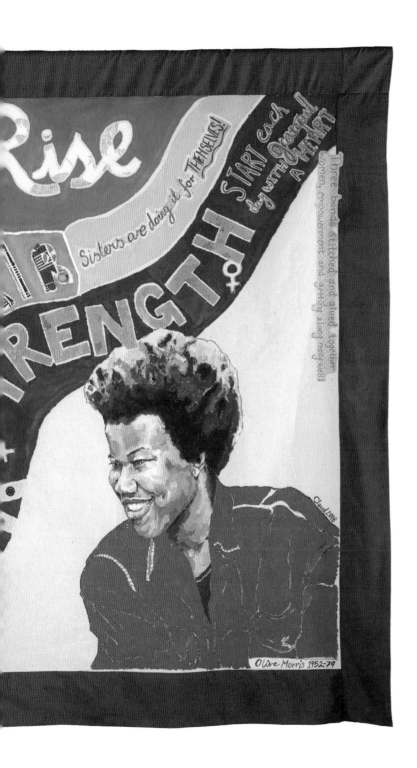

CLAUDETTE JOHNSON

Artist
Claudette Johnson

Contributors
Service users from
the East London
Foundation Trust,
Tower Hamlets

London,
England

Cotton, vinyl, wool, net,
fabric paint, buttons

1600 × 2100 mm
1.37 kg

✎ COMMISSION

This banner was created by women service users from the East London Foundation Trust in Tower Hamlets over a series of workshops led by artist Claudette Johnson.

The banner features 'And Still I Rise', the title of a poetry collection by poet and civil rights activist Maya Angelou, as well as words and values that are important to the women who designed the banner. It also features a portrait of the black British activist Olive Morris, a leading light in the feminist, black nationalist and squatters' rights campaigns of the 70s. The focus of the banner grew from the recurring themes which arose in the group's discussions: fairness, self-worth, being able to define oneself instead of being defined by others, freedom and hope.

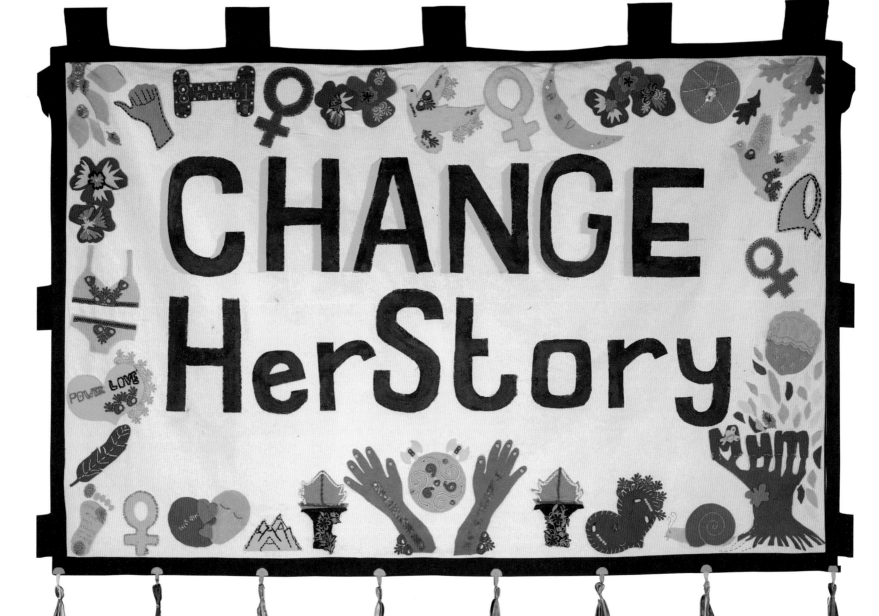

CARDBOARD CITIZENS

Artist
Natasha Cossey

Contributors
Gloria Farren,
Sasha Winslow, Anastasia
McGinlay, Chelsie Debohun,
Ann-Marie Regis, Bunty
Matthias, Kamby Kamara,
Anabel Claro

London,
England

Cotton, canvas, felt

1570 × 2060 mm (4 ×)
2 kg

Cardboard Citizens is a theatre company and charity, making life-changing theatre with people affected by homelessness. The banner was created by the company's female members, who have experience of homelessness, alongside artist Natasha Cossey. Inspired by the suffragettes, the group reflected on their experiences of solidarity, resistance and their heroines from whom they take strength. These stories are represented by the images and symbols on the banner. 'Change Her Story' pays homage to the strong women who have fought before us and is a provocation to consider what needs to change to improve opportunities for women now, and in the future.

THE DUKES

Artist
Victoria Frausin

Contributors
Dukes Theatre and
East Meets West

Lancaster,
England

Cotton, polyester,
mixed textiles

1365 × 2120 mm
1.1 kg

An international group of women from eighteen different countries joined together to design and sew while drawing strength, inspiration, encouragement and empowerment from each other. Through the calmness of this activity, we learnt the differences and deep similarities between us.

Inspired by the 1913 banner of the NUWSS, our banner is one of fresh hopes and renewed aspirations of women for our present and future.

It is part of three pieces, including a second banner with embroidered women, and sashes worn by the group on the PROCESSIONS march adorned in different languages with the place, country and year when (if) women won the right to vote around the world

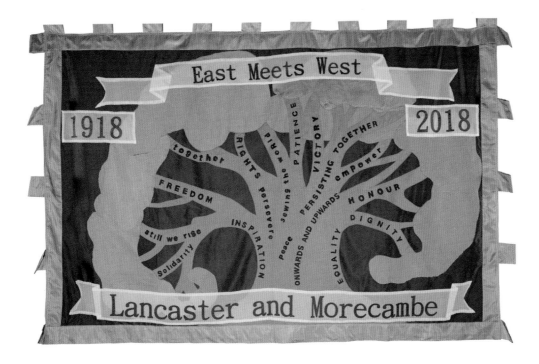

BRITISH CERAMICS BIENNIAL

Artists
Joanna Ayre, with
Rita Floyd, Jean Gleave,
Cathie Powell-Davies,
Charis Jones

Contributors
Burslem Jubilee
and volunteers

Stoke-on-Trent,
England

Bone china, mixed textiles

1080 × 480 mm (4 ×)
6 kg

Each button on this banner was made by hand from bone-china clay in Stoke-on-Trent, the centre for ceramics manufacture in the UK. Two highly skilled bone-china flower makers, who learned their trade working within the pottery industry, shared the process of making the intricate violet flowers and leaves. The makers could update them according to their own design. The buttons were made during workshops across Stoke-on-Trent, with women of all ages joining in to add their own individual pieces. In addition to making their own buttons, the Burslem Jubilee group sewed the banner and carried it with pride at PROCESSIONS in London.

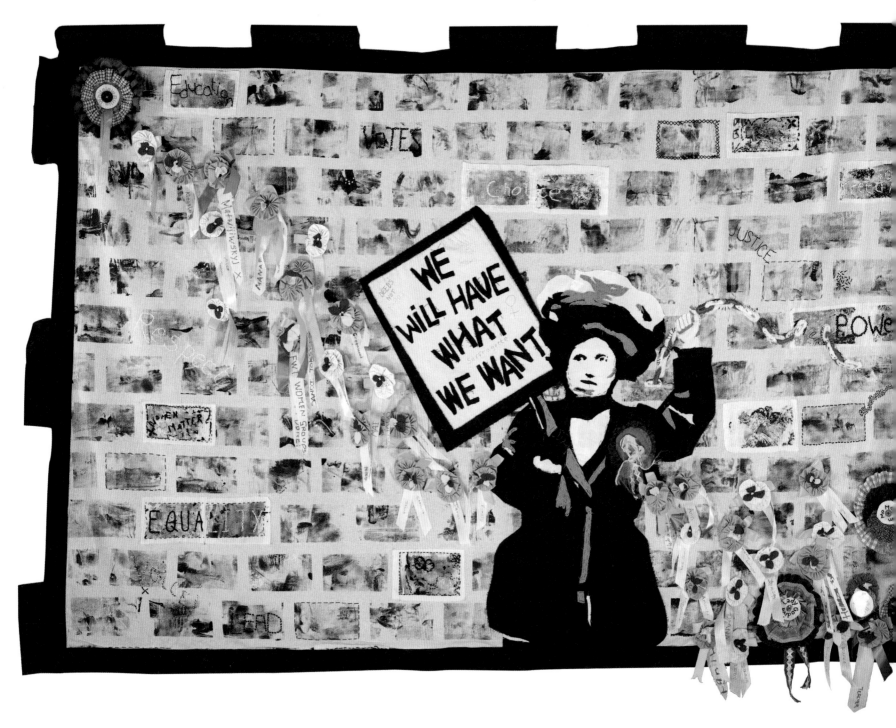

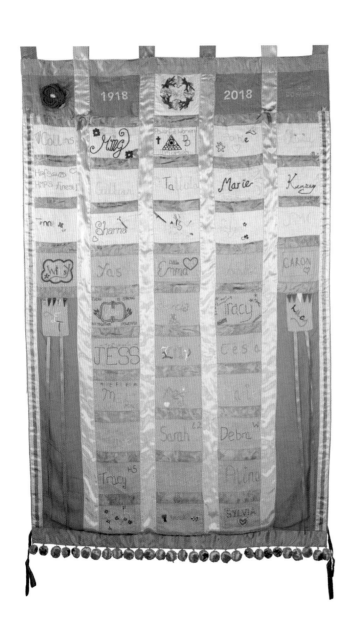

COVENTRY ARTSPACE PARTNERSHIPS

Artist
Anne Forgan

Contributors
Foleshill Women's Training
and the Weavers' Workshop

Coventry,
England

Mixed textiles

2220 × 1990 mm

1.7 kg

This banner celebrates the continuing solidarity of women in overcoming past, present and future struggles. The individual flowers represent the group – the tails of each one showing the name of a woman (heroine, sister, mother, friend) who has been a source of inspiration or support. While making the banner, the group shared the stories of why they were grateful to these amazing women and the difference they had made to their lives. Artist Anne Forgan designed and made the banner with the group, with the support of artist Karen Johnson.

HISTORIC ENGLAND

Artist
Lucy Orta

Contributors
Women from *Making for Change*, HMP Downview

London,
England

Linen, cotton, silk

2640 × 1350 mm

2.25 kg

This banner highlights the history of women's rights, witnessed and reflected in London's unique heritage. Historic England worked with the London College of Fashion, artist Lucy Orta, and women from the *Making for Change* programme at HMP Downview. The programme was founded in Holloway Prison, one of the most notorious sites associated with the suffrage movement in London. This banner engages with this incredible history, reflecting the perspective of the last remaining women connected to HMP Holloway, who are still denied the vote.

IMAGINEER

Artists
Julia O'Connell
and Julie Joannides

Contributors
From Moathouse Neighbour-
hood and Leisure Centre:
Carol Speed, Caroline Smith,
Janet Barrett, Jenni Gray,
Sylvia Hannah and Christine
Shankland; Women of
Willenhall: Jayne Foster,
Samantha Lees, Najna Yussup,
Phillipa Lewis and Joanne
Worwood; Imagineer
Productions' Monday Night
Makers Group: Dayah Sagoo,
Harjinder Sagoo, Raushani
Sagoo, Tina Batey, Spencer
Hassall, Daisy Chattha, Anne
Williamson, Ingrid Thornton,
Jane Bant, Spencer Hassall,
Beth Gibson, Jane Hytch

Coventry,
England

Cotton

1550 × 2100 mm
1.5 kg

This banner was created with three
groups of women in Willenhall,
Wood End and Radford. The women
voted for which words should be
put on the banner. They worked for
hours, both in the workshop sessions
and at home, to cross-stitch details
onto the borders, stitching for the
women they cared about in their
lives. The hummingbirds highlight the
beautiful story and message of the
bird — one of perseverance and
doing one's bit to make the world
a better place.

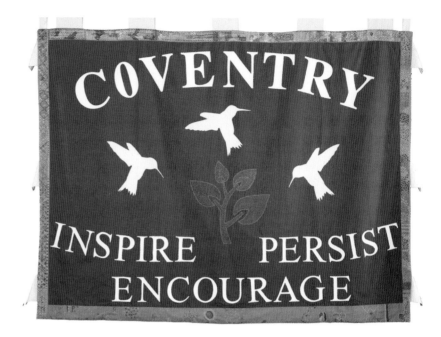

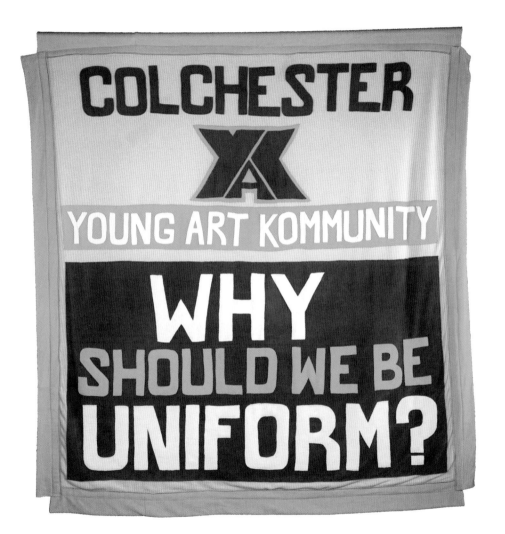

FIRSTSITE

Artist
Clare Marsh

Contributors
Firstsite's Young
Art Kommunity (YAK)

Colchester,
England

Fleece

2140 × 2110 mm
3.5 kg

Working with textile artist Clare Marsh, Firstsite's Young Art Kommunity (YAK) began with exploring the history of the suffragettes' struggle. YAK were particularly moved by the lengths suffragettes were prepared to go to in their fight against the outrageous inequalities women experienced.

The group discussed the importance of universal suffrage and the current struggles confronting their generation, with a focus on voting age, young women, clothing and the way individuality can be expressed. School uniform was a topic addressed at length, as was the dress code still expected of women within a business environment, exemplified by the incident in 2016 of a receptionist being sent home from work at a corporate finance company after refusing to wear high heels. After discussion of possible wording for the banner, the group decided to focus on the expression of individual voices as part of a universal message of solidarity. The result was: 'Why should we be uniform?' combined with sashes made and worn by individual participants expressing their own personal self-definitions.

'If you have come here to help me, you are wasting your time. But if you have come because your liberation is bound up with mine, then let us work together'

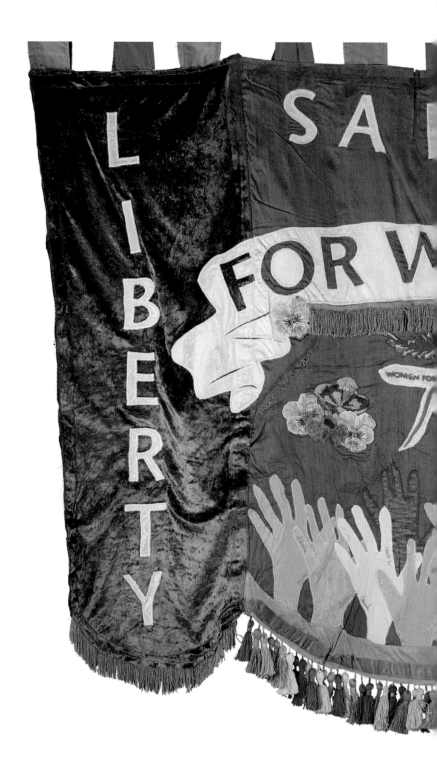

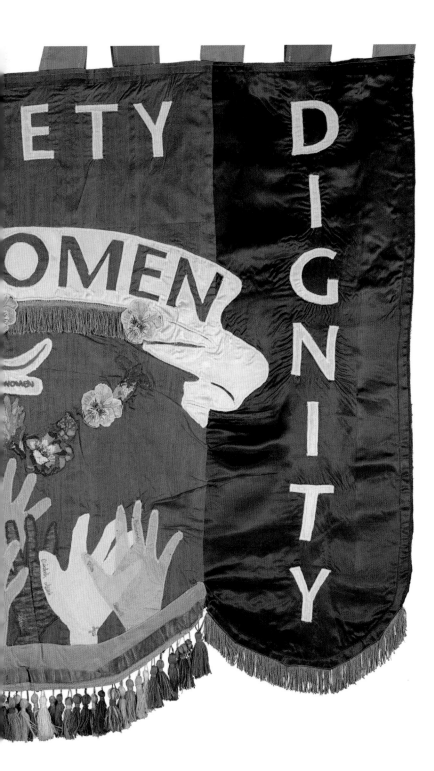

JESS DE WAHLS

Artist
Jess de Wahls

Contributors
Women for Refugee Women

London,
England

Mixed textiles

1150 × 1380 mm
0.83 kg

✖ COMMISSION

In the words of artist, activist and academic Lilla Watson: 'If you have come here to help me, you are wasting your time. But if you have come because your liberation is bound up with mine, then let us work together.'

In a series of workshops, Women for Refugee Women and textile artist Jess de Wahls came together to produce a banner stating, 'Liberty – Safety – Dignity – for Women', reflecting what must be achieved for all women. The banner depicts hand-embroidered national flowers of the participants as well as their handprints in fabric. It is made of entirely recycled materials.

WOMEN OF SHROPSHIRE

WE ARE HERE

DISABILITY ARTS IN SHROPSHIRE (DASH)

Artist
Anne-Marie Lagram

Contributors
Shropshire
Subversive Stitchers

Shrewsbury,
England

Felt, wool, embroidery silks,
beads, buttons

1650 × 2070 mm
2.22 kg

Led by artist Anne-Marie Lagram, the DASH workshops examined the history of suffrage and the original banners made by suffragettes in 1918. They researched inspiring women of Shropshire, and the names of these women can be seen embroidered onto the Shropshire Hills. The sun above the hills declares 'We Are Here' (as no one seems to know where Shropshire is!). Bordering the centre are designs inspired by historic pin badges and issues that women still face and campaign about today, prefaced by hashtags. The hands framing the banner show the solidarity the banner has created for women in Shropshire.

EASTGATE THEATRE

Artist
Deborah Campbell

Contributors
Local community groups, including the Guiding Association, Women's Institute, and Peebles High School art students

Peebles,
Scotland

Mixed textiles,
buttons, beads

1370 × 2160 mm
1.45 kg

For suffragettes, the bicycle became the method by which women had access to independent travel without chaperones. This gave them the freedom to come together in the fight for women's rights and the bicycle therefore became a symbol of the emancipation. Tweeddale is a haven for cycling and many women and girls are actively involved in the sport, so the bicycle was an obvious source of inspiration when creating the banner.

Participants each independently created a hand-embroidered leaf, which incorporates either their name, a word appropriate to the suffragette movement, or to today's continuing struggle for equal rights.

LOOK AGAIN FESTIVAL

Artist
Natalie Kerr

Contributors
Granite Guardian Gals

Aberdeen,
Scotland

Various textiles

1400 × 2400 mm
1.62 kg

This banner was inspired by a wonderful letter from the collections of Aberdeen Art Gallery and Museums. Addressed to pioneering journalist and Aberdeen suffragette Caroline Phillips, it details arrangements for a march in 1907 similar to PROCESSIONS, bringing women together from across Scotland to demonstrate for the vote.

The group states: 'We have explored what it means to be your own true self in society today. We hope to take up space, support each other, find strength in defiance and power in our friendships.'

RUTHIN CRAFT CENTRE

Artists
Lisa Carter and
Bethan Hughes

Contributors
Ruthin Craft Centre

Ruthin,
Wales

Calico, ribbon

1710 × 1150 mm
1.16 kg

'*Bleidlais*' is the Welsh word for vote. The '*lais*' in *bleidlais* also means 'voice'. '*Defnyddia dy Bleidlais*' / 'Use Your Vote (Voice)' underlines the relationship and importance of using both in achieving equality for all. The image has been designed to be a visual action, the hand-painted black lines on the calico referencing both the imprisonments of 1918 and the contemporary barriers to equality today. The distinctive suffragette colours in ribbon, breaking the bars, represent the continued need for a change in perceptions.

Ruthin and Ruthin Craft Centre have a longstanding relationship with quilting and textile artists. The banner pays homage to these skills and techniques.

'The hand-painted black lines reference both the imprisonments of 1918 and the barriers to equality today'

METAL CULTURE
PETERBOROUGH

Artists
Kate Genever
and Katie Smith

Contributors
Metal Culture Peterborough,
in partnership with Huntingdon
and Peterborough Women's
Institute, Soroptimist
International, Iqra Academy,
HMP Peterborough, Coffee
Morning Sisters, Embroiderers'
Guild and the general public

Peterborough,
England

Silk, felt, wool,
cotton, buttons

2120 × 1160 mm
2.4 kg

The banners' central statements, 'We Will Not be Still' and 'We Have the Courage', are drawn from longer letters written by the group to the suffragettes. Two of these letters can be seen embroidered directly onto the purple blankets. The pansies were made by women from across Peterborough, some of whom could not attend the group's weekly sessions but wanted to contribute by making something at home. Everyone involved stitched their signature onto the reverse of the large banners and created personalised pennants which were carried as part of PROCESSIONS in London on Sunday 10 June.

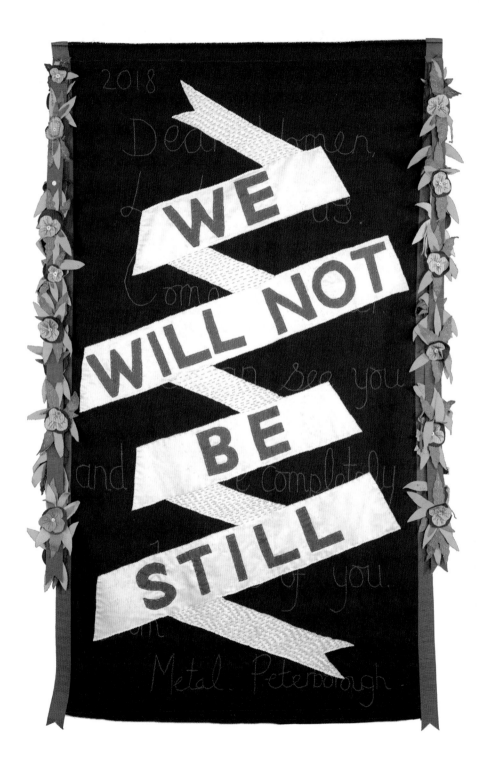

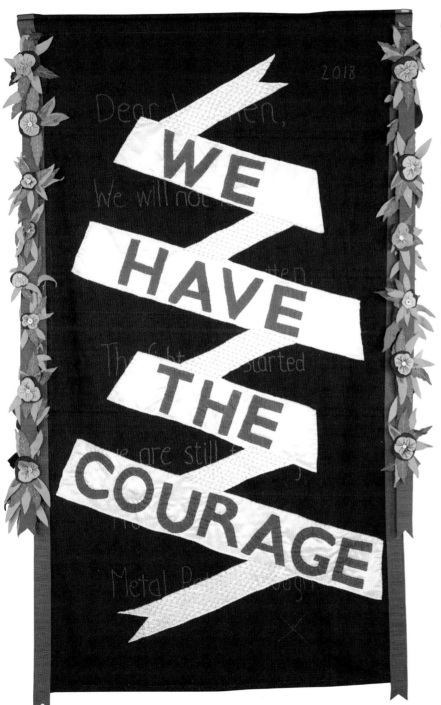

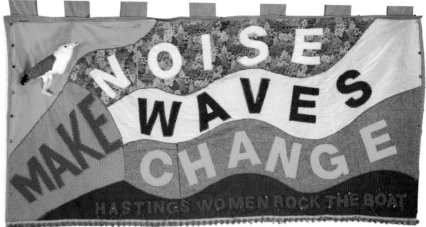

JERWOOD GALLERY

Artist
Janey Moffat

Contributors
Jerwood
PROCESSIONS group

Hastings,
England

Cotton, polycotton, denim,
felt, safety pins, studs, chain,
wool, yarn

1065 × 1930 mm
1.6 kg

The Hastings women in the group wished to capture the positive yet gently rebellious spirit that embodies their town, with a nod to its sunny seaside location and history of punks and bohemian eccentrics. The banner is a call to female change-makers across generations living in Hastings. It asks them to stand up and free their voices in an unafraid bid to evolve equality for women, particularly for those who are oppressed and unable to speak for themselves. The seagull is named Muriel after Ms Matters, the famous hot-air ballooning, daredevil suffragist who lived in Hastings.

'Vivienne Westwood created this banner for PROCESSIONS to celebrate 100 years of votes for women, and to highlight the global effort still needed for women's and human rights'

VIVIENNE WESTWOOD

Artist
Vivienne Westwood

London,
England

Mixed textiles, paint

2100 x 1300 mm
1.4 kg

COMMISSION

British designer and activist Dame Vivienne Westwood rose to fame in the late 1970s, with her anarchic designs shaping the look of the punk movement. Today, she's known as one of the most unconventional and outspoken designers in the world.

She created this banner for PROCESSIONS to celebrate 100 years of votes for women, and to highlight the global effort still needed for women's and human rights.

The banner highlights the need for the Catholic Church to reconsider their views on contraception in support of women's rights and global evolution.

The banner was created in Westwood's London design studio, made from offcuts of fabric and hand-painted graphics.

MODERN ART OXFORD

Artist
Nicola Donovan

Contributors
Group of local textile artists

Oxford,
England

Cotton, silk, photo transfer,
gold leaf, sequin chainmail

2045 × 1290 mm

2 kg

Modern Art Oxford is thrilled to have been involved in PROCESSIONS. They worked with a group of local textiles artists to create a single banner representing women, their rights and their hopes for the future.

As Nicola Donovan says, 'Our message is that the right to vote is hard won, and that it gives all of us some power, if we use it. If we feel powerless, there is even more reason to use it, because nothing will change unless we do.'

PERTH THEATRE /
HORSECROSS ARTS

Artists
Pester & Rossi and the
women of Perth

Contributors
Perth Theatre volunteers

Perth,
Scotland

Mixed textiles

2020 × 2100 mm
1.8 kg

This banner was inspired by an original suffrage banner created by Perth Suffrage Society, which included the double-headed eagle from the Perth City crest.

The wings of the bird have become a collage of fabric hands creating the background, with two women sitting at the top, and a large brain in the middle representing strong female minds. The banner uses the traditional suffragette colours: green, representing hope and the emblem of spring; white for purity in private and public life; and violet, representing the instinct of freedom and dignity. The group collated words and phrases that united the hopes and concerns they share as women and girls today.

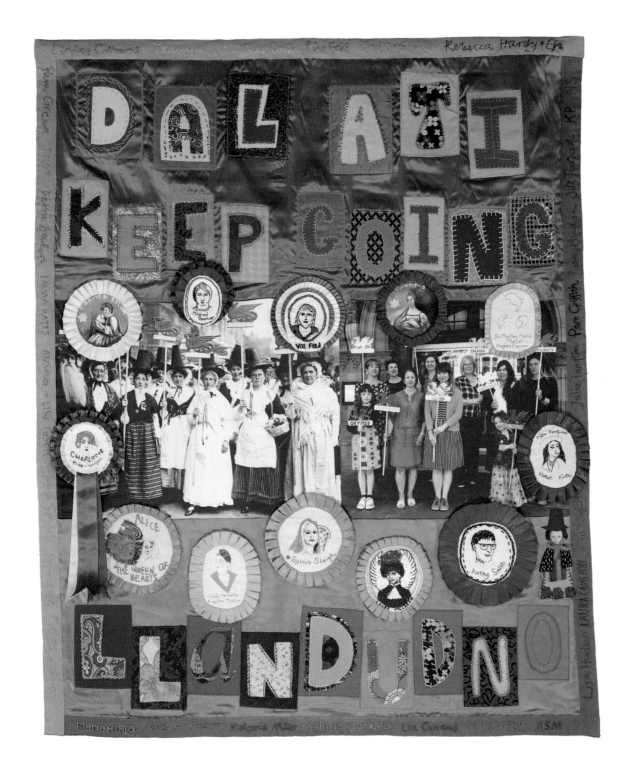

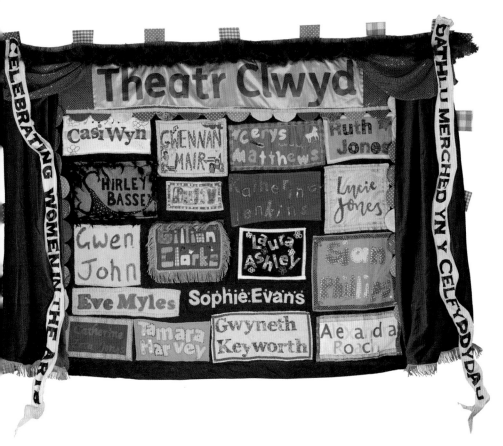

MOSTYN

Artist
Melanie Miller

Contributors
Mostyn Art Gallery
and Culture Action
Llandudno (CALL)
workshop participants

Llandudno,
Wales

Mixed textiles

1280 × 1060 mm
0.95 kg

The banner was made by a group of twenty-four women and girls aged from seven to their mid-seventies, over three day-long sessions. The banner includes an archive image from the Museum of London, of Welsh participants in the 1911 Coronation Procession. The image has been recreated outside Mostyn Gallery and features some of the workshop participants.

The banner also features stitched portraits of notable women from North Wales. Some of these were inspired by CALL artist Lindsey Colbourne's 'Llandudno through the stories of women' project: mapllandudno.org/hanes-llanddynes. Others, selected by the group, include local suffragists Charlotte Price-White, Mildred Spencer and Laura McLaren, and the late Val Feld, Labour politician and equalities campaigner. Feld's sister stitched the portrait.

THEATR CLWYD

Artist
Ticky Lowe

Contributors
Portfolio, Company 25,
Company 55,
and the theatre's
PROCESSIONS group

Mold,
Wales

Mixed textiles

1450 × 2135 mm
3.3 kg

Theatr Clwyd collaborated with visual artist Ticky Lowe to develop a concept for their banner to commemorate 100 years since women were able to vote. They decided to have 'Celebrating Welsh Women in the Arts' as their theme, and the participants decided which women were represented.

The group didn't hold back when designing their banner and were keen to make it as elaborate and flamboyant as they could, using as many sewing techniques as possible. It was important to use colourful fabrics and also to emphasise the suffragette colours.

139

PROJECT ABILITY

Artist
Sandi Kiehlmann

Contributors
Attendees and support staff
of Project Ability's studio for
people with mental ill health
and learning disabilities

Glasgow,
Scotland

Mixed textiles

1950 × 1280 mm
1.38 kg

Project Ability has a strong visual
identity and the group decided
to employ this as the main design
feature. The visual is a graphic
representation of the singer Madonna.
Project Ability represents community
and creativity, friendship and
wellbeing. These themes were at
the forefront of the design. The
group decided to use felt as it is easy
to manipulate and would provide
solid colour. The women taking part
represent a broad community
of interests; they wanted to
demonstrate unity and advocacy
for creative expression.

NATIONAL MUSEUMS NORTHERN IRELAND

Artist
Ursula Burke

Contributors
Women in Stitches,
Shankill Women's Centre

Holywood,
Northern Ireland

Mixed textiles,
cotton, linen, silk

1150 × 1300 mm
1.17 kg

Women in Stitches is a cross-
community group of women from
north and west Belfast who are part
of a Good Relations peacebuilding
programme run by Shankill Women's
Centre. The main panel is executed
in appliqué and embroidery, and was
inspired by National Museums NI's
rich textile collections. The symbol of
the hummingbird, which is the group's
identifying image, is used throughout
the banner.

 The design is ripe with symbolism.
On either side of the banner is
a row of embroidered panels. Each
panel was hand embroidered by the
women in the group, and depicts
a rose in various stages of bloom,
reflecting the evolution of the
women's movement.

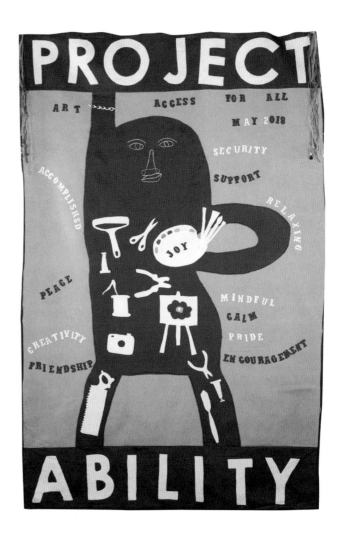

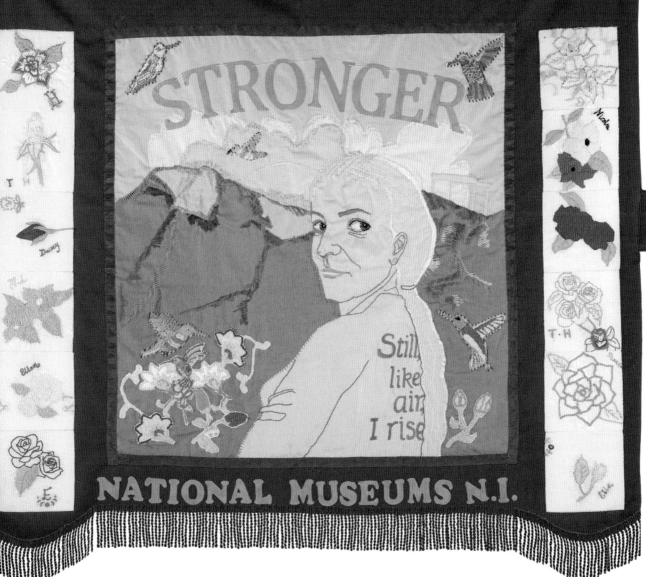

PRISM ARTS

Artists
Helen Walsh, with the
support of Katie Lock

Contributors
Gail Baskett, Margaret
Braidford, Marilyn Brown,
Leah Cameron, Betty
Campbell, Janette Fisher,
Rebecca Hamilton, Cheryl
Hickman, Catherine Lacey,
Amber Maxfield,
Vicki Maxfield, Ali McCaw,
Alison McKee, Geraldine
Murray-Bowman, Kat Prior,
Barbara Renel, Oona
Roberts, Marion Smith

Carlisle,
England

Chenille, cotton,
velvet, cord, organza

2440 × 1610 mm
2.3 kg

The group wanted to create
a banner that represented them
now, while also expressing their
hopes for the future and recognising
where they have come from. The
design incorporates a heart-shaped
pendulum which has settled in the
centre and is entwined with the word
'Respect'. The arc of the pendulum
is described in running stitch and
represents how the balance of power
swings back and forth. By showing
the pendulum in the centre, the group
aimed to show how, by respecting
each other's views and rights,
a point of equality can be reached.

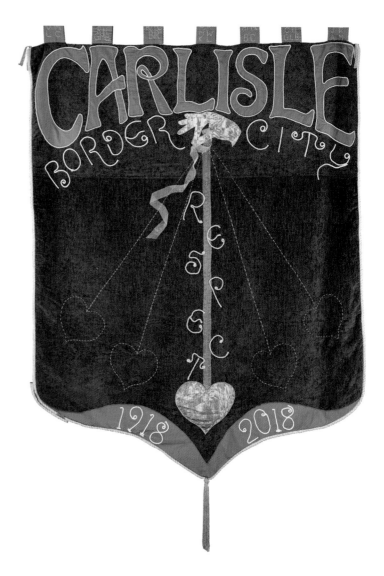

142

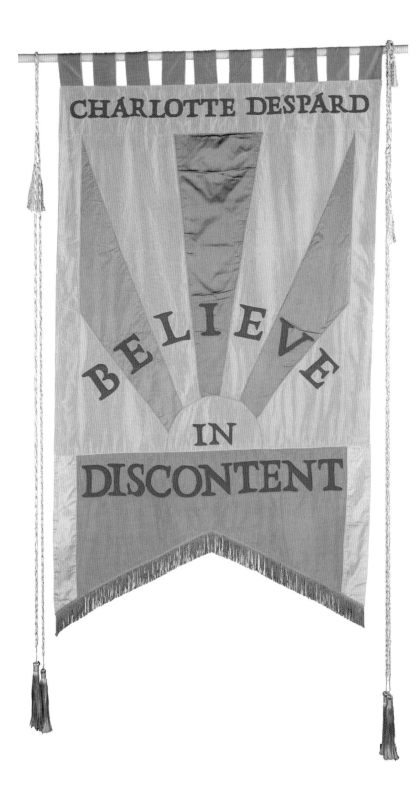

NINE ELMS VAUXHALL PARTNERSHIP (WANDSWORTH BOROUGH COUNCIL)

Artist
Ruth Ewan

Contributors
Devon Ingold, Katherine Hallgarten, Katy Holmes, Vanessa Matthews, Erenie Mullens-Burgess, Maritza Tschepp, Jo Tsagka and Amanda Waite, supported by Jenny Pengilly and Rosie Hermon; final banner fabricated by Laura Lees

London,
England

Silk, mixed textiles

2270 × 1310 mm
1.67 kg

This banner is a tribute to the incredible life and work of suffragist, social activist and co-founder of the Women's Freedom League, Charlotte Despard. In the second half of her life Mrs Despard moved to Nine Elms on the south bank of the River Thames in central London, a very deprived area in the late nineteenth century. Mrs Despard worked tirelessly to improve conditions for local people by setting up free healthcare services and social clubs and becoming a Poor Law guardian. She continued to fight for the poor and dispossessed for nearly fifty years, right up until her death in 1939, aged ninety-five.

JUSTICE FOR WOM

WITHOUT FEAR

LABOUR

Truth

AFFECTION

ROKSANDA

Artist
Roksanda

Contributors
Made with the women who
live, work and are inspired
by the Old Bailey

London,
England

Mixed textiles

1470 x 1540 mm
1.67 kg

✕ COMMISSION

In 1912 and 1913, Emily Davison and Emmeline Pankhurst stood in the dock in Court 1 of the Central Criminal Court – known as the Old Bailey – and declared to the world what they were doing and why.

The modern women of the Bailey (from judges to witness support) worked with Roksanda to create our 'Justice For Women' PROCESSIONS banner, as relevant today as it was 100 years ago.

The imagery is of Lady Justice (who stands above the Old Bailey dome), with the words 'Without Fear or Favour, Affection or Ill Will' representing the judicial oath. The figures 'Labour', 'Learning', 'Truth' and 'Art' decorate the inside of the dome of the Grand Hall at the Old Bailey, and gold is used to reflect a bright future for women. Ribbons reach down to lift a new generation of strong women up through the Central Criminal Court.

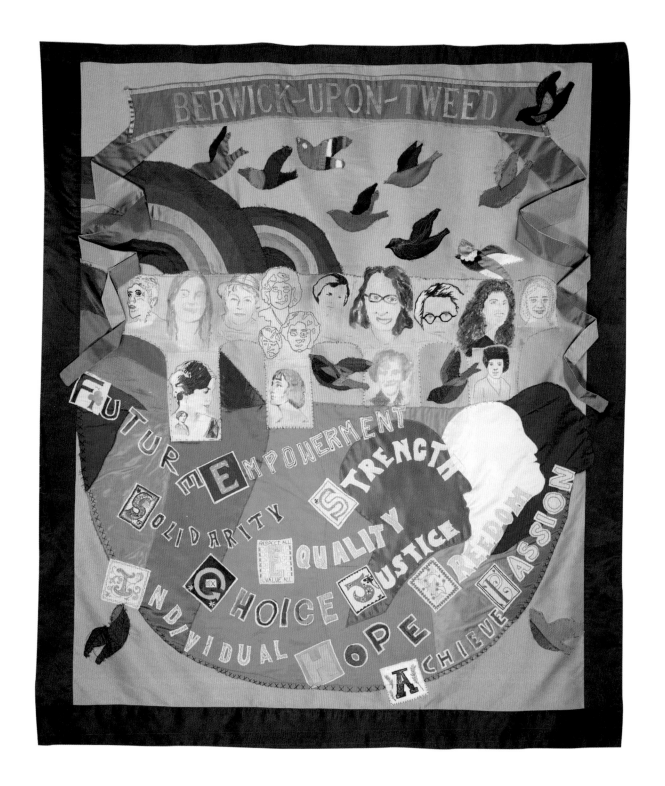

'Each our own, together
we stand, loud and proud,
hand in hand'

BERWICK VISUAL ARTS

Artist
Emma Shankland

Contributors
Tessa Archbold, Caron Astley,
Andrea Butler, Nicola Coulter,
Rosemary Everett, Eleanor
Gilchrist, Moira Kay, Rose Kay,
Josie McChrystal, Teresa
Newham, Genni Poole,
Emma Wheatley

Berwick-upon-Tweed,
England

Mixed textiles

1910 × 1590 mm
1.53 kg

The setting for this silk banner is
Berwick-upon-Tweed's Royal Border
Bridge. It is built anew with women's
faces, past and present. Framing them
are embroidered birds of freedom
and words of empowerment, while
a rainbow of diversity and hope
arcs in the background. Everyone
involved in the creation of this
banner explored new mediums,
materials and traditional styles
to create this huge labour of love,
friendship and discovery.

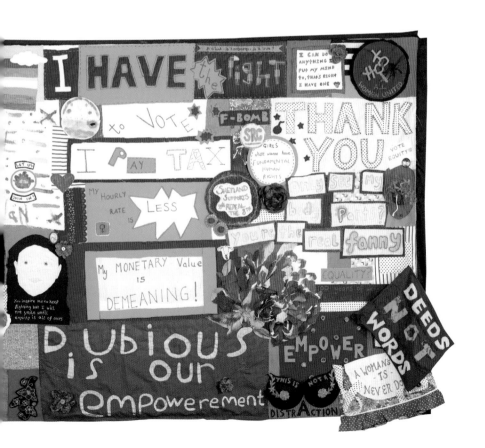

SHETLAND ARTS DEVELOPMENT AGENCY

Artist
Christina Inkster

Contributors
The women of Shetland

Shetland,
Scotland

Mixed textiles
and appliqué

1500 × 2200 mm
2.6 kg

'We are the women of Shetland.
This is our banner.
Our banner is our community;
our community of women;
each our own, together we stand,
loud and proud, hand in hand.
Hear us roar, from the shore.
Prejudice? A total bore!
We are here, furthermore,
equity, we adore!
Let us join in great galore,
may valour be for evermore.'

NATIONAL THEATRE OF SCOTLAND

Artist
Ana Inés Jabares-Pita

Contributors
Ms, Miss, Mrs

Glasgow,
Scotland

Felt, cotton

1400 × 1030 mm
2.24 kg

This banner represents laundry! Doing the washing! Traditional women's work!

It is made up of a variety of clothing — women's, men's and children's — representing the whole household.

The group was inspired by the film *Suffragette*, which they watched together. They laughed, cried and shouted at the screen together, and learned that women passed messages to each other through the laundry service to arrange meetings, rallies, share news and recruit. The group wants equality — equal rights for all women, equal pay, equal recognition and equal representation. It has been 100 years and the message of the banner is that women are still doing more than our share of the washing!

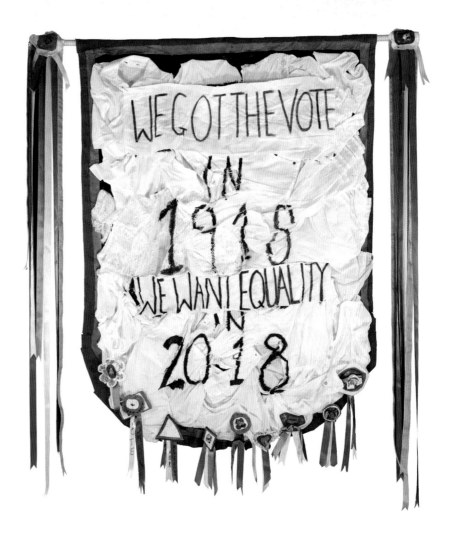

GEMARTS

Artist
Michelle Wood

Contributors
GemArts and GVEMSG
Feel Good Group

Gateshead,
England

Mixed fabrics, sari silk, buttons, beads, digital print, lino print, fabric paint

1150 × 1340 mm
0.8 kg

The group created their banner to show reflections of the past and hope for a better future. A central lotus flower, representing harmony and equality, is framed by 100 hand-made flowers celebrating 100 years since the first women got the right to vote. Within the lotus leaves, the word 'vote' is embroidered in the different languages spoken within the group.

Symbolising the diverse voices of the suffragette movement, an image of Princess Sophia Duleep Singh, an accredited physician who pioneered the cause of women's rights in Britain, is featured. For the group, the right to vote means 'change, freedom and respect'.

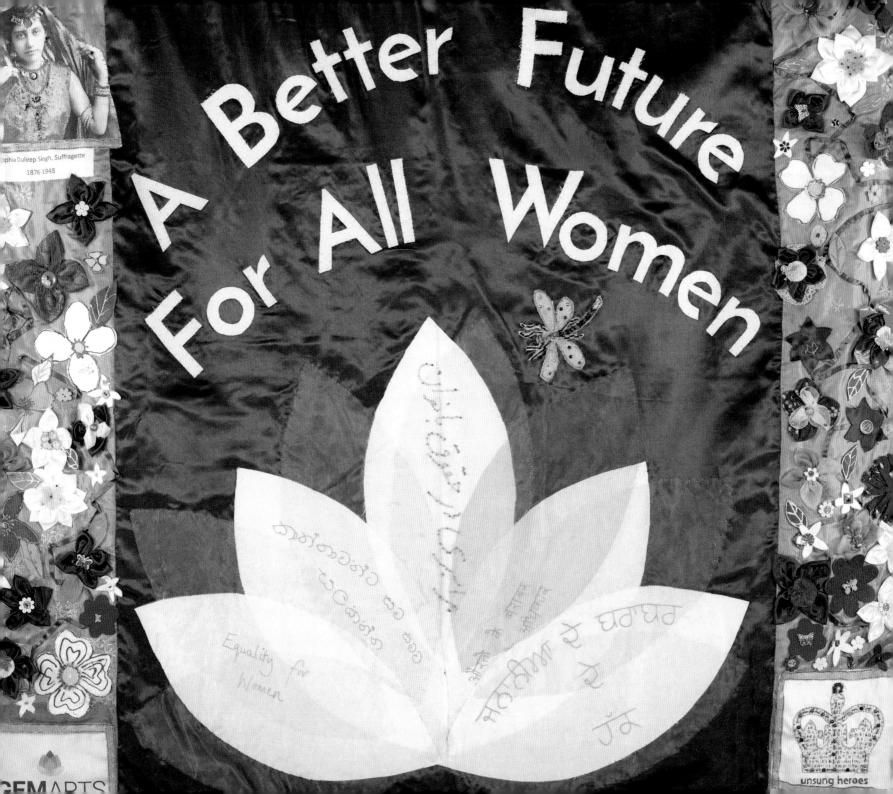

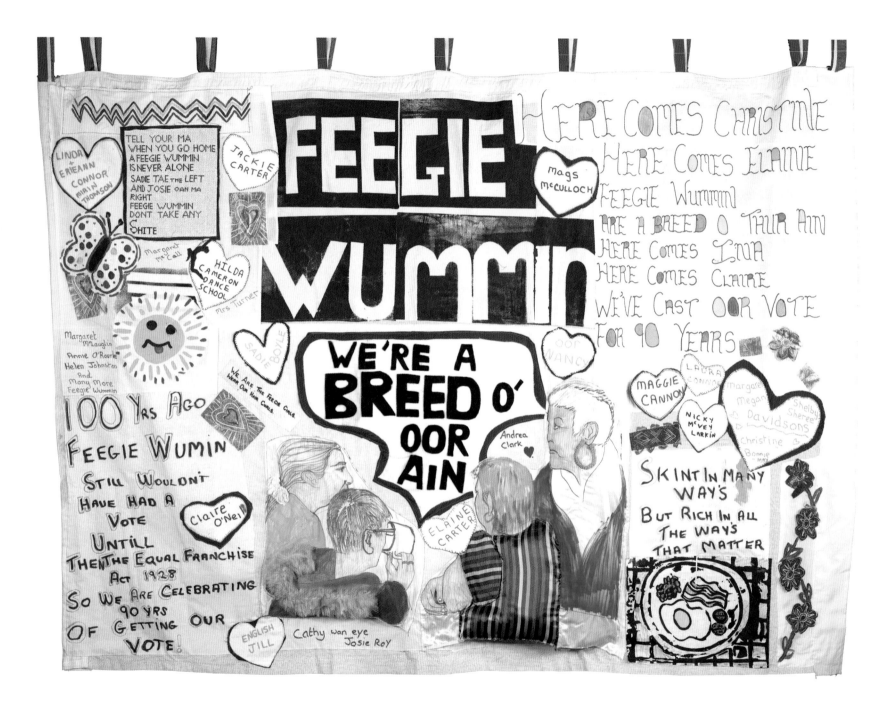

'The banner survived
a house fire, phoenix-like,
and was partly remade
after the procession'

TANNAHILL CENTRE

Artist
Mandy Macintosh

Contributors
The Feegie Needlers and
SWIFT (Strong Women In
Ferguslie Together), a closed
group for younger women
in Ferguslie, many with very
young children

Paisley,
Scotland

Mixed textiles

1600 × 2300 mm
2.24 kg

The Feegie Wummin banner pictures
women meeting at the Tannahill
Centre in the act of discussing the
history of women's suffrage, including
issues of class. The work was made
during weeks of dialogue and stitching
using painting, quilting embroidery
and appliqué on canvas. The banner
survived a house fire, phoenix-like,
and was partly remade after the
procession. Among some of the
strongest and most resourceful women
I have ever encountered; consider
the consciousness raised, and it's only
going to go higher. 'Here comes Josie,
here comes Claire, we've cast oor
vote fur 90 years.'

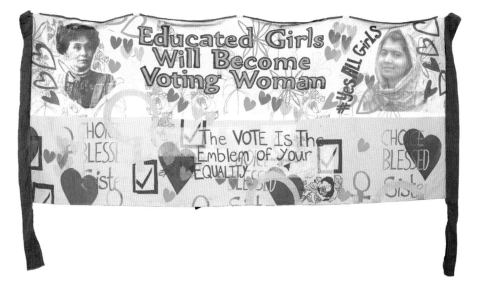

R-SPACE GALLERY

Artist
Lucy Turner

Contributors
R-Space Gallery

Lisburn,
Northern Ireland

Mixed textiles

1900 × 2600 mm
1.12 kg

The group started working on the
process of screen-printing on Irish
linen. They had never experienced
this process, so with hand-cut stencils
they worked on the purple stripe,
playing with colour shapes such as
hearts, flowers and stars. The banner
is intended to represent the 'girl child'
and the 'voting woman'. Nobel Peace
Prize winner Malala is a worthy
contemporary figure to represent
girls and young women today.
Emmeline Pankhurst represents the
voting woman. The banner is layered
with colour and symbols, including
roses and jasmine, the national
flowers of England and Pakistan.

CLEAN BREAK

Artist
Miriam Nabarro

Contributors
Clean Break

London,
England

Mixed textiles

1400 × 2370 mm
2.98 kg

This banner grew from a series of collaborative workshops centred around votes, voice, women and those who are excluded from voting. The group did extensive research and discovered a 1918 slogan, 'Voteless Not Voiceless', which they decided to reuse. They found a piece of 100-year-old linen and dyed it in the colours of the suffragette movement. They then borrowed gestures which the group had created in a theatre exercise about power. As Clean Break works with women with lived experience of the criminal justice system, and as prisoners in the UK are denied the vote, the group felt that there was still a lot to shout about.

'They found a piece
of 100-year-old linen and
dyed it in the colours of
the suffragette movement'

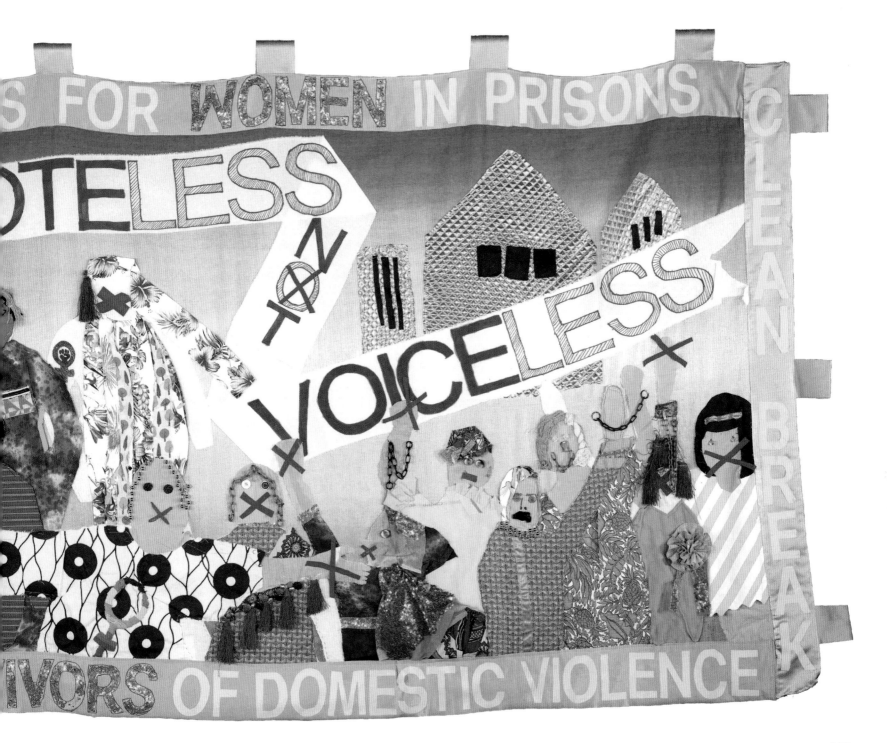

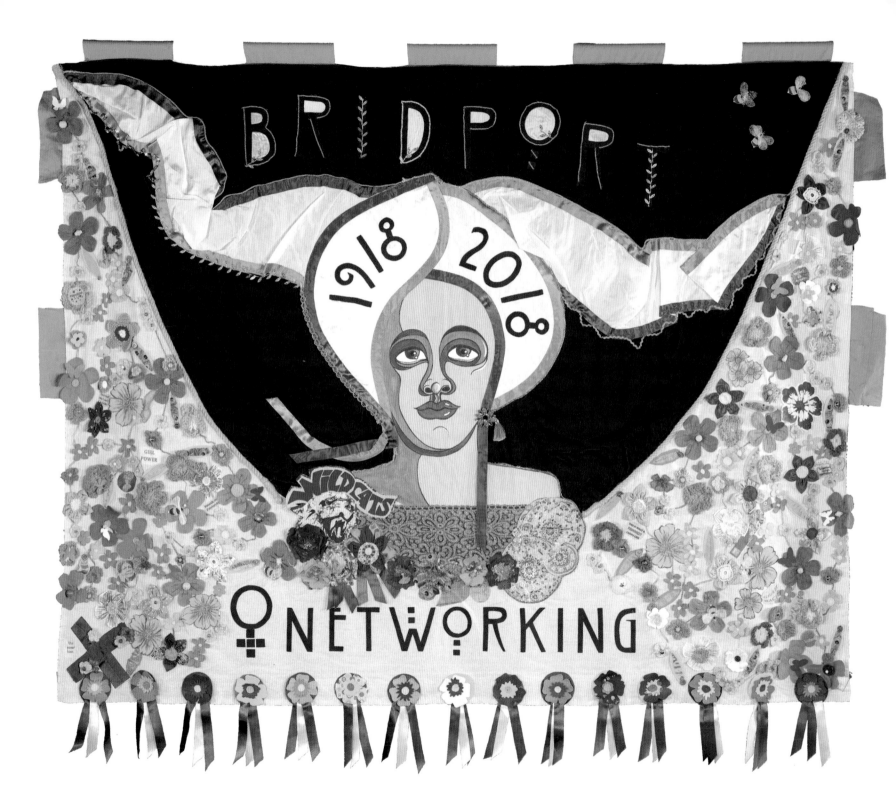

We were all wearing white, as our suffragette sisters had in the 1913 march for Emily Davison's funeral, so it was easy to spot our group from Bridport as we gathered together in Trafalgar Square. The banner still wrapped up and the poles a liability, we made our way down the Mall to the beginning of the march. One of us was in a wheelchair so the bumpy pavement was soon abandoned for the road itself; we felt we owned London and just waved cheerfully at the taxis that beeped and cyclists ringing their bells at us!

Nothing had prepared us for the thrill of the mass of women at the start of the march. Women everywhere; unfurling banners, crying out in excitement as the banners declared the town, city, village, group that had made them. Newcastle, Birmingham, Furzedown, each proudly declared where they came from and included powerful statements of solidarity. 'Smash the Patriarchy' was a favourite, as was 'Courage Calls to Courage'. Our banner reflected the work of women in Bridport – 'Networking' – and had tri-colour, purple, green and white fishing nets extending from the top of each pole.

The march curled on through St James's, down Pall Mall and Whitehall, and suddenly there were my two younger sisters, marching with their London friends. Such hugs, such cries of sisterly delight, how they loved our banner and how we loved theirs . . .

The road filled up behind us for photos of the ribbon of purple, white and green stretching from Trafalgar Square to the Houses of Parliament, an image that captured our feelings of pride and determination to carry on the fight for proper equality and freedom. '*March, march, many as one. Shoulder to shoulder and friend to friend!*'

Margie Barbour,
PROCESSIONS participant

BRIDPORT ARTS CENTRE

Artist
Rosemary Edwards

Contributors
BridFem

Bridport,
England

Mixed textiles, beads

1730 × 2130 mm
2.78 kg

This banner celebrates women past, present and future through the power of women networking and working together. Based on previous struggles of women in the net-making industry in Bridport, including the Wildcats of 1912 who were the first women to strike and win. Arbitrated by Ada Newton, they kept their pay and became the first women to be unionised in the area.

The central figure is inspired by the painting The Spirit of Bridport. She is surrounded by flax flowers and made by the community to represent their interconnectedness and strength in numbers to get things done, in the spirit of 'deeds not words'.

TAIGH CHEARSABHAGH TRUST

Artists
Deidre Nelson, assisted by Kirsty O'Connor

Contributors
Anna Black, Rosie Blake, Margaret Cowie, Stephanie Cumming, Margaret Fenton, Mary Harman, Barbara Hunter, Marnie Keltie, Cathie Laing, Vanessa Langley, Natasha Natarajan, Deirdre Nelson, Kirsty MacLeod, Mary McCormick, Anne MacKenzie, Anne Monk, Mairi Morrison, Kirsty O'Connor, Margaret Paterson, Anne Rabbitts, Gail Spears, Kirsty Walker, Amanda Woods, Amanda Wyvill, Cally Yeatman

North Uist,
Scotland

Cotton, Harris tweed, silk

1550 × 2200 mm
1.26 kg

The slogan, 'Spiorad Boireannaich Uibhist An-dè, An-diugh 's A-màireach' ('Spirit of Uist Women Past, Present and Future'), celebrates the strong spirit of the women of Uist, rooted in Gaelic culture and the beautiful islands themselves. Inspired by the suffragette's handkerchief from Holloway prison, signatures of ordinary yet extraordinary Uist women were gathered and embroidered onto the banner.

Names will be added, including notable women of the past, to attached streamers as an ongoing process. Hand-stitching together connected participants with their forebears and forged new friendships in the present. The group's hope is that young women will continue to be inspired in creating the Uist community of the future.

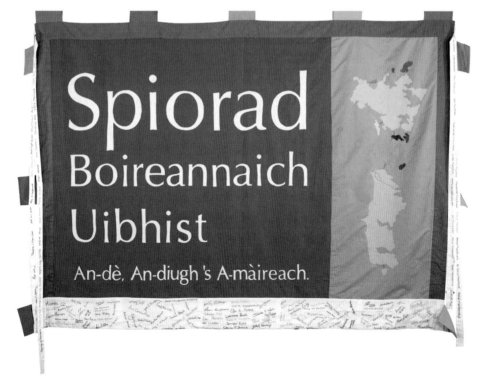

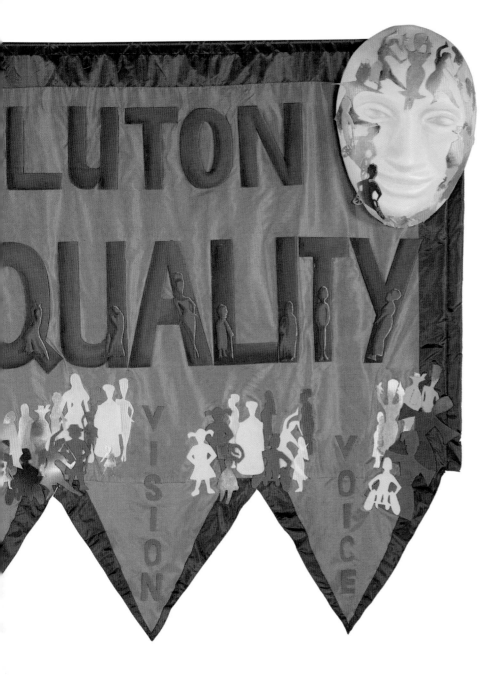

UK CENTRE FOR CARNIVAL ARTS

Artist
Clary Salandy

Contributors
Contributing groups included:
The UK Centre For Carnival
Arts, Luton Association of
Mas, Attendees to the Luton
'Women Like Me' Conference

Individual contributors:
Janet Skepple,
Margaret Mathews,
Amara Lee Thompson,
Klaudia Kulakiewicz,
Anastazja Engel-Kozak,
Maureen Scarlett, Durrelle
KuKu, Sylvia Thomas,
Dr Nazia Khanum OBE DL,
Maureen Drummond, Sue
Beaumont, Laxmi Kanbi,
Kate Birrell, Michelle Lewis,
Clary Salandy, Patricia
Forbes, Annmarie Williams

Luton,
England

Silk, foam, paint, velcro

2100 × 3030 mm
2.88 kg

This banner is an expression of
equality and diversity, values which
the group want to convey that the
people of Luton strive to uphold.

Two faces of different colours
are equally placed on either side of
the word 'Luton'. They are in the
colours of the suffragette movement
and decorated with the figures of
people, representing Luton's diversity.

The word 'equality' is underpinned
by a crowd of colourful women,
who advocate for 'three Vs': 'To be
valued, to be visionary, and to
use their voices for positive change'.
Carnival Arts artists and the
community worked together to bring
this message to life in the banner.

MADE IN CORBY

Artists
The Eloquent Fold
(Carole Miles and
Phiona Richards)

Contributors
Made in Corby

Corby,
England

Polyester, cotton, silk, velvet,
gold lamé, buttons, brocade,
mixed fibres

1330 × 1920 mm
2.04 kg

This banner celebrates the individual and collective strength, grace and intelligence of women, especially the women of Corby. The violets were chosen as a symbol of growth, hope and inspiration. Together, the group became a 'creative voice' for women of all ages and backgrounds by sharing their past and present, as well as their hopes and aspirations for the future. 'Deeds Not Words' is also the town motto of Corby, so it was important to the group that it was included, especially given its connection to the suffragette movement.

'«Deeds Not Words» is also the town motto of Corby, so it was important to the group that it was included, especially given its connection to the suffragette movement'

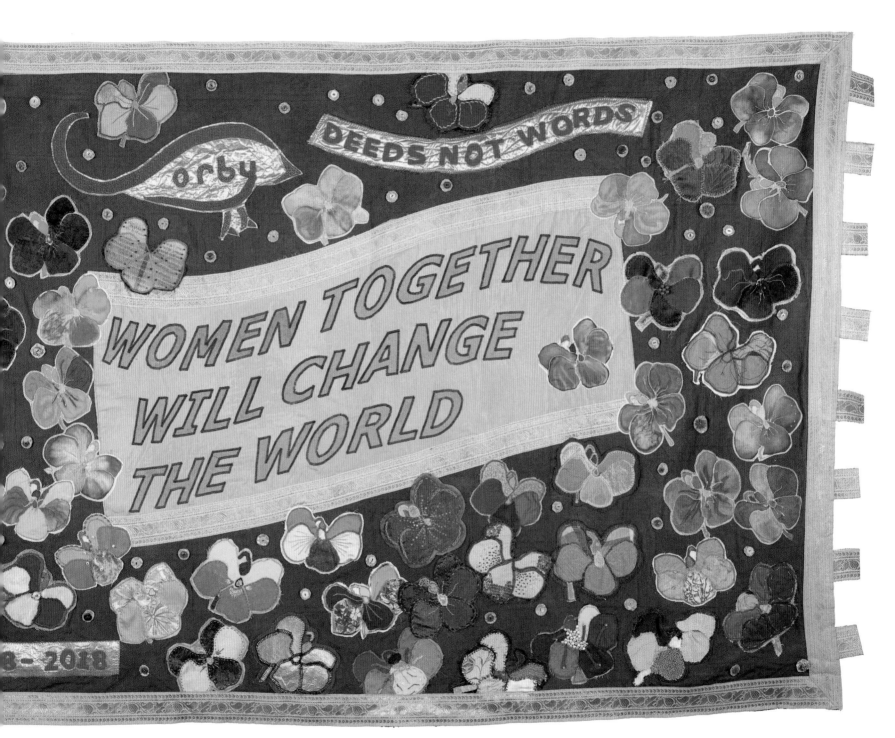

METAL CULTURE SOUTHEND-ON-SEA: 'YES WE CAN!'

Artist
Heidi Wigmore

Contributors
Heidi Wigmore
Essex Girls Liberation
Front and members
of the public aged 13–75

Southend-on-Sea,
England

Vinyl, cotton, wool,
net, buttons

1355 × 1950 mm
2.5 kg

The 'Yes We Can!' banner celebrates the girls' multiple identities and 'creative selves'. It is an assertive, self-assured response to the pressure they all feel from social media to be 'perfect'. Together, they created the slogan, which is a positive rallying cry to girls everywhere.

The aesthetic of the banner is a subversion of the ubiquitous 'selfie' and includes fantasy figures composed of expressive 'knowing' self-portraits with collaged bodies. These figures express freedom and creativity, flying free against a blue-sky backdrop. The digitally printed design is finished with metallic holographic vinyl and celebratory handmade pompoms for maximum effect and fun.

METAL CULTURE SOUTHEND-ON-SEA: 'WOMEN OF ESSEX'

Artist
Heidi Wigmore

Contributors
Heidi Wigmore Girls aged
11–14 from the Deanes
School, Thundersley

Southend-on-Sea,
England

Vinyl, cotton, wool,
net, buttons

1242 × 1950 mm
2 kg

This 'Women of Essex' banner celebrates suffragettes who had Essex connections, women from the Clever Essex project who achieved great things in literature, science, theatre and politics in the wider world, and contemporary women active in the Essex Girls Liberation Front, who exist to challenge the negative connotations around the 'Essex Girl' stereotype. The quote came from Essex suffragette Amy Hicks, at a rally in Colchester in 1908, who said that campaigners for women's suffrage were 'neither freaks nor frumps!'

The digitally printed collage aesthetic is appropriated from the iconic Beatles Sgt. Pepper album cover, while the handmade and embroidered flowers honour the memory of the women who 'Dared to be Free'.

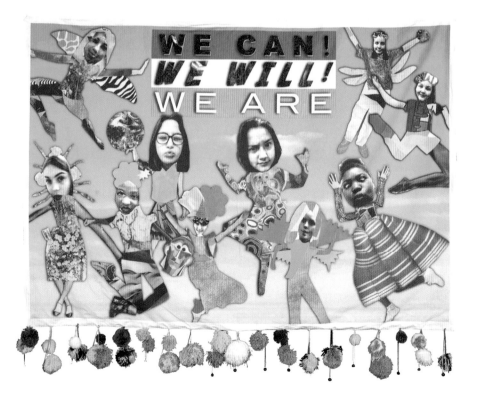

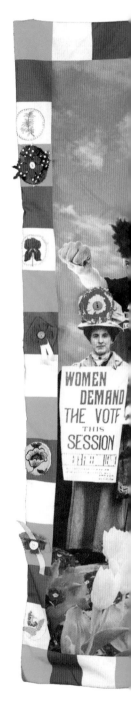

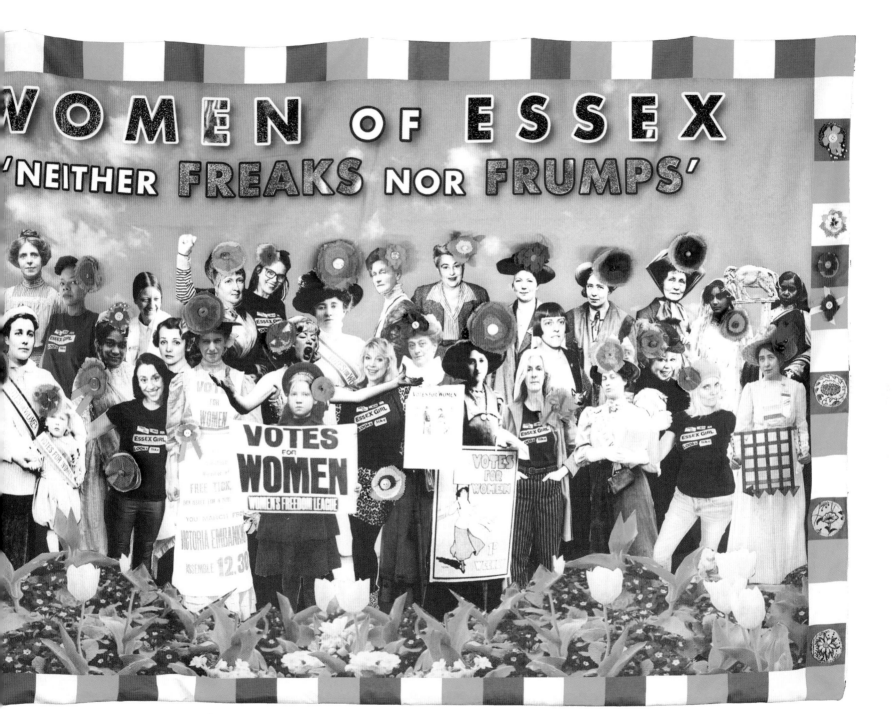

WOC ACTIVISTS
WE HONOUR YOU

ALTHEIA JONES-LECOINTE
BEVERLEY BRYAN
CLAUDIA JONES
CONNIE MACK
DIANE ABBOT
ELIZABETH OBI
FREEDOM OF...
GAIL LEWIS
KATHLEEN WRASAMA
LAWRENCE
LEILA HASSAN HOWE
LOLITA ROY
OLIVE MORRIS
POWER&PEACE
SARAH PARKER REMOND
LEEP SINGH
STELLA DADZIE
ALTHEIA JONES-LECOINTE
BEVERLEY BRYAN
CLAUDIA JONES
CONNIE MACK
DIANE ABBOT
DOREEN LAWRENCE
ELIZABETH OBI
FREEDOM OF...

HEATHER AGYEPONG

Artist
Heather Agyepong

Contributors
Year 7 pupils,
Harris Girls' School

East Dulwich, London,
England

Screenprint on fabric

1250 × 1450 mm
0.76 kg

✎ COMMISSION

Year 7 girls reimagined themselves as women of colour (WoC) British activists to symbolise the spirit that lives on within the next generation. The banner highlights the forgotten WoC and celebrates what they have done for women's rights and marginalised communities in Britain.

'Year 7 girls reimagined themselves as women of colour (WoC) British activists to symbolise the spirit that lives on within the next generation'

TOP FLOOR ART /
ROWALLANE
COMMUNITY HUB

Artist
Emma Whitehead

Contributors
Top Floor Art Studio Group:
Lynda Kelly, Jaele McColgan,
Bridget Pullen, Janice McHenry,
Ita McGoldrick, Geri Graham,
Pamela Emerson, Hazel Bland,
Carolyn Macdougall; assisted
by members of the public
during the Get Creative
Festival, and Sarah Lynn

Saintfield,
Northern Ireland

Linen with mixed textiles,
beads, buttons, maps,
ribbon, linen, felt,
buttons, silk

4020 × 2030 mm
2.82 kg

The 'Rowallane Better Futures'
banner was designed by members
of the studio group and was very
much a collaborative effort. Each
member either made individual
pieces or contributed to the central
panel, which depicts local images.
A range of techniques have been used:
appliqué, knitting, embroidery,
crochet, soft sculpture and beading.
The main message, 'Women Crafting
Better Futures', highlights the group's
hopes for the future and their own
creativity, with motifs representing
women's contribution to education,
medicine and science. The group is
grateful to Roisin Scully for donating
the beautiful linen for the panel; it is
over 100 years old and was produced
in Belfast by her great-grandfather.

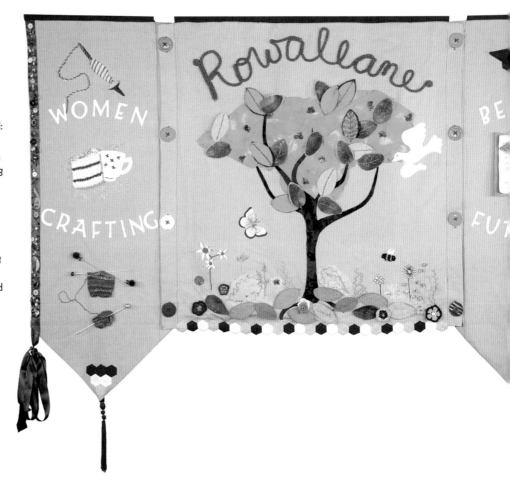

WOMEN'S ARTS ASSOCIATION

Artists
Wales Assembly of Women,
Women's Arts Association,
Art Central Friends, Mercury
Theatre Wales, SEEdS,
Canton Women's Institute,
Oasis Refugee Centre and
individual women interested in
stitching, making and liberty

Cardiff,
Wales

Mixed textiles

1450 × 2850 mm
3.48 kg

The Women's Arts Association (WAA) decided that instead of commissioning an artist their members and the other makers would each design a square. These would be stitched together to form a banner. This promotes the principles of equality and also establishes a reference to women who have made patchwork in so many different and beautiful designs for hundreds of years.

The squares were made by members of the WAA, community groups who practice stitching together, refugees, women with very few stitching and or design skills, women who offered to make one, who were politically motivated or artistically motivated, in other words as diverse a group as we could gather together.

Many different designs were made and a huge variety of materials used: sequins, embroidery thread, feathers, buttons, ribbons. Many were embellished with political messages about women's rights.

The name of each participant is printed on a label on the reverse of the banner.

Jilly Hicks, Chairwoman of the WAA, wrote that 'the coming together during the workshops forged new friendships and increased our membership'.

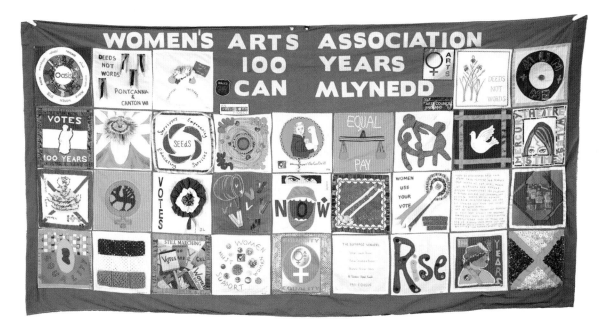

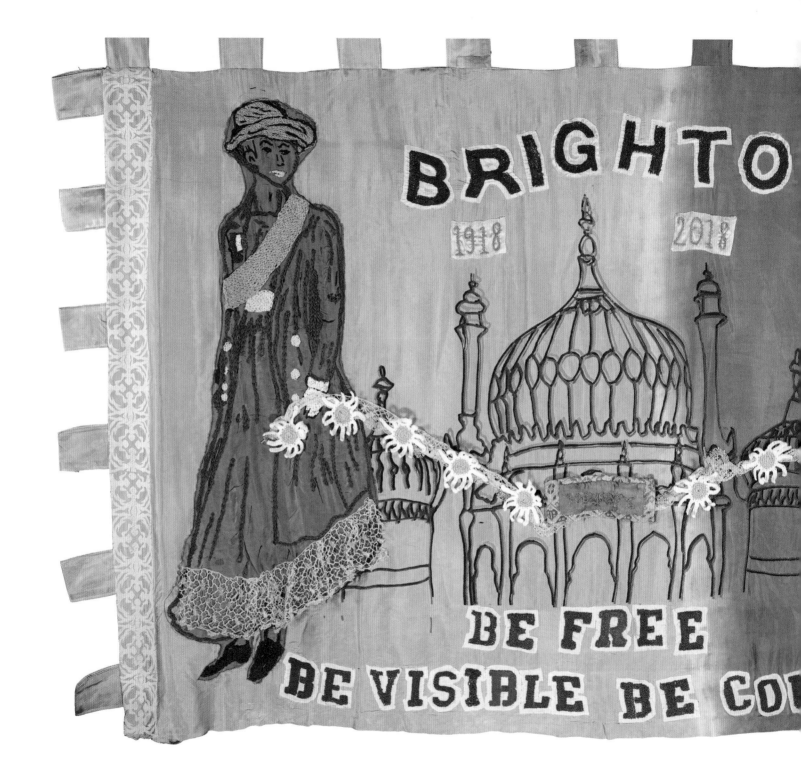

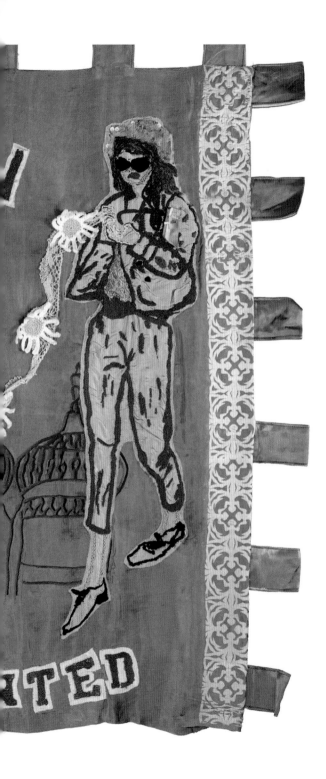

OMEIMA MUDAWI-ROWLINGS

Artist
Omeima Mudawi-Rowlings

Contributors
Ten hearing and eight deaf women: Lili Roseveare, Colette McDowell, Jennifer Engledow, Carole Sanderson, Louise Friedli, Olivia Tumim, Alison Rogers, Amaia Olasagarre, Katherine Scase, Oriele Steiner, Kimberley Swann, Parveen Dunlin, Penny Hall, Yasmin Kovic, Savita Burke, Jaqueline Buksh, Lily Nile Mudawi-Rowlings, Mary Mallett

Brighton,
England

Viscose, satin, silk, cotton canvas, lace

1270 × 2060 mm
1.73 kg

✖ COMMISSION

With the Royal Pavilion, Brighton's most iconic building, in the background, the images of the two suffragettes represent the battles and achievements of the past being handed over to modern women for them to remember, honour and continue. For the group, the daisy chain symbolises the idea that they are inextricably linked to the past as well as to each other: by working together, women will achieve equality of representation. The group honours the 'Give Women Votes' campaign through the use of green, white and violet. As a community of hearing and deaf women in Brighton, they celebrate achievements gained, and remember, in the ongoing campaigns for equality, that they need to 'Be Visible, have a duty to Be Counted, so they can Be Free'.

TURNER CONTEMPORARY

Artist
Jessica Voorsanger

Contributors
Jessica Voorsanger's Posse of
Protesters, including POW!
Thanet, East Kent Mencap,
and UCA Canterbury

Margate,
England

Mixed textiles

2100 × 3030 mm
2.88 kg

The banner was produced beside the sea in Margate, Kent. The four corners feature portraits by artist Jessica Voorsanger of inspirational women: Millicent Fawcett (1847–1929), British feminist, intellectual, political leader, activist and writer; Sojourner Truth (c. 1797–1883), African-American abolitionist and women's rights activist; Princess Sophia Duleep Singh (1876–1948), a prominent suffragette and accredited physician in the United Kingdom; and Emmeline Pankhurst (1858–1928), the leader of the British suffragette movement. These are stitched amongst individual panels created by each woman in the group, who proudly marched in suffragette costumes, ringing glass bells, for PROCESSIONS.

'The four corners feature portraits of inspirational women: Millicent Fawcett; Sojourner Truth; Princess Sophia Duleep Singh; and Emmeline Pankhurst'

Don't be a Shrinking **VIOLET**

Voorsanger's Posse of Protesters

MAKE MORE NOISE!

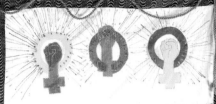

FAWCETT

STILL WE RISE

MARGATE

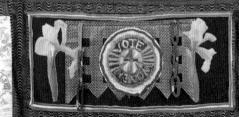

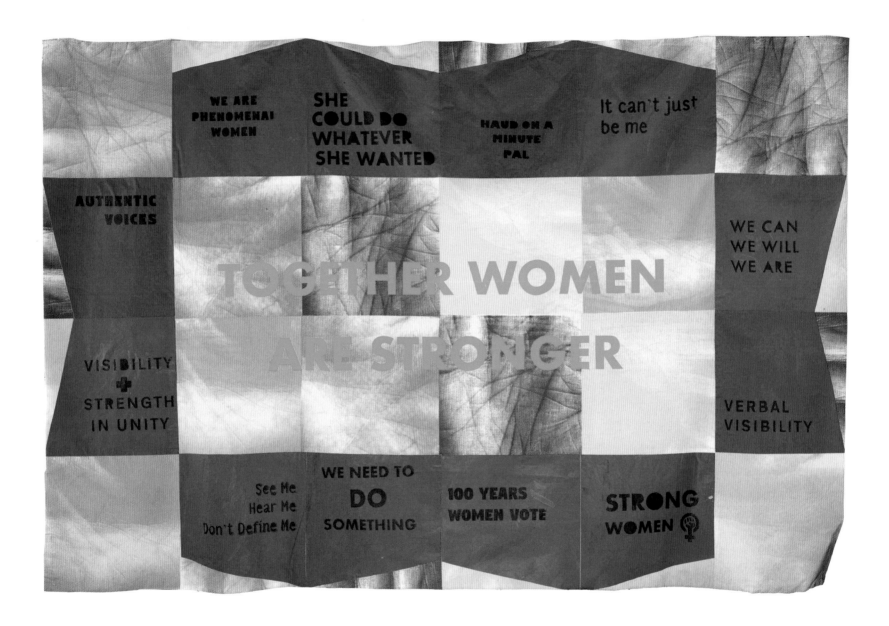

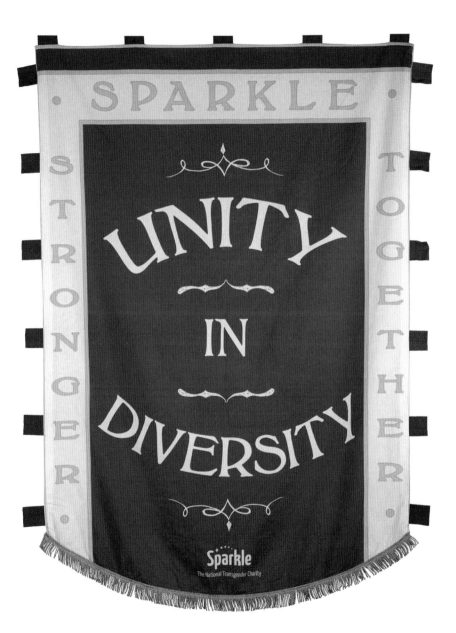

GLASGOW WOMEN'S LIBRARY

Artist
Helen de Main

Contributors
Glasgow Women's Library workshop attendees: Helen, Foxy, Daniela, Beverly, Freya, Mac, Kathryn, Freya, Betty, Anita, Ruby, Karen, Ashley, Annabel, Joanne, Alison, Lisa, Sandy, Jean, Paria, Emma, Shazia, Bridie, Karen, Aleena, Alice, Rumana, Zeenat, Mhurai, Ebony, Amalia, Rachael

Glasgow,
Scotland

Screenprint on fabric

1400 × 1995 mm
1 kg

The backdrop of this screen-printed banner is made up of repeating close-up images of women's hands. The graphic shape that surrounds the central image was inspired by the group's research into different flag and banner shapes. The texts were drawn from conversations around what it means to be a woman in 2018, as well as from material in the Glasgow Women's Library archive and museum collection, notably the banner and badge collection. Individuals worked on texts for the smaller sections, as the group was keen to present a variety of women's voices. The group then printed these together.

SPARKLE: THE NATIONAL TRANSGENDER CHARITY

Artist
Kate Davies

Contributors
Sparkle, with Kate Davies and Manchester Parents Group

Manchester,
England

Printed calico

2210 × 1620 mm
1.12 kg

The banner is inspired by the Manchester suffragette banner which originally appeared alongside Emmeline Pankhurst at a protest rally held in Stevenson Square in the centre of Manchester in 1908, and is currently on display in the city's People's History Museum.

Designed by Kate Davies of Passionfly, the graphic artist responsible for Sparkle's unique visual identity, the 'Unity in Diversity' slogan is taken from the charity's current campaign, appealing for allies to the trans and non-binary community. Printed by Contrado Imaging, the use of calico is a reference to Manchester's rich textile heritage.

NORFOLK & NORWICH FESTIVAL

Artist
Fiona Muller

Contributors
Fiona Muller, Norfolk
& Norwich Festival
Solidarity Group

Norwich,
England

Cotton, mixed textiles

1580 × 2145 mm
1.93 kg

The sheer fabric on the front of this banner is printed with anti-feminist quotes and posters. These have then been slashed through with a cross, representing the act of voting and paying homage to suffragettes, who slashed paintings to publicise their cause.

Underneath is a message of solidarity from the group to women who are unable to vote. Each letter is embroidered with abstract images representing women who can't vote because of the laws of their native country, or because they are homeless, imprisoned, or refugees. On the reverse of the banner are embroidered hidden inspirational messages, representing the messages suffragettes left for each other on the walls of their prison cells.

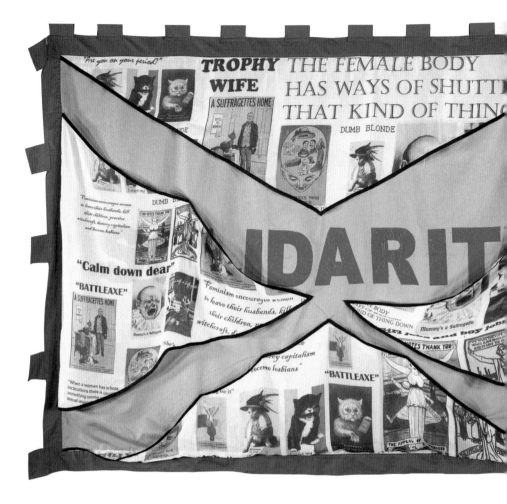

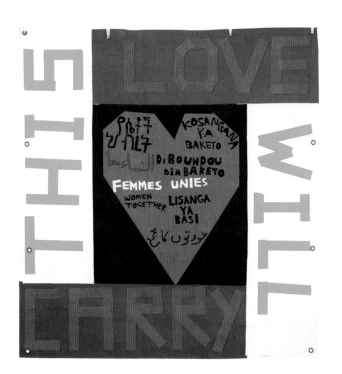

METAL CULTURE LIVERPOOL

Artist
Cristina Lina

Contributors
Wheel Meet Again, Asylum Link, Harthill Youth Centre, Picton Roma Community, Picton Children's Centre, Metal Open Session

Liverpool,
England

Gaffa tape, PVC

1550 × 1450 mm
2.3 kg

Metal Culture Liverpool made ten banners with various women-only groups from around the Picton area. This banner was made with Asylum Link. Each group decided on a unique phrase for their banner, following a sharing of the participants' own experiences of being a woman in Liverpool today. Some of the banners have incorporated the native languages of the women involved, displaying phrases such as 'This Girl Can' and 'Women Together'. They have been made using gaffer tape on tarpaulin, DIY materials that reflect the independent spirit of the women involved.

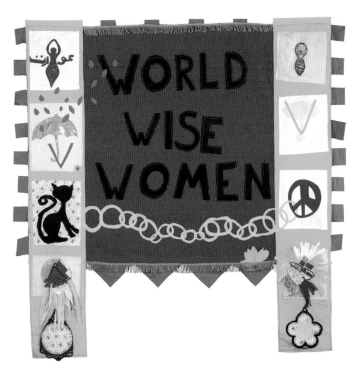

MILLENNIUM COURT ARTS CENTRE

Artist
Tonya McMullan

Contributors
Women of the World group: Reattach, Agneiska, Noy, Licina, Kanta, Sadie, Isobel, Dure, Beba, Bena, Sakiko, Sinead

Portadown,
Northern Ireland

Cotton, satin, pre-worn clothing, wool

1780 × 1800 mm (3 ×)
0.75 kg

Millennium Court Arts Centre (MCAC) is a fresh and experimental arts centre based in Portadown, Northern Ireland, focusing on contemporary visual art.

Approached by MCAC, the Women of the World group eagerly took hold of the project. They discussed the different situations regarding the women's liberation movement in each of their home countries, and the vastly different global situations present today.

Using colourful fabrics, personal clothing, embroidery, screen-printing and appliqué, the banner draws out cultural and personal references, and symbols relevant to each individual in the group. For example, the umbrella represents protection but also isolation.

COMAR

Artist
Alicia Hendrick

Contributors
Local schoolgirls,
the Guiding Association
and women's group (SWI)

Isle of Mull,
Scotland

Tweed, tartan,
beeswax, cotton, net

1470 × 1900 mm
1.4 kg (w/o pole) or
1.7 kg (incl. pole)

A series of workshops throughout Mull and Iona involved dozens of women and girls aged from eight to over eighty.

Artist Alicia Hendrick says: 'Our banner is a celebration of the inspirational women of our islands. It takes the shape of a sail held aloft by oars and incorporates handmade fishing net. The map of Mull is filled with images of island women, and in the sea are inscribed the names of more women we admire. Influenced by the suffragette banner-maker Mary Lowndes, we have incorporated the very fabric of our islands, using local tweed, tartan and beeswax. We have embroidered lyrics, words and poetry from local women writers.'

LINK4LIFE /
TOUCHSTONES
ROCHDALE

Artist
Jasleen Kaur

Contributors
Sandra, Clare, Abbie, Angel,
Jean, Siobhan, Debra

Rochdale,
England

Mixed textiles

1080 × 1530 mm
0.25 kg

Through a number of creative writing exercises, women from Rochdale collectively worked with artist Jasleen Kaur. They created the banner through responding to various questions around what it means to be a woman in Britain today, based on the theme of home and nostalgia. Inspired by handmade protest banners from current and historical political events, the women considered how they could produce powerful and meaningful pieces of work. By merging their messages, the group selected words that reflected them as individuals to create a strong and meaningful banner. Experimenting with colour and patterns, they added appropriate details and symbols.

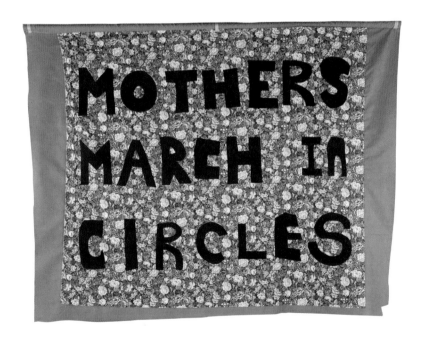

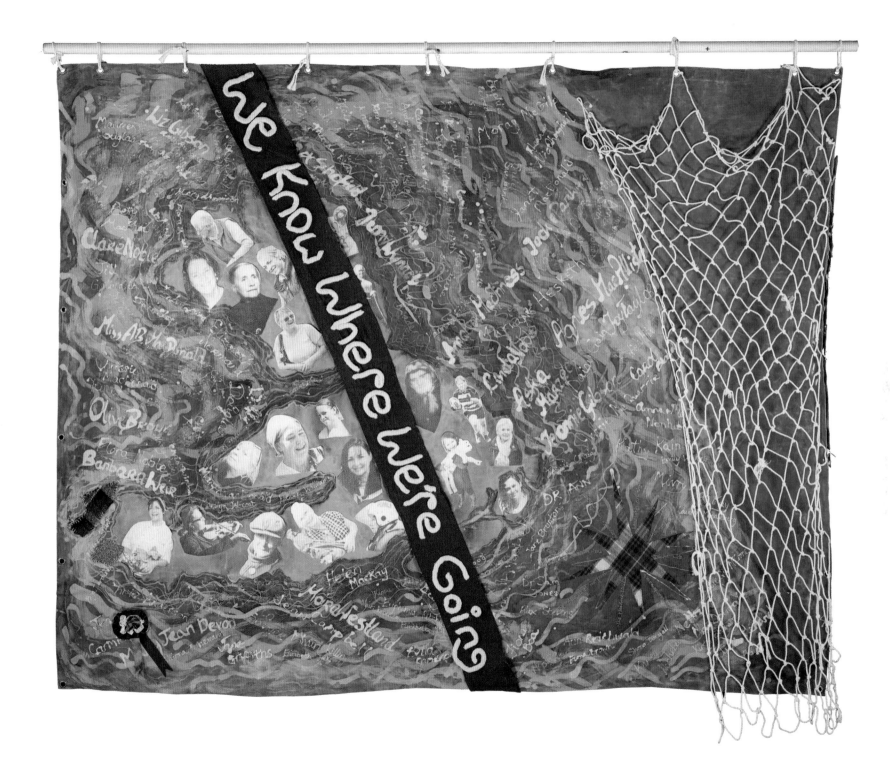

THE QUILTERS'
GUILD OF
THE BRITISH ISLES

Artist
Alison Garner

Contributors
Mary Garvey, Dami Crossley,
Evelyne Wheeler, Shirley
McBreen, Judy Stannard,
Pat Miles; members of
Region 1, and attendees
of the Quilters' Guild
2018 AGM

York,
England

Mixed textiles

1140 × 880 mm
0.85 kg

The idea of the banner came from the corporate identity of the Quilters' Guild. Their use of squares to denote quilted patches gave an idea of a quilted banner using the suffragette colours. Shades of green, white and purple were cut and sewn together to give the impression of a quilt.

The 'shadow forms' are outlines of quilters, both modern and from 100 years ago — connecting quilters who would have fought for the vote, to the quilters of today who proudly use their vote. The embroidered crosses denote women's right to make their mark.

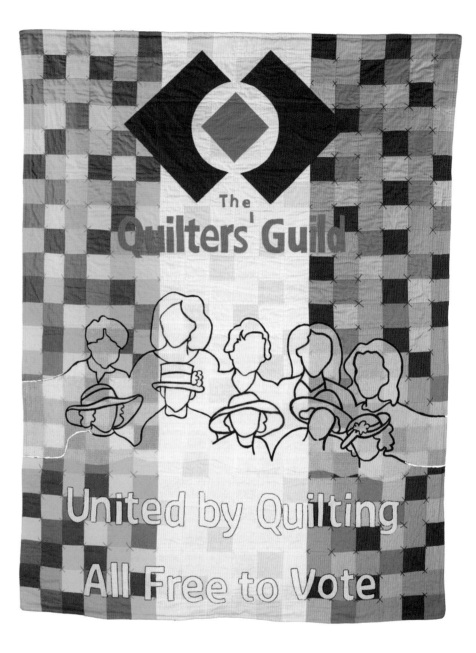

LAKES ALIVE

Artist
Jacky Puzey

Contributors
Sue Madden, Jenny Wain, Marisa Crane, Joanne Woods, Kate Ashworth, Margot Agnew, Sarah Hiscoke, Penny Mcmullan, Corrine Young, Kay Banks, Holly Goodfellow

Kendal,
England

Mixed textiles

1200 × 1590 mm
2.1 kg

Showing embroidered silhouettes on a background of landscape and industry, this unique and intricate banner created by Lakes Alive and fifteen women, represents five important women in Cumbria in the early to mid-1900s. It embodies some of the issues that are still faced by women, including the gender pay gap, gender stereotypes, and ownership of women's bodies.

From the landscape, a striking map of the Watling Street March emerges, a route which saw 50,000 women pilgrimage from Carlisle to London to protest their vote in 1913, a truly inspiring moment in the history of northern women which the group wanted to celebrate.

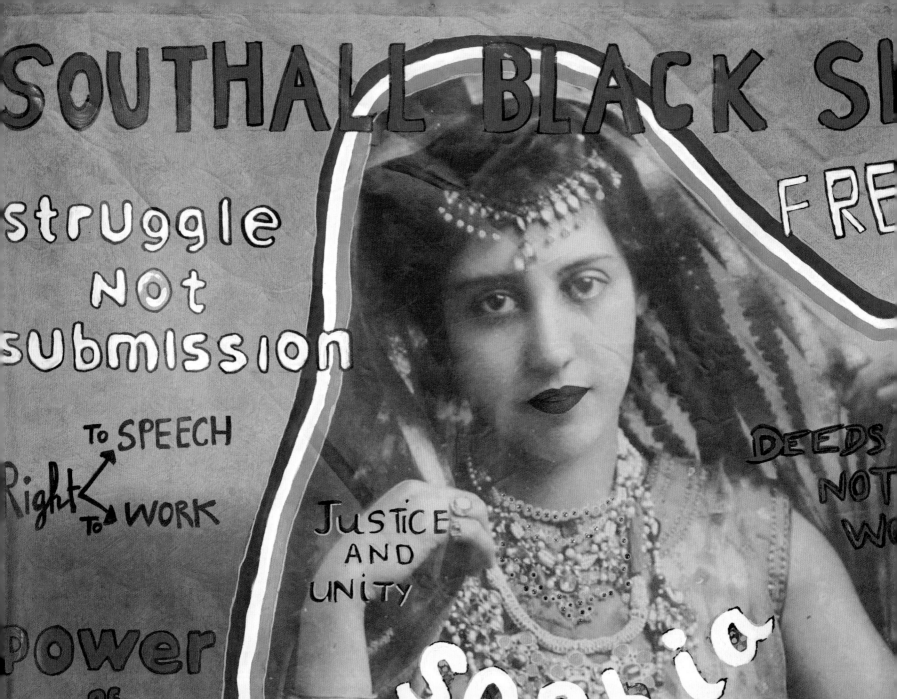

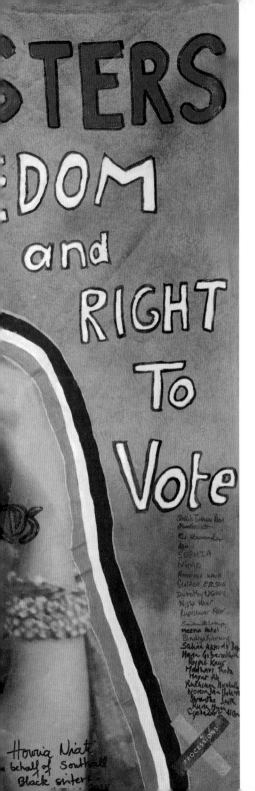

STERS
EDOM
and
RIGHT
To
Vote

Houria Niati
behalf of Southall
Black sisters

SOUTHALL
BLACK SISTERS

Artist
Houria Niati

Contributors
Southall Black Sisters (SBS)
Support Group clients

Southall,
England

Mixed textiles,
acrylic paint

1000 × 1600 mm
0.67 kg

The group created a banner celebrating the centenary of the first women to get the vote. They discussed themes of the suffragette movement, equating it to the demonstrations and activism of Southall Black Sisters (SBS). Their banner pays homage to Princess Sophia Duleep Singh (1876–1948), a key figure in the suffragette movement and a contemporary of Emmeline Pankhurst (1858–1928), whose contribution has been mostly forgotten.

SBS clients included phrases which resonated with them, such as 'Deeds Not Words' and 'Struggle Not Submission', to convey their message that some women today still do not have the vote.

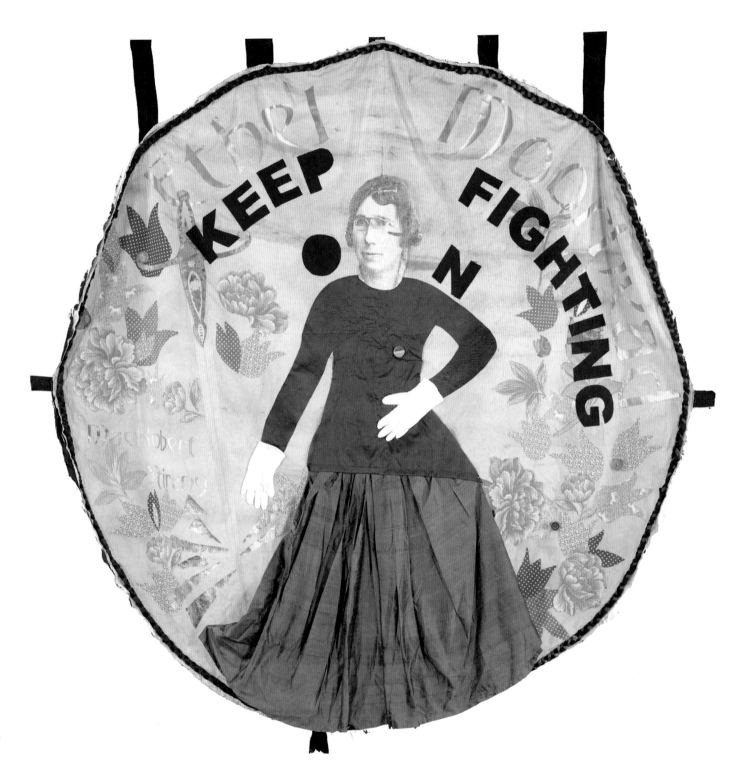

MACROBERT ARTS CENTRE: 'ETHEL MOORHEAD'

Artist
Nadine Gorency

Contributors
Macrobert
PROCESSIONS Group

Stirling,
Scotland

Mixed textiles

2230 × 2250 mm
2.6 kg

This banner was inspired by and is dedicated to Ethel Moorhead, one of the lesser known but most militant and proactive suffragettes of her era. In 1912, Ethel was found with bloody hands and arrested after she smashed a glass case at the Wallace Monument in Stirling. The group was keen to create a banner that paid homage to her strength, determination and commitment to militancy.

The group used upcycling methods, with one of the participants donating her silk wedding dress to create Ethel's dress. It transpired that the PROCESSIONS march on 10 June was the same date as the participant's wedding anniversary.

MACROBERT ARTS CENTRE: 'FORTH VALLEY'

Artist
Nadine Gorency

Contributors
Macrobert
PROCESSIONS Group

Stirling,
Scotland

Mixed textiles

1470 × 2055 mm
1.6 kg

This second banner was inspired by the landscape, the vibrant history of the Macrobert area and the exquisite and intricate textile craft used in suffragettes' banners.

Stirling is known as the gateway from the Lowlands to the Highlands, and the purple-heather-covered Campsie Fells, along with lush, green rolling hills, fitted perfectly with the suffragettes' iconic colour scheme.

A string of suffragettes is seen marching on these hills towards the Wallace Monument, evocative of Ethel Moorhead's defiant actions. Applying upcycling methods, fabric off-cuts were used to emulate beautiful landscapes and fused plastic bags became the meandering River Forth.

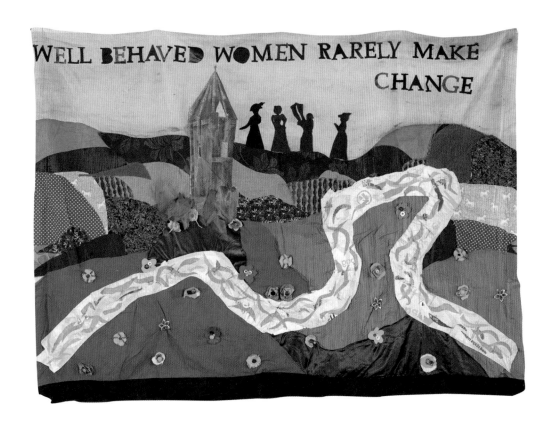

RECLAIM THE AGENDA

Artist
Deirdre McKenna

Contributors
Youth Action Northern
Ireland, Belfast Feminist
Network, Trademark
Belfast, and Lawrence
Street Workshops

Belfast,
Northern Ireland

Oil on canvas, linen,
fine Irish wool from Flax
Mills, Co. Londonderry

1900 × 2600 mm
1.12 kg

The banner was created through a series of workshops and conversations around women's historic struggle for equality, and the many years spent campaigning, protesting, lobbying, organising public meetings, rallies and strikes, and even enduring prison sentences, to win the right to vote. Inspired by their 'suffragette sisters', the group continues to protest and lobby for equality. They intend this banner to be a protest to communicate their desire for improved childcare, reproductive health rights, and marriage equality, and to reflect their energy and determination in campaigning. The group intend their banner to show clearly that they are not stopping until they get what they want.

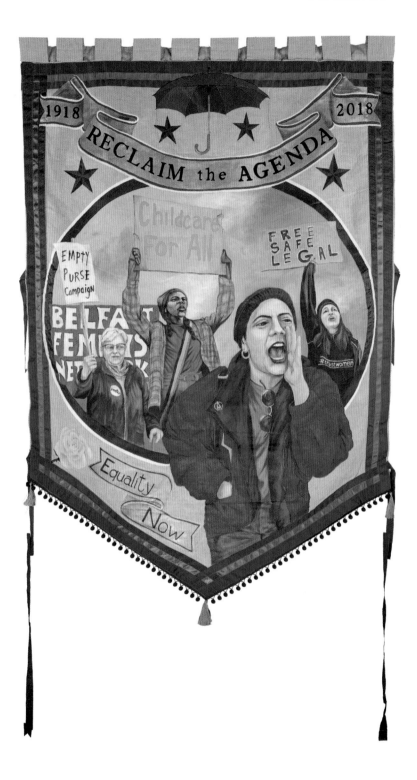

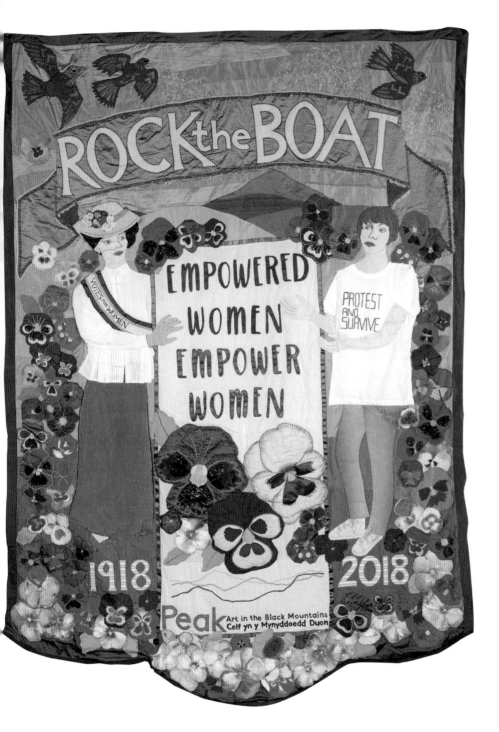

PEAK CYMRU

Artist
Bettina Reeves

Contributors
Peak PROCESSIONS Group

Crickhowell,
Wales

Mixed textiles

2350 × 1580 mm
1.37 kg

The group's aim was to celebrate the 100th anniversary of the start of women's suffrage in Britain. They wanted to honour the persistence and passion shown by the suffragettes and to reflect the ongoing concerns of feminism in 2018. The chosen slogans and symbols apply to both eras: the group wanted to convey that women still need to 'Rock the Boat', and that 'Empowered Women Empower Women' is as true today as in 1918. The 100 pansies represent free spirits, and the birds represent freedom. A group of women of diverse ages and experience formed this banner-making community and together were moved by the challenge of ideas and craft, and excited at participating in the large-scale artwork, PROCESSIONS.

SUBSCRIBER LIST

Melanie Abbott
Claire Whitehead Adnams
Fiona Alderman
Catherine Allan
Hilda Anderson
Marian Anderson
Rotraut Anderson
Tessa Archbold
Jennifer Arneil
ArtlinkHull
The Arts Council
 of Northern Ireland
Lillian Atkinson
Lucy Atkinson
Caroline Auckland
Lindsay Aveyard

Gill Bailey
Aurora Barber
Ottilie Barber
Margie Barbour
Rosie Barclay
Ann Barr
Krysia Bass
Imogen Bates
Elizabeth Baxter
Amanda Baynton-Williams
Beth Beaton
Leigh Beaton
Bedford Creative Arts
Francesca Bell
Annie Birchenough
Anne Bovett
Karen Bowman
Katie Bradford
The Brick Box Ladies
Julie Brixey-Williams
Holly Broughton
Gemma Brown

Karen Brown
Stephen Brown
Ruth Buckingham
Helen Bunker
Maureen Bura
Pamela Burniston
Sarah Burrows
Jemma Burton

Ruth Campbell
Tara L Carroll
Mary Carroll-Shovelle
Zena Carter
Lucy Cartwright
Angela Casey
Dorcas Casey
Kit Casey
Octavia Casey
Ursula Casey
Mary T Cassidy-Smith
Roz Chalk
Caroline Chandler
Maura Charlton-Thomson
Anne Marie Chebib
Marian Cinnamond
Tracy Clark
Belle Claudi
V Irene Cockroft
Susan Croft
Susannah Crook
Lynne Cumming

Sally Dalley
Claire Darke
DASH
Julia G Davies
Lucy Davies
Fenella Dawnay
Brenda Day
Jude Dean
Sarah Juliet Dearing
Marcelle Lorren Deaton
Charlotte Dew
Melanie Diggle
Prof Rebecca Dobash
Claire Dossi
Hazel Douglas
Agnes Doyle
Emma Drury
Alice Dungworth
Susan Dungworth

Judith Everett
Rosemary Edwards
Susan Lily Edwards
Lynda Elson
Jill Entwistle
Gina Espinosa
Mair Evans
Siân Elizabeth Evans

The Feegie Wummin
Niki Fforde
Fiona Fisher
Suzanne Fisher
Flint
Ana Fonseca
Carolyn M L Forsyth
Dawn Fuller
Tabitha Fuller

Cathy Gallagher
Shelley Garner
Adele Gatley
Judy Gibbons
Belinda Gillett
Tricia Gordon
Annie Gosney
Veronica Gould
Gill Govan
Jam Gray
Sue Green
Evelyn Greeves

Stella Hall
Joy Hamer
Porter Hanson
Amanda Haran
Stephanie Harding
Glenys Harrington
Iris Harris
Ellen Harrison
Dr Harry Harvey
Madeleine Hasler
Amy Hawkins
Claire Hawkins
Anne Hay
Sarah Haythornthwaite
Nic Heal
Alicia Hendrick
Sandra Hinds
Saffron Hives
Louise Hoare

Melanie Hobday
Ruth Hogarth
Gemma Horobin
Alice Hoyle
Elsa Hoyle
Nicola Huggett
Bethan M Hughes
Sophie Humphries
Norma D Hunter
Annie Husband
Kirsty Husband
Safeena Hutchison

Claire James
Helen Janecek
Clare Jones
Elin Wyn Erfyl Jones
Evie Jordan
Karen Julke

Vicky Kalogeropoulou
Lynda Kazimoglu
Joan Keating
Emily Kemp
Beverley Kendall
Kinetika People
Chloe Lee Kinrade-Thomas
Pamela King
Stephanie Kirkness
Richard Kitson
B Knight
Amelia Kosminsky
Sasha Kosminsky
Helen Kowald
Jocelyn Kynch

Effie Larkin
Elsie Lawrence
Elizabeth Lediert
Jacqui Leigh
Carol Lewis
Nia Lewis
Lighthouse,
 Poole's Centre for the Arts
Helen Lorimer

Katja Maas
Carolyn MacDougall
Georgia Mallin
Vanessa Mallin
Deborah Mann
Laura Mann
Hat Margolies
Alexandra Marks CBE
Anabel Marsh
Steve Marshall
Becky Martin
Jennifer Matuszek
Rosemary Mayo-Lythall
Janey McChesney
Josie McChrystal
Ben McCluskey
Maeve McDonnell
Lizzie McDougall
Dr Margaret McEntegart
Alison McGowan
Emma McGurk
Gwynneth McManus
Julia McMurray
Angela McSherry
Metal Culture
Middlesbrough
 Institute of Modern Art
Carole Miles
Deirdre Millar
Fran Miller
Janey Moffatt

Molly Molloy
Adrianne Monroe
Iris Montecalvo
Miranda Moodie
Ailsa Morrison
Theona Morrison
Polly Morrow
Omeima Mudawi-Rowlings
Chellsie Muirhead
Fiona Muller
Paola Munns
Anne Munro
Zoe Murphy
Selena Muscat
Sarah Myers

Felicity Naylor
Sheung Ching Ng
Lily Nice
Ruby Nice
Norfolk & Norwich Festival
Susan Northcott
Joanna Nurse

Ruth Oakley
Paige Ockendon
Chris O'Connor
Kristin O'Donnell
Enda O'Regan
Susan Owen

Evie Pang
Susan Pares
Karey Parsons
Sarahjane Patterson
Joanna Patton
Natalie Perry
Rebecca Peterson
Cydney Pettey
Nina Phillips
Ellen Phillipson
Mikenda Plant
Karen Poley
Laura Pottinger
Dawn Prentice
Tina Price-Johnson
Paula Prichard-Duggan
Sian Prime
Siân Puttock

Helen Quigley

Nicole Radnay
Xandi Rae
Elise Ward Rasmussen
Jill Ratcliffe-Davis
Honor Read
Alexis Redmond MBE DL
Prof Phil Redmond CBE
Lorraine Reed-Wenman
Tracey Rees-Cooke
Wendy Reis
Barbara Renel
Phiona Richards
Jen Richardson
Lindy Richardson
Wendy Roberts
Robbi Robson
Cindy Rogers
Jemima Roques
Tamsin Roques
Molly Ross

Nell Sampson
Sarah Sanna
Nadia Shamma
Lauren Shaw
Mindy Ann Sherman
Jessica K Shovelle
Tamsin Silvey
Anna Siraut
Katie Smith
Catriona Smyth
Rhona Smyth
Matilda Somervell
South Hill Park Arts Centre
Beverley Stanislaus
Jo Stevens MP
Aylson Stewart
Karyn Stewart
Lindsay Stewart
Claire Stuart

Taigh Chearsabhagh
 Museum & Arts Centre
Jessica Temple
Lisa Temple
Margaret Thompson
Tower Hamlets
 Centre for Mental Health,
 East London NHS
 Foundation Trust
Fiona Tredgett
Marianne Turner

Alison Ud-din
Asha Usiskin

Flavie Vial
Vivien Vincent
Anna Vrij

Kirsty Stonell Walker
Laura Walker
Lynda Walker
Liz Walmsley
Claire Walsh
Helen Walsh
Susan Walters
Jess Webb
Janice White
Jennifer Dennison White
Emma Whitehead
Heidi Wigmore
Bryonie Williams
Helen Willmott
Rosie Wolfenden
Women's Arts
 Association Wales
Sue Woodcock
Jo Woodworth
Karen Wright
Denise Wyllie

INDEX

Page references in *italics* indicate images.

CREDITS

PROCESSIONS FUNDERS AND SUPPORTERS

Thank you to our funders and supporters who enabled PROCESSIONS and to all who took part.

PROCESSIONS was commissioned by 14–18 NOW, the UK's arts programme for the First World War centenary and produced by Artichoke. With support from the National Lottery through Arts Council England and the Heritage Lottery Fund, and from the Department for Digital, Culture, Media and Sport.

PROCESSIONS Cardiff was produced by Artichoke in partnership with Festival of Voice and Wales Millennium Centre.

Proud partner

NatWest

Major partners

Government Equalities Office
City of London Corporation

Major supporters

Arts Council Wales
Creative Scotland
Event Scotland
Facebook
Paul Hamlyn Foundation
Scottish Government

Partners

Arts Council Northern Ireland
The Crown Estate
Marble Arch London
Rothschild Foundation
Welsh Government

Affiliates

30% Club
Airbnb
Belfast City Council
Big Lottery Fund Wales
City of Edinburgh Council
Greater London Authority
Hogan Lovells
New Zealand High Commission

Supporters

Cardiff Council's Cultural Projects Scheme
Edwards & Company
Evolve
The Sylvia Waddilove Foundation UK
The Worshipful Company of Carpenters
The Worshipful Company of Haberdashers

Artichoke core funders

Arts Council England
Bloomberg Philanthropies
Leathersellers' Company Charitable Fund

With special thanks to

Clear Channel
Grey London
Google Arts & Culture
JC Decaux
Primesight

PROCESSIONS
TEΔMS ΔND BOΔRDS

Artichoke

Lydia Brightling-Reed
Sarah Coop
Fiona Darling
Fenella Dawnay
Louise Dennison
Janey Elliot
Aaron Gordon
Neil Goulder
Kate Harvey
Clare Hunter
Emily Lake
Helen Marriage
Kate Ottway
Catrin Owen
Ma-ayan Plane
Carmen Ralstein
Soleil Redwood
Geetanjali Sayal
Emily Turner
Tilda Verrells
Anna Vinegrad

England

Jonathan Bartlett
Julian Bentley
Anne Marie Chebib
Jim Dugan
Nikki Dunk
Alan Jacobi
Rowena Sommerville

Northern Ireland

Beverly Craig
Shauna McNeilly
Lyn Sheridan

Scotland

Ian Bone
Jean Cameron
Emma Henderson
Audrey Leonard
Anne McLaughlin

Wales

Sarah Cole
Nia Jones
Rachel Kinchin
Charlotte Lewis
Kayte McLeod
Elin Rees

Delivery Partners

Aiken PR
AKA
Flint PR
Forward Action
Media Workshop
Unusual

14–18 NOW

Emma Dunton
Claire Eva
Nigel Hinds
Jenny Waldman
Pak Ling Wan
Albright Special
Bolton & Quinn
The Cogency

Special thanks to

Fiona Adler
Amelia Allen
Sheila Burnett
Alice Clifford
Anita Corbin
Jonathan Courtney
Tim Dollimore
Lucy Dundas
Kanya King
Alex Lloyd
Amrit Kaur Lohia
Lesley Martin
Brian Morrison
Gillian Murphy
Dr Helen Pankhurst
 CBE
Dame Seona Reid
Grace Ridley-Smith
Annie Rushton
June Sarpong OBE
Polly Thomas
Hannah Vitos

Development Board

Stephanie Flanders,
 Chair
Dame Julia Cleverdon
Lady Lucy French
Baroness Dido Harding
Vikki Heywood CBE
Ghislaine Kenyon
Caroline Marsh
Becky Power
Nigel Pullman
MT Rainey
Helene Reardon-Bond
 OBE

Artichoke Board

Stephanie Flanders,
 Chair
Peter Freeman
 (Chair to 2019)
Dalwardin Babu
Jan Boud
Judith Chan
Allan Cook
Sarah Coop
Ivo Dawnay
Ruth Hogarth
Ghislaine Kenyon
 (to 2019)
Richard Kitson OBE
Tim Marlow (to 2020)
Helen Marriage MBE
David Micklem
Nii Sackey (to 2019)

EDITOR
Anna Vinegrad

EDITORIAL TEAM
Harriet Coleman, Fenella
Dawnay, Catrin Owen
and Graeme Hall
Design by Justine Bannwart

First published in
Great Britain in 2020 by
Profile Editions, an imprint
of Profile Books Ltd
29 Cloth Fair
London EC1A 7JQ
www.profileeditions.com

PROFILE
EDITIONS

AN
ARTICHOKE
PROJECT

14-18-NOW
WW1 CENTENARY ART COMMISSIONS

ARTICHOKE FUNDERS
Artichoke is proud to
be a National Portfolio
Organisation and receive
regular funding from Arts
Council England

Supported using public funding by
ARTS COUNCIL
ENGLAND
LOTTERY FUNDED

Idea generator partner
Bloomberg
Philanthropies

www.artichoke.uk.com
Artichoke Trust is a registered
charity No.1112716 and
a company registered in
England No.5429030

ISBN 978 1 78816 5457

Printed and bound in Italy
by L.E.G.O. Spa-Vicenza

FSC
MIX
Paper from
responsible sources
FSC® C023419

Supported using public funding by
heritage
lottery fund
ARTS COUNCIL ENGLAND
LOTTERY FUNDED

Department for
Digital, Culture
Media & Sport

FIRST WORLD WAR CENTENARY
LED BY IWM

10 9 8 7 6 5 4 3 2 1

The moral rights of the
authors have been asserted